# HABATAT GALLERIES

## 40TH ANNUAL
## INTERNATIONAL GLASS INVITATIONAL
### Awards Exhibition 2012

# Anniversary Edition

April 26th 2012 – June 18th, 2012
Grand Opening: April 28th, 2012  8:00 PM

**HABATAT GALLERIES MICHIGAN**
4400 Fernlee Avenue | Royal Oak, Michigan, 48073
248.554.0590 | 248.554.0594 fax | info@habatat.com | www.habatat.com

This catalogue is dedicated to John Lawson, Director of
Habatat Galleries. For 28 years John has set up exhibitions in
the gallery and our presentations at SOFA, Wheaton Village,
and Art Palm Beach. He has calmed the most excitable
artists, dealt with the most demanding collectors, handled the
concerns of a diverse staff and, oh yes, made my life easier!

We have all been enriched by this wonderful person. John will
retire from Habatat as of July of this year. He will continue to
serve collectors, consulting on lighting and display and be a
consultant to us on exhibits. We wish our friend well on his
new endeavors and will miss him dearly.

- Ferdinand Hampson

HABATAT GALLERIES

Ferdinand & Kathy Hampson
Corey Hampson
John Lawson
Aaron Schey
Debbie Clason
Rob Bambrough
Rob Shimmell
Barak Fite
Nick Solomon

Jurors:

Bruce W. Pepich
Executive Director and Curator of Collections, Racine Art Museum, Racine, Wisconsin

Larry Sibrack
Noted lecturer, docent and collector

William Warmus
Noted curator, art historian and author

Design and Layout by John Bowman
Planning by Ferdinand Hampson, Corey Hampson and Aaron Schey
Compilation and Editing by Aaron Schey and John Lawson

This catalogue was published to coincide with the exhibition *40th International Glass Invitational*
at Habatat Galleries, Royal Oak, Michigan, Thursday, April 26, 2012 to Monday, June 18, 2012.

ISBN 978-1-928572-00-8

# THE 40TH ANNUAL INTERNATIONAL GLASS INVITATIONAL – ANNIVERSARY EDITION

Anniversaries are always a time to reflect. This year we are reflecting upon 40 years of memories! This theme was presented to the artists in this exhibition. We asked them to tell stories of their lives or their past experiences with the International. The results are published with an image of their work in this catalogue. This is a very different approach to our previous publications and we would like to thank the artists, collectors and staff for their memories and participation.

Our milestone is shared with the 50th year anniversary of American Studio Glass. One hundred and sixty eight museums and art centers will help us celebrate with exhibitions, lectures and displays of contemporary glass throughout the United States. No when your interest began in this 50 year history, I hope that it has enriched your lives as it has ours.

For this introduction we have asked members of our staff, and some of our earliest collectors, to tell a story about the history of this event and the impact it has had.

### Myra and Hal Weiss – collectors:

For us, avid glass collectors for over 20 years, Ferd's annual Habatat International Invitational has been the highlight of the year. Starting with the Triatria extravanzas (one year, each room representing artists from a different nation), we met artists and collectors from all over the United States and the world, making dear, wonderful friends. Then on to Pontiac, with its musical sideshows, Ferd proved to be not only an expert on contemporary glass art, but also a major impressario of multimedia events. And currently in Royal Oak, an auctioneer extraordinaire. Kathy and Ferd have become very special, close treasured friends who have opened up a magical world of beauty. They have guided us through this amazing kaleidoscope of glass. We look forward to the future filled with new adventures led by the fabulous Habatat team.

### Debbie Clason – Habatat Galleries:

I have worked at Habatat Galleries for 15 years. One of my most memorable experiences involved the artist Mundy Hepburn, an unusual fellow that apparently enjoyed installing his work in his underwear. I walked into the middle of an installation and received an eye full of Mundy Hepburn, boxer shorts and a sleeveless tee shirt. His nonchalant attitude made the situation as comfortable as possible – but I have never forgotten!

### Mary Corkran – collector:

Blair and I attended our first Habatat Spring Show in Lathrup Village in March 1980, and I have missed only one since then. We were new collectors, and with our sons age four and five, casually drove from Washington, DC to Detroit the second weekend. We were so excited when we walked into the gallery, but stunned by the enormous number of red dots. Little had we realized that there were many avid collectors who came the opening day. The race was on.

*(continued on page 5)*

# Participating Artists

Rik Allen
Shelley Muzylowski Allen
Herb Babcock
Rick Beck
Michael Behrens
Robert Bender
Howard Ben Tré
Alex Bernstein
Martin Blank
Zoltan Bohus
Peter Borkovics
Stanislaw Jan Borowski
Christina Bothwell
Latchezar Boyadjiev
Peter Bremers
Emily Brock
Lucio Bubacco
William Carlson
José Chardiet
Nicole Chesney
Dale Chihuly
Daniel Clayman
Deanna Clayton
Keith Clayton
Matthew Curtis
Dan Dailey
Miriam Sylvia Di Fiore
Laura Donefer
Irene Frolic
Susan Taylor Glasgow
Robin Grebe
Eric Hilton
Tomáš Hlavička
Petr Hora
David Huchthausen
Toshio Iezumi
Martin Janecky
Luke Jerram
Richard Jolley
Vladimira Klumpar
Jenny Pohlman & Sabrina Knowles
Judith LaScola
Shayna Leib
Antoine Leperlier
Jeremy Lepisto
K. William LeQuier
Steve Linn

Marvin Lipofsky
Susan Longini
Carmen Lozar
Maria Lugossy
László Lukácsi
Lucy Lyon
John Miller
Debora Moore
William Morris
Kathleen Mulcahy
Paul Nelson
Bretislav Novak Jr.
Stepan Pala
Albert Paley
Zora Palova
Mark Peiser
Sibylle Peretti
Marc Petrovic
Stephan Rolphe Powell
Clifford Rainey
Colin Reid
Richard Ritter
Marlene Rose
Martin Rosol
Kari Russell-Pool
Davide Salvadore
Jack Schmidt
Mary Shaffer
Paul Stankard
Therman Statom
Ethan Stern
April Surgent
Tim Tate
Michael Taylor
Margit Toth
Brian Usher
Bertil Vallien
Janusz Walentynowicz
Leah Wingfield & Stephen Clements
Ann Wolff
John Wood
Hiorshi Yamano
Brent Kee Young
Albert Young
Udo Zembok
Toots Zynsky

In the next years, after driving all night with boys asleep, we arrived at the gallery early even before there were preview days. Blair and I took turns seeing the exhibition first and would write down our top five favorites to be discussed over coffee later. The budget was small, but the passion was enormous. On our third visit it was my turn to go in first, even though I looked disheveled from a night on the road. The staff was busy unpacking and putting art on stands. I quietly walked around looking at each object when Tom Boone asked me to leave because they were getting ready for a show. He thought I was one of the bag ladies who inhabited the area.

Other children went skiing or to the beach during spring break but not our sons: they got to go to Detroit. March weather was not always warm and inviting, but there were those hotels with indoor/outdoor pools, a fabulous zoo that had penguins, Greektown, the Science Museum and many other treats that most collectors do not know exist. David and Scott learned to view art with hands clasped behind their backs. They met artists and watched their work develop and change.

The Gallery moved to larger spaces and the date changed to April, but the shows at Lathrup Village were special. The space was packed with glass art, and the work moved. You had to look very carefully to see it all. Sometime a treasure was on the floor or on a favored stand only to be somewhere else within the hour as collectors wanted to see it in a different light. Not only was the display of art was different then, but record keeping was also different. In those early days the calendar for upcoming shows was kept on a piece of cardboard torn from a packing box. During the National, as the show was then called, the "art schedule" was kept on Ferd's desk. There were twelve boxes which contained the names of the artist and the month. If a collector was interested in a piece, they signed the list. Then before the opening of the show, the collectors were contacted in the order they had signed up to receive pictures of the pieces. That is how Blair and I acquired our Pragnanz #5 by Bill Carlson in the fall of 1983. We were first on the list. Corning was second.

The location of the gallery changed. Artist came and went. April became the month for the opening. The festivities expanded and included auctions, lectures, seeing collections, and elaborate parties. Throughout these changes there was one constant factor which was the camaraderie of the people: gallery personnel, artists, and collectors. The last thirty-two years provide me with delightful memories. I regret I missed the first eight. Thanks Habatat.

### Kathy Hampson – Habatat Galleries:

As often happens in any business, we get caught up in the everyday machinations of our gallery . . . the promotion, marketing, advertising, publications, exhibition schedules and design. I come home and realize, I have been sequestered in my small cubicle the entire time. So my fondest memories of Habatat are the days just prior to our International Invitationals.

We, as a team, must roll up our sleeves and begin the amazing process of transforming our "world." We paint, build, construct, unpack, clean and dust. Incredible pieces arrive each day and we are in awe of them. They rest upon pedestals, some reflectively gleaming, some remarkable in their form, some providing interesting narratives and commentaries. All coming alive under the lights. A magical transformation even Merlin would envy.

So when I'm stuck at my desk, wondering why, I simply remember these very special days.

*(continued on page 6)*

## Vic and Cathy Leo – collector:

Kathleen and I have attended every one of Habatat's International Shows, first as collectors and then as artist. It was in the 21st year of the Habatat International Show (1993) that we had the pleasure of meeting an anonymous gentleman who turned out to be quite an accomplished artist. We were strolling thru the gardens and artist installations in the Triatria building which housed Habatat Gallery, when we saw an older gentleman dressed formally in a suit, looking like he did not quite know where things were. I asked him if we could be of help and in his minimal English and Kathleen's broken Italian we got along famously right from the outset. Since I'm Italian also, it was a bit of old home week. He introduced himself as Livio and soon we sat down to have some of Habatat's renowned food and refreshment offerings. We spent a charming half hour conversing about this being his first trip to Habatat Gallery, and generally talking about Italy, our respective world travels, and glass sculpture. It was only when he gave us his card as we stood up to continue touring the show that we discovered that we had been talking with Livio Seguso. Stunned, I revealed that we owned a piece of his work, Nucleo, and we immediately began to speak about his work and his art. This is the hallmark of the distinguished gentleman artist, to be humble in the world, to be part of old world chivalry, and to share with total strangers. Glassmaker, sculptor, citizen of the world, Livio Seguso, we salute you.

## Ferdinand Hampson – Habatat Galleries:

Corey asked me to write a story about a memorable event during the International. Obviously these "events" occur every year but one that comes to mind is when we found additional space for the International Glass Expo in a building under construction. During the 1980's and 1990's, to house the exhibition, we would need to find a venue other than the gallery to expand the exhibition into. Of course these were usually raw spaces requiring lighting, painting and etc. I came up with the idea that if we strung 20 low voltage (6 volt) bulbs onto a wire, it would equal 120 volts. I plugged this concoction into a wall socket in my home and amazingly it worked! I figured we saved about $2,000 for each string without the fixtures, so I brought them on the last set up day, and that night with the pride of a great inventor I hung my strands of bulbs. What I didn't figure was if you moved one light to illuminate a piece, the other 19 moved in a variety of directions, including lighting the ceiling. After a couple of hours of trying we finally moved the pedestals where the light was – that was just before we blew all of the fuses on the floor and had to crawl on our hands and knees to find the door. Just another 4:00 a.m. night before the preview days!

## Aaron Schey – Habatat Galleries:

I sometimes take for granted the experiences and people in my career. It is always very important for me to step back and see how honored I am to be included in this glass culture. The love of my life, Sara, was recently exposed to this culture at the 39th International Glass Invitational and had the opportunity to see all the beautiful works and colorful people that it encompasses.

During the International party at Ferd and Kathy's (my parent's) home, she had the chance to meet the people who are the cogs of the glass community. Artists, collectors and Habatat's staff all blended together in one large festive group. I enjoyed introducing Sara to each person whom I have been privileged to work among and develop special friendships with at Habatat. It was an exciting experience for me to share my career in such a joyous and intriguing way. I felt very proud and honored that part of my life involves so many fascinating, humorous and sincere people.

## John Lawson – Habatat Galleries:

This year, it is the 40th International. The very first annual exhibit that I was involved with was the 12th National Exhibition in 1984. That means that I have been involved with 28 annual exhibitions over the years. Quite a length of time working with staff and artists to organize and stage this event that is so important to so many.

Over the years we have staged these exhibits in varied environments from unfinished high rise office buildings to beautiful atriums filled with fountains and exotic plant life, from 19th century reimaged buildings to our wonderful 14,000 square foot gallery complex. We have used limousines, buses and vans as shuttles to move our visitors to the various sites of the yearly exhibit. We have created exciting venues to display the works in those many exhibitions.

The dedication and thoughtfulness to take some very raw spaces and turn them into venues that instill awe in the visitor's eyes can only happen with some very creative people. I have had the pleasure to work with people such as Woody, Bob and especially Rickey whose talents are incredible. The newer team, of over ten year's duration, at the gallery is no less impressive. Rob B., Rob S. and Barak along with the amazing gallery staff and others have helped create some of the most beautiful exhibits Habatat Galleries has ever organized. Thanks also to my partner, Vern, who helped out many an International behind the scenes and did bartending, too.

That being said, none of this could have happened without the artists invited to this yearly exhibition. The talent and creativity that these individuals bring is beyond belief. We are overwhelmed by them and each and every one has given us insight and memories that will last a lifetime.

What does the 40th International mean to me? It is a future filled with excitement and possibilities and a look back at the past filled with hard but exciting work, the beauty of art and memories of wonderful friendships.

Oftentimes we store experiences in what can be imagined as little bottles. Sometimes these bottles get dusty from neglect. I think it is important to occasionally open these bottles and examine the contents. They are the stories that make up our lives - these little bottles help build what we are today. I grew up with artists. When I was small, they stayed at my home played games with me and exposed me to new and exciting thoughts. As a teenager I would laugh sometimes argue but more often learn from these amazing people. I have lived a privileged life surrounded by bright collectors and artists that shared their passions with me. During college I missed the great passion that these individuals shared with me - the collectors' enthusiasm and the artists' passion about what they make.

Passion is a funny thing . . . it can be contagious.

- Corey Hampson

# Award of Excellence 2011

## Collector's Choice 2011

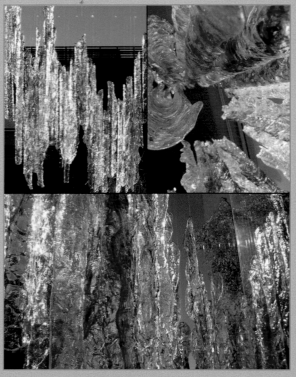

Martin Blank

## People's Choice 2011

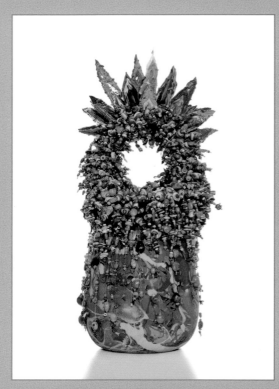

Laura Donefer

## Noted Collectors' Award
Steve and Linda Wake - Noted collectors from Chicago

Rick Beck

Stanislaw Jan Borowski

Latchezar Boyadjiev

Dale Chihuly

Toshio Iezumi

Charlie Miner

Clifford Rainey

Paul Stankard

## Independent Consultant Award
Lillian Zonars - Independent Curator from Bloomfield Hills, Michigan

**Peter Bremers**

**José Chardiet**

**Daniel Clayman**

**Petr Hora**

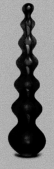

**Vladimira Klumpar**

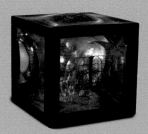

**Antoine Leperlier**

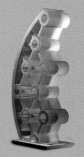

**Mark Peiser**

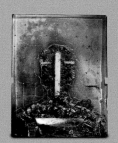

**Bertil Vallien**

## Kalamazoo Institute of Arts Award
Vicki Wright - Director of Collections and Exhibitions at the Kalamazoo Institute of Arts

Michael Behrens

Howard Ben Tré

Emily Brock

Dan Dailey

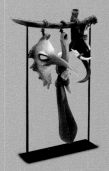

William Morris

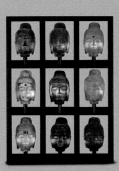

Marlene Rose

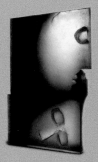

Ann Wolff

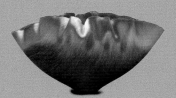

Toots Zynsky

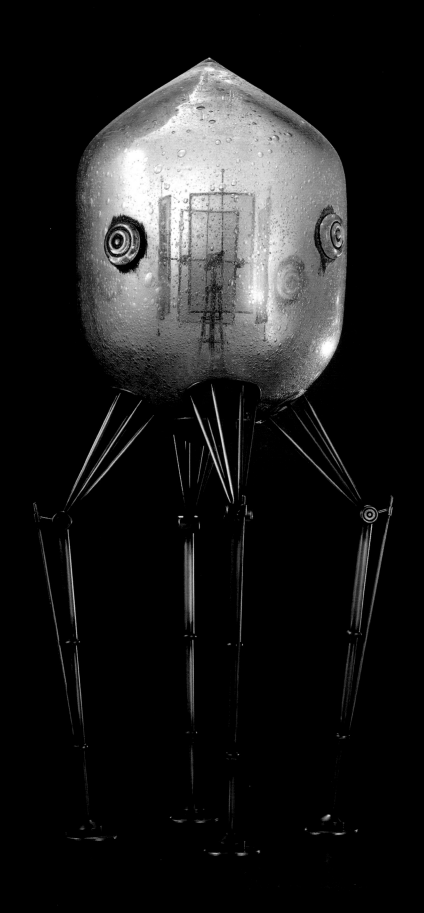

While I draw, make my components, and assemble my work, I am often haunted by my memory of a quote from the 1975 film "Jaws"... As Richard Dreyfuss's character Matt Hopper loads his cages and scientific equipment into the ship "Orca" before setting out to hunt for the massive Great White Shark, the ship's brash and salty captain Quint says [seeing Hooper's equipment] "What are you? Some kind of half-assed astronaut?"

To this question asked of me, I say, "Yes, absolutely".

-Rik Allen

**Turing Exterra** - 2009
34 x 16 x 16"
blown glass, steel, wire mesh
Photo: KP studios

11

# Shelley Muzylowski Allen

Last year, during Habatat's 39th Invitational, I participated in the Primal Instinct exhibition at the Janice Charach Gallery with a group of fellow artists. On the afternoon of the opening, I was standing next to my piece - a Horse Netsuke Pot - when one of the artists (and now a friend) commented on my diminutive size compared to the large scale of the piece.

He then asked me if I lived in the Pacific Northwest. I told him I did, and he said he had someone I should meet who might be able to assist me in making such large pieces. Did I know Rik Allen? After my shocked amusement wore off, I told him that not only did I know Rik Allen; I was married to him.

—Shelley Muzylowski Allen

**Can Tankeres** - 2012
13 x 23 x 9"
blown and off-hand sculpted glass, concrete, steel
Photo: Russell Johnson

# Herb Babcock

After earning my BFA in sculpture, Ford Motor Company hired me as a Clay Modeler in Design. I moved to Dearborn for two years to earn enough money to pay for my MFA in sculpture. To furnish my apartment, my fiancé and I went to Wicker World in Dearborn. They were long gone but a new gallery was setting up in that space with paintings, prints, glass, sculpture and clay. We introduced ourselves to the young owners Ferd Hampson, his sister, Linda, and her husband, Tom Boone. Eventually we helped them with some displays and they offered to exhibit some of my bronze sculpture and blown glass. I studied glass in Vermont in 1969 and Toledo in 1970.

Entering the Graduate Program at Cranbrook Academy of Art in 1971, I studied sculpture. During my two years there, I built and ran a small glass studio at Cranbrook. After graduation, I accepted a position as Section Chair of the Glass studio at what is now the College for Creative Studies. By this time, Habatat was immersed in glass and commitment to presenting the best of contemporary glass. I have been with Habatat Galleries since the beginning.

- Herb Babcock

**High Plain** - 2012
32 x 18 x 20"
Cast glass and bronze

# Rick Beck

Many years ago, 1991-94, I was an artist in residence at the Penland School of Crafts and one day in 1993 I was in the studio blowing glass when in walks a man and his son.

I introduced myself and my wife, Valerie, to them and learned they were from Michigan and had a gallery called Habatat near Detroit. Ferdinand and Corey Hampson had just randomly visited that day and I had just recently started casting prototypes of screws and I was eager to show him. I had been blowing glass until my recent experiments in casting.

Corey lit up with excitement as he had his first experience blowing and working with glass that day with us in the studio.

I began showing my work with Habatat 10 years later and enjoyed our relationship ever since.

Congratulations on 40 years of the International Glass Invitational!

- Rick Beck

**Reclining Figure** - 2012
78 x 48 x 14"
cast and fabricated glass
Photo: David H. Ramsey

# Michael Behrens

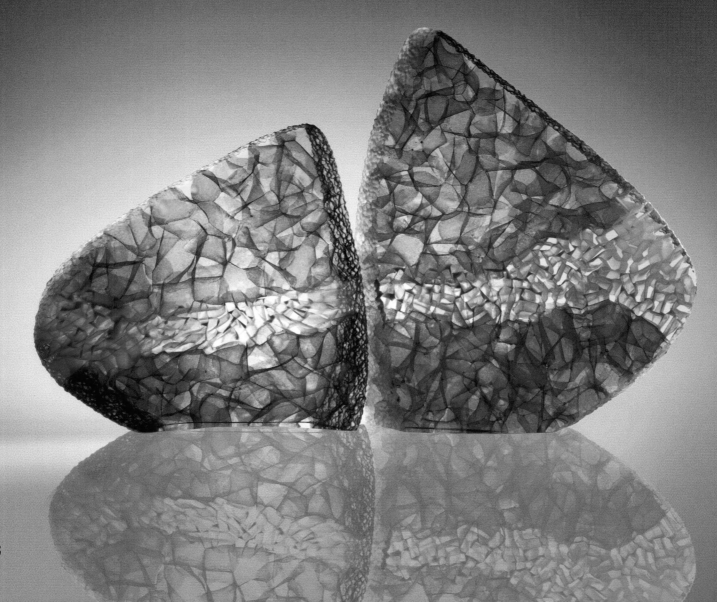

Traveling from the SOFA-Show 2011 to the Habatat post exhibition party was really fun. Going downstairs to where the cabs were we discovered that, once again, there was a long line and few cabs since the expo had just closed and all the people were leaving.

We found a limousine which was waiting so Ferd and Corey arranged a good price with the driver. What the driver did not know was that there were around 20 of us just waiting to get to the party and after all of us cramming into the limo it was a totally crowded. Luckily, the drive did not take too long otherwise I would not have been able to move my legs again since I was sitting on them on the floor!

Enjoy these images of the limo ;-)

- Michael Behrens

**Sea-Forms** - 2012-31
26 x 41 x 7"
kiln-casted glass
Photo: Paul Niessen, Maastricht, The Netherlands

# Bender

Although I received many years of training in the ceramics field, my wife Christina Bothwell and I are pretty much self taught in glass casting. This means that there is a lot of learning that takes place through trial and error, about things like annealing schedules.

I once suggested that Christina try incorporating aluminum into her work. Aluminum has a melting temperature of about 1400 degrees, so I knew the mold making material for glass could handle that. On one particular occasion something very curious happened. No matter how much aluminum chunks I added to the mold, it wouldn't seem to fill up. After a couple of hours of feeding this hungry mold, I decided to peer into the kiln to take a closer look.

Surrounding the mold (on the floor of the kiln) was a shimmering lake of Aluminum. The kiln was filling up. In my controlled panic the first thing I did was to pull the plug. Then I removed the top two rings of the kiln, exposing the mold to the open room.

I knew that the kiln was ruined if I let the metal cool to a solid in the kiln, so I got this bright idea. I would lift the bottom ring just enough to let the aluminum leak onto the cement floor, thus emptying it out of the kiln. It didn't leak. It shot out and missed my leg by a narrow margin.

It rolled around the floor like a living entity. I hurriedly pushed flammable things out of the molten aluminum's path. The rubber shoes on the kiln stand caught fire. Fortunately, I had an extinguisher handy. I barked out orders to myself, as if I needed to hear an audible command on how to proceed.

In the end the kiln remained standing, although its fate seemed in doubt for a while. Now I take precautions, like placing the mold in a large pot and packing sand around the mold. (We don't use too much aluminum anymore).

- Robert Bender

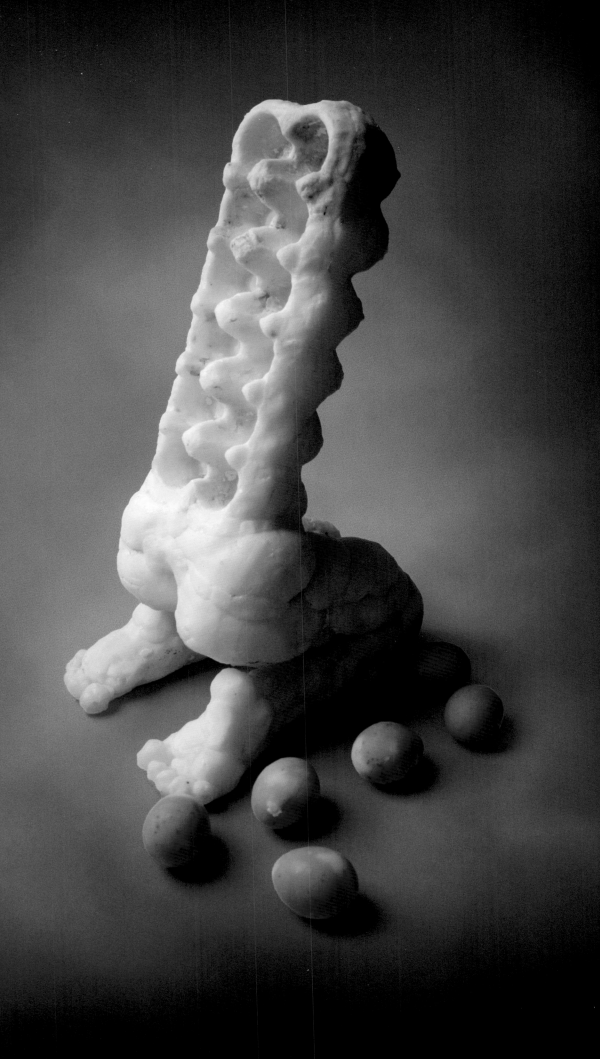

# Howard Ben Tré

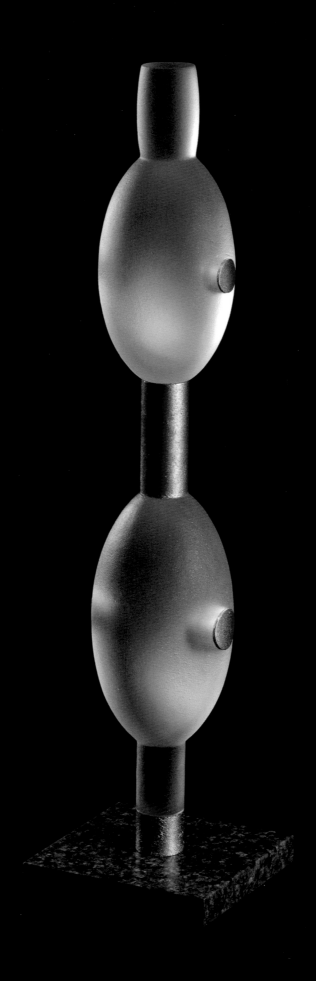

At first, I was astonished that this could be the 40th anniversary of the Habatat National/International. I counted the years back and realized that Ferd was a 20 something at the time, just a few years older than myself.

When you consider that the Maastricht Art Fair, the premier art fair in the world, is a mere 25 years old this year, one gets a better perspective on Habatat's accomplishments.
It has been, of course, Ferd's knowledge of the media, his vision for its growth, his buoyant personality coupled with his chutzpah that led from 1972 to 2012.

The next decade will culminate in 2022. Ferd will be retired or at least kept safely in the back room with only a phone to use. The next generation of Habatat will discover new artists and create new exhibitions. They will have a high bar to exceed and are well on their way.

I look forward to the 50th and to what Corey and Aaron will bring us.

<div align="right">
- Howard Ben Tré<br>
Providence, RI<br>
March 2012
</div>

**Axis 5 #3** - 2012
23.5 x 4"
Granite Base: 7/8 x 6 x 6"
cast glass, aluminum, gold leaf, bronze powders, pigmented wax
Photo: Ric Muarry

I was at one of my very first International Exhibitions 8 or 9 years ago and started up a casual conversation with a collector there. I asked her, "What have you seen in the show that you liked?" and she responded, "Well, I'll show you what I BOUGHT." She then took me on a long tour of the whole gallery, pointing out piece after piece after impressive piece. Wow! She said that this is the greatest show of the year at the greatest gallery with the best artists, showing their best work, and I knew then more than ever that she wasn't kidding. It's great to be a part of the amazing Habatat family.

- Alex Bernstein

**Winged Horizon** - 2012
12 x 26.5 x 1.5"
cast and cut glass
Photo: Steve Mann

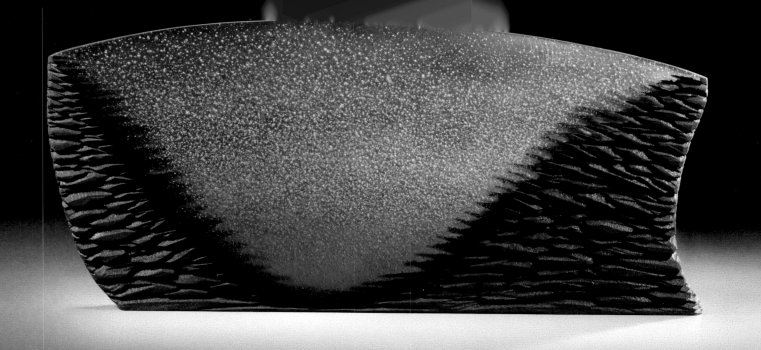

# Martin Blank

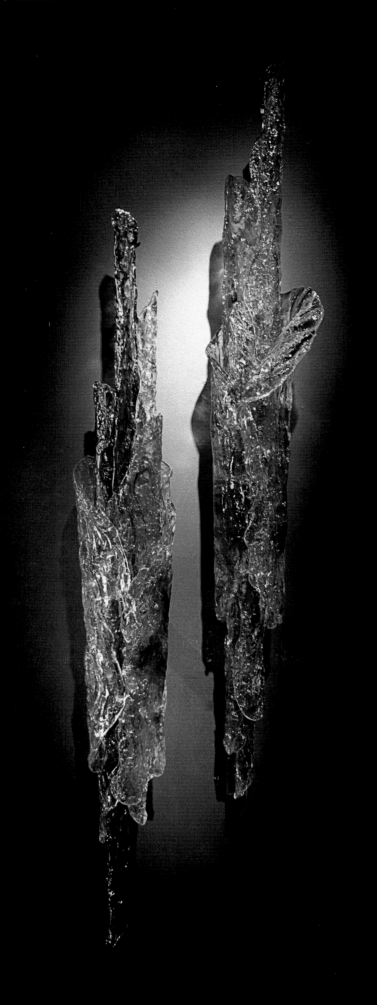

If a gallery can make money with you... it's good.

If you, and your gallery can create a long lasting, trusting relationship... it's great!

If your gallery relationship nurtures you, helps you grow an artist, helps you be a better human being, and becomes a friendship that can last a lifetime...... it's a true blessing!!

It's rare, but it does happen. I can honestly say that my relationship with Ferd and everyone at the Habatat Gallery has been all of the above.

Thanks for the many years of effort, trust and huge laughs!

- Martin Blank

**Amber Quiver I** - 2012
64 x 9 x12"
**Amber Quiver II** - 2012
64 x 9 x 12"
both pieces hot sculpted glass
Photo: Chuck Lysen

We first discovered Zoltan Bohus when Dr. Robert Loeffler, who lives in Washington D.C. and is of Hungarian descent, introduced us along with his wife Maria Lugossy. We were immediately struck by the architectural nature of his work and by the purity of its form. This was twenty years ago. He has been in every International since that time.

Both Zoltan and Maria have made major strides in elevating the craft of glass to fine art in Europe as well as the United States. We are very grateful for their participating once again in our International Glass Invitational.

- Ferdinand Hampson

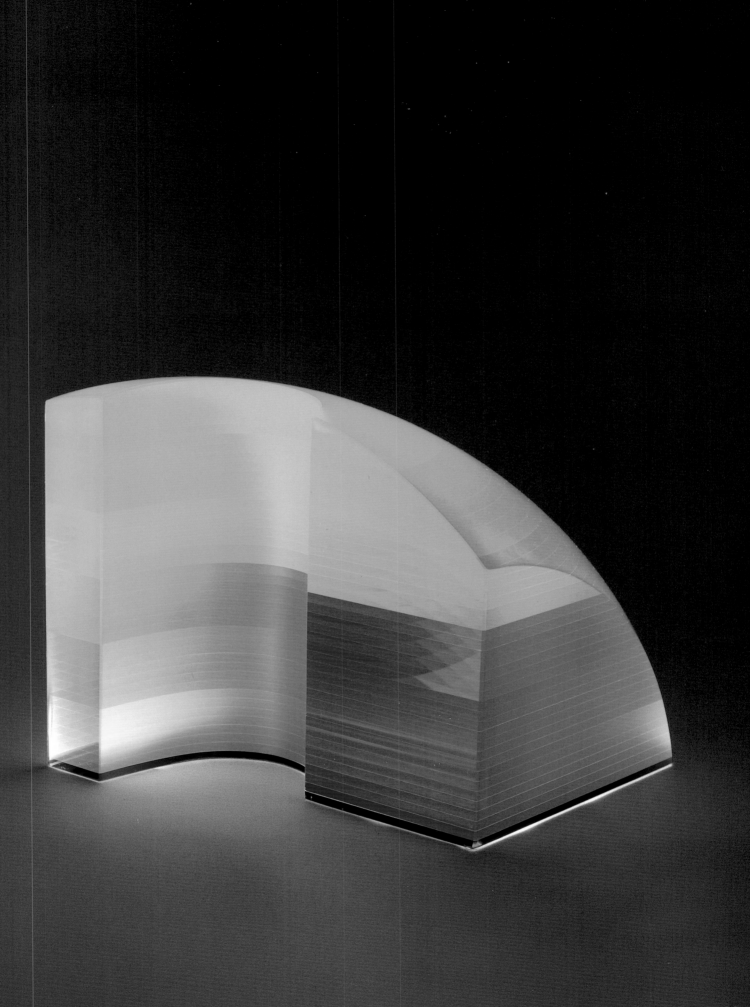

# Peter Borkovics

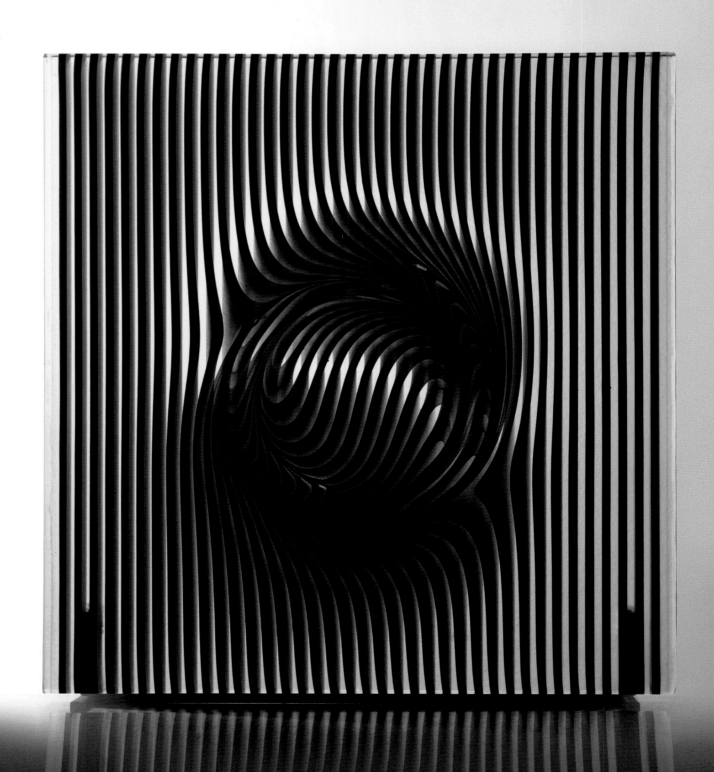

It's over 13 years now that I've been teaching at a 300 year old secondary school of visual arts.

One day, me and my colleague were in the middle of a project and we met at school... both dressed in our most comfortable clothes for doing our usual work with glass at the furnace.

A couple of students were there too working on their project... Before leaving, we stayed there for a while to talk about a few things, like the good old days, when we used to go to this very same school, and how we had stayed in late into the night skipping all the parties and latest movies. All we were doing was creating one work of art after another, we would send them to all possible competitions... and most of them we did win, too. Then we prepared and applied to the university... and, of course, we were admitted. We spent nearly every weekend working in a glass factory, we were straight A students... and ever since we have never had to look for a job, we are practically overloaded with plenty of serious work.

... while remembering all these good things we noticed that the students there were kind of evesdropping to our conversation, so we turned to them and said: "You see, if you take this profession seriously, you too, can get to where we are now."

They stared at us and they saw two unshaved, tired men wearing dirty ragged clothes.
None of them applied for glass faculty.

They didn't see one thing, however: we really are building our dreams.

- Peter Borkovics

**Vortex lines 2** - 2012
19 x 19 x 1.5"
kiln-formed color and polishing glass

# Sanislaw Jan Borowski

Let us all cherish this great opportunity and let us see and be seen.

Ode to the current artwork:

"It was hot in the veld that night,

as a sparkling ray of light,

shone across those dudes,

as it stood - then it pales and mutes.

There came a smell towards them,

in the silence that sleeps before them,

and they could not wait to touch,

the dry earth - they had already waited so much.

hush......hush......hush....

I heard a sound inside of me

it resonated in the heat

and all my friends and lovers -

sang
it
back
to
me.

if..love is in the moment....it´s in the heat of the night. "

- Stanislaw Jan Borowski

**In The Heat Of The Night** - 2012
36 x 28 x 14"
hot sculpted and assembled glass with steel base
Photo: Proart, Grzegosz Matoryn

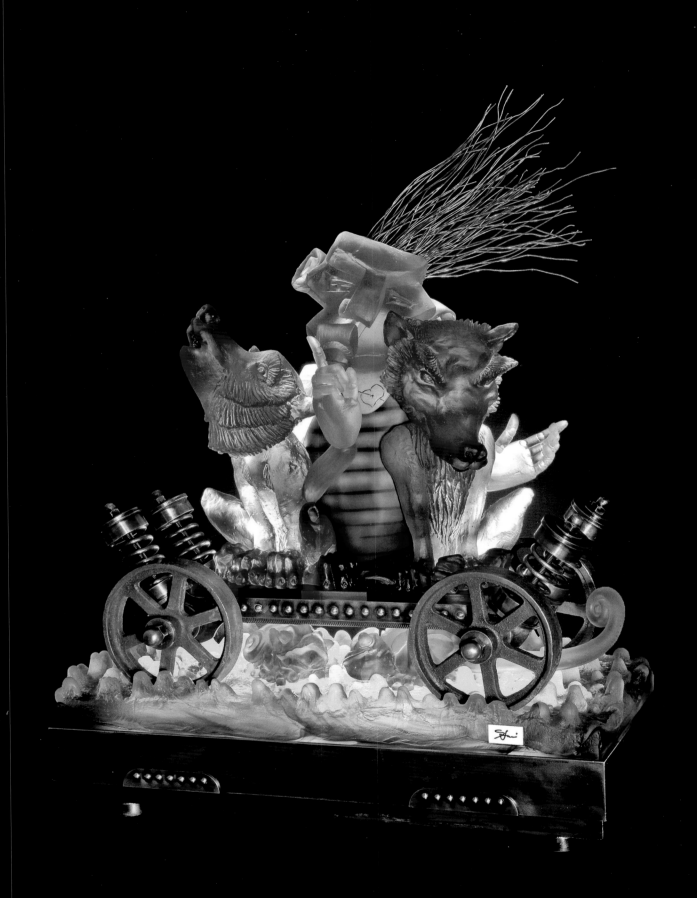

# Christina Bothwell

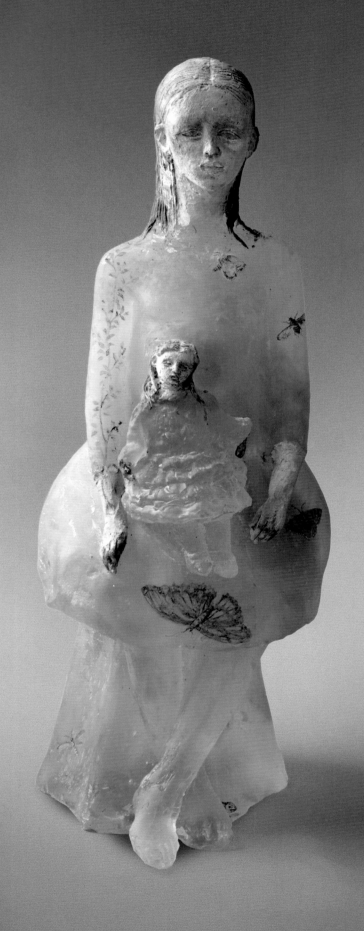

About eight years ago when I was first showing my glass pieces, I had the opportunity to speak in front of the Glass Art Alliance Collector Group, at a small gallery in New York. I was really looking forward to this opportunity- even though my speaking engagement was the same day as my father's funeral.

We traveled from Philadelphia to New York right after the memorial service. My husband was with me, as was our eight month old baby Sophie, and our large Australian Sheppard dog, Puppy.

The group of assembled collectors was very polite.... they listened to me attentively, asking polite questions here and there. Suddenly, when my back was turned toward the screen where my images were being displayed, I heard a bustle of chairs moving, a group intake of breath, and muffled laughter.

Somehow my dog had gotten out of the car and had run into the gallery, where she was quietly going from person to person- begging for hor d'oevres.... I hadn't noticed her come in, and apparently she had been there for a good while- looking plaintively into each person's eyes, with a look that seemed to suggest that I never fed her at home!

The gallery owner was good natured by this unexpected visit, and I think my dog entertained people. Puppy's surprise appearance took the edge off of my anxiety about speaking.

- Christina Bothwell

**Butterflies** - 2012
26 x 10 x 12"
cast glass
Photo: Robert Bender

# Latchezar Boyadjiev

I first met with Ferd at the GAS conference in Kent, Ohio in 1988. I was "fresh off the boat" - being only two years in the country.  Habatat was the first gallery to show and sell my first sculptures. They were instrumental in starting my career as an artist in the USA.

I am so thankful to be one of the exhibiting artists at this amazing gallery for 24 years!

Working with the staff has always been a great experience and lots of fun and I am looking forward to continue working with Habatat in the future as my new ideas unfold!

- Latchezar Boyadjiev

**Gate** - 2012
39 x 24 x 4"
cast glass
Photo: Latchezar Boyadjiev

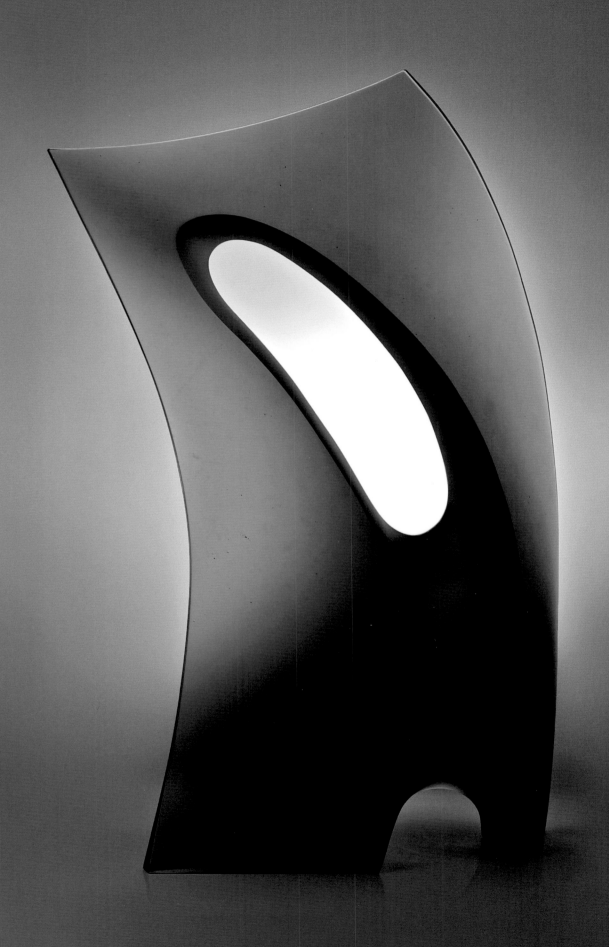

**Iceberg & Paraphernalia '11-236** - 2011
39 x 28 x 4"
cast glass
Photo: Paul Niessen

# Emily Brock

Looking at my archives, I recently found a slide of the first piece I sent to the gallery in 1986. It was a small bedroom. As a way of revisiting this sculpture, I have made another bedroom to send to the gallery for the 40th International. With the passage of time and the honing of my skills, I found myself able to bring more content and complexity to the narrative. Also, clearly the range of materials and tools has changed significantly since the mid 1980's. But one thing has remained a constant, showing my work with Habatat Gallery. This has not only provided me with a way to pursue my artistic career, but has also offered me diverse and humorous experiences that have enriched my life.

I recall an incident when another artist's glass sphere magically rolled off the pedestal and proceeded across the floor to gasps of the viewers and the horror of the gallery staff. No harm was done.

I also have apparently developed a frustrating ritual of driving around Detroit, hopelessly lost in a rental car, in search of things pertaining to this event.

One of my favorite experiences occurred in 1987, when I was first showing my work with the gallery. The title of the exhibition was "Celebrations." It included a series of sculptures about parties and gatherings......"The Dinner Party", "New Year's Eve", "The Birthday Party," and "Fifty Two Pickup - The Card Party." For the opening, the entry awning was completely filled with brightly colored balloons. The festive theme continued into the gallery room where balloons and streamers covered the ceiling and drifted throughout. It was indeed a party.

And yet, every year there is a blend of anxiety, anticipation and satisfaction when my work arrives safely at the gallery and is beautifully installed.

Thank you Habatat!

- Emily Brock

**Flight of Dreams** - 2012
17 x 13.75 x 13.75"
kilnworked, cast and lampworked glass assembled with silicone adhesive
Photo: Norman Johnson

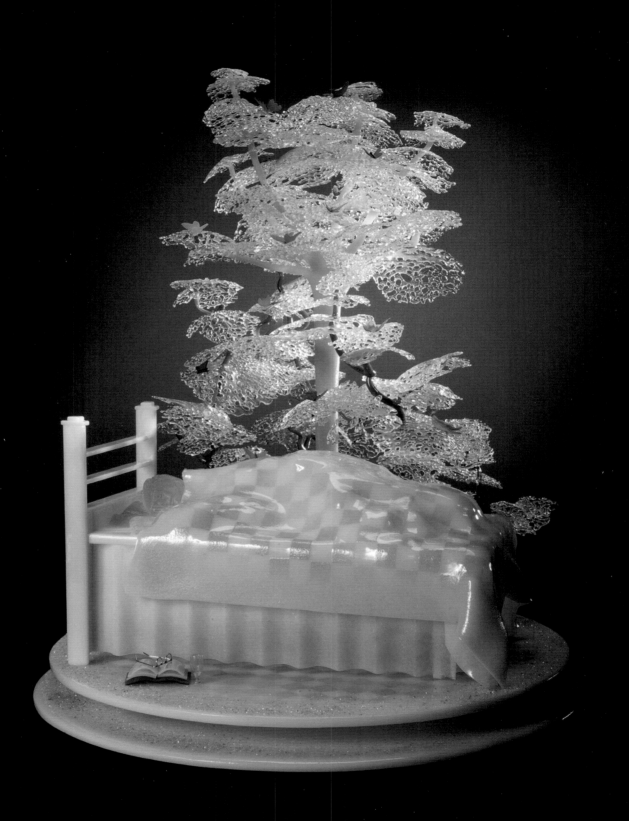

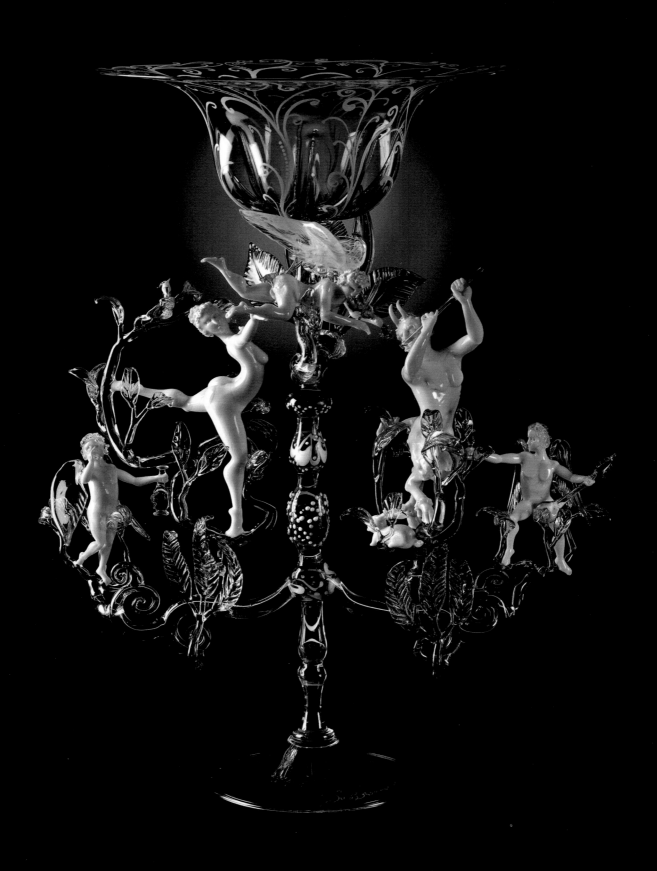

Habatat Galleries "brought" me to the United States the first time.

This happened 22 years ago when Ferd Hampson invited me for the "Habatat Galleries 18th Annual International Glass Invitational", December 1990, and for my first USA Solo exhibition, at Habatat Galleries - Farmington Hills, Michigan, September 12, 1992...

Since then, it has been a crescendo of respect, esteem, affection and friendship that have made our collaboration pleasant, smooth and continuous.

At Kathy and Ferd's home I always feel "at home" and experience never-fail-funny episodes: Once Cristina and I chased a squirrel that had been trapped in their home. We were afraid that the Kathy and Ferd's "killer-cat" would shred the poor creature (their cat was a real "wild Hunter"!)..It was incredibly comical! And we still remember the fantastic and scary Halloween we celebrated together in their home, waiting for masked children with baskets of treats to knock on the door and listen to awesome -horror music as well...My first Halloween!

Ferd laughs all the time at my jokes spoken in my "broken English"..Although I don't think he ever understands what I say, sometimes even I don't understand ...and I like that!

I love the professionalism and friendly atmosphere that characterizes the Habatat Galleries and I hope that between us there will be another 40 years of friendship and collaboration!

<div align="right">- Lucio Buba</div>

**Musicians in the Garden of Eden** - 2012
19 x 15 x 15"
flame worked glass
Photo: Anna Lott Donadel

# William Carlson

Forty years......Forty Internationals......Forty deadlines......
Forty artist statements each year attempting to be different
and more insightful then the year before.......have turned me
into the insecure paranoid schizophrenic that I am today......
thanks Ferd.....you've always been a great fiend....oh I mean,
friend................

It's all been worth it....I am just not sure about the next Forty
Internationals.

- William Carlson

**Lividus** - 2010
82 x 46 x 2"
cast and polished glass with metal oxide

In the early 1980's, I had just finished graduate school at Kent State University. Even though I had started exhibiting my work at Habatat with a certain amount of success, I lacked the self-confidence to go off on my own and start a glass studio. I decided to interview for a studio assistant position with another more established artist. This artist was having an opening at Habatat Galleries in Lathrup Village, Michigan, so I arranged to meet with him there for an interview.

Shortly after arriving at the gallery, Ferd pulled me aside and asked "how much would it cost you to build a studio?" He offered to underwrite the cost, to be paid back from future sales. He felt that it was time for me to put energy into my own work, not someone else's. I didn't take Ferd up on his offer, but it gave me the incentive I needed to not take the job and go it on my own. Thank you Ferd!

- José Chardiet

**Miramar** - 2012
25.5 x 12 x 8"
sand cast and hot worked glass
Photo: Marty Doyle

# Nicole Chesney

2012 marks 40 years of Habatat Galleries' commitment to presenting an international survey of glass art and 50 years of Studio Glass in America. It was 15 years ago, in 1997 that my work was first exhibited in the exhibition, "Young Glass International" at the Glasmuseum in Ebeltoft, Denmark. It was an honor to be included then just as it is an honor today to be part of such an amazingly rich and varied field.

- Nicole Chesney

I am inspired by the writings of French philosopher Gaston Bachelard who once described himself "not as a philosopher so much as a thinker who grants himself the right to dream." While Bachelard explores many types of dreams, he says "the space in which we shall spend our nocturnal hours has no perspective, no distance. ...And the skies we soar through are wholly interior - skies of desire or hope..." Later, the reader is invited to "measure the distance between that which is seen and that which is dreamt."

Oil paintings on etched, mirrored glass explore the sources of "sky water" - the fog that hangs in the air and the clouds that drift through the sky. The literal moisture and humidity that gives water to the air also obscures the "mirror" of the sky. These elements, air and water, often join to create an infinite, seamless "unsilvered mirror" where the horizon ceases and the beyond continues.

Bachelard proposes a sequence of reverie, contemplation and finally representation, to lead us to his notions of a meditative 'colorless sky that has infinite transparency and unifies the opposite impressions of presence and distance.' He quotes Coleridge: "The sight of a profound sky is, of all impressions, the closest to a feeling. It is more a feeling than a visual thing, or rather, it is the definitive fusion, the complete union of feeling and sight."

**Evene** - 2011
60 x 102 x 1"
oil painting on etched mirror

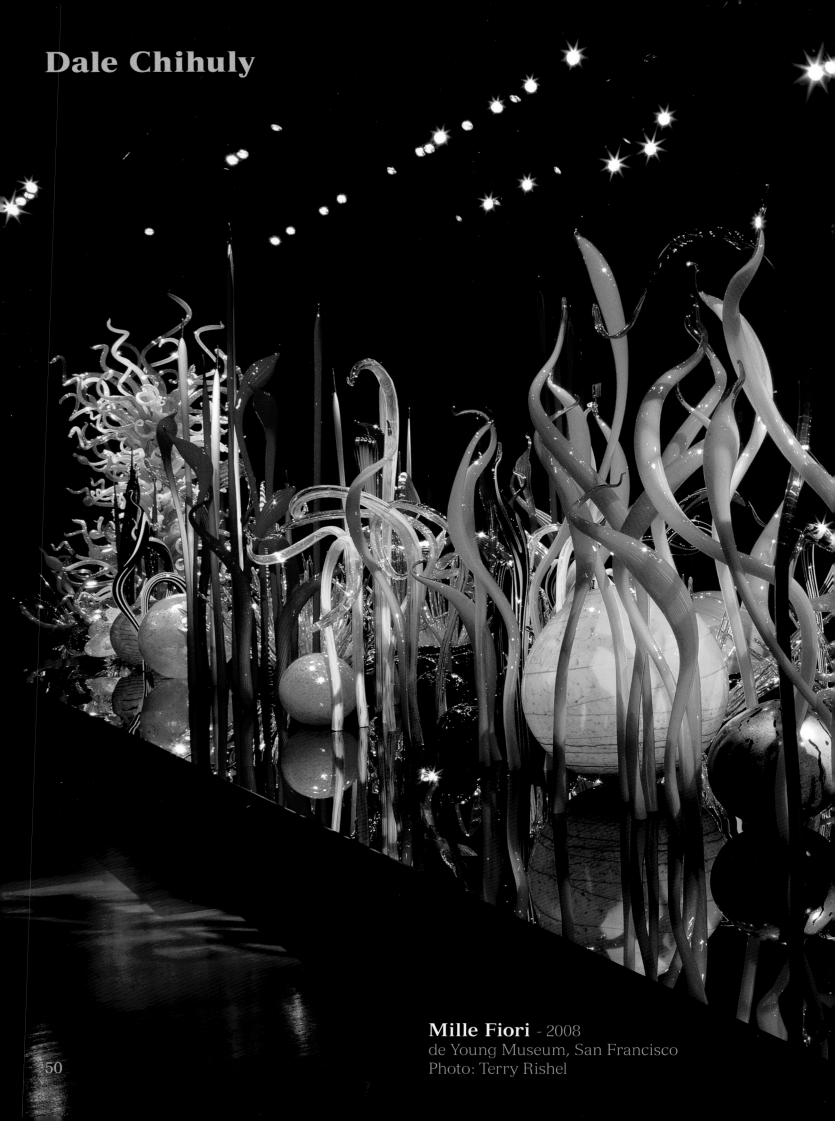

# Dale Chihuly

**Mille Fiori** - 2008
de Young Museum, San Francisco
Photo: Terry Rishel

Dale Chihuly

Dear Ferd,

Greetings from the Boathouse. Congratulations on the 40th Anniversary of your International! What an accomplishment & something you can be so proud of. We've been working together since the early 70s & I appreciate all that you have done to support my work over the years. It's been a great pleasure working together & having you represent my work.

Sincerely
Chihuly

No. 005

# Daniel Clayman

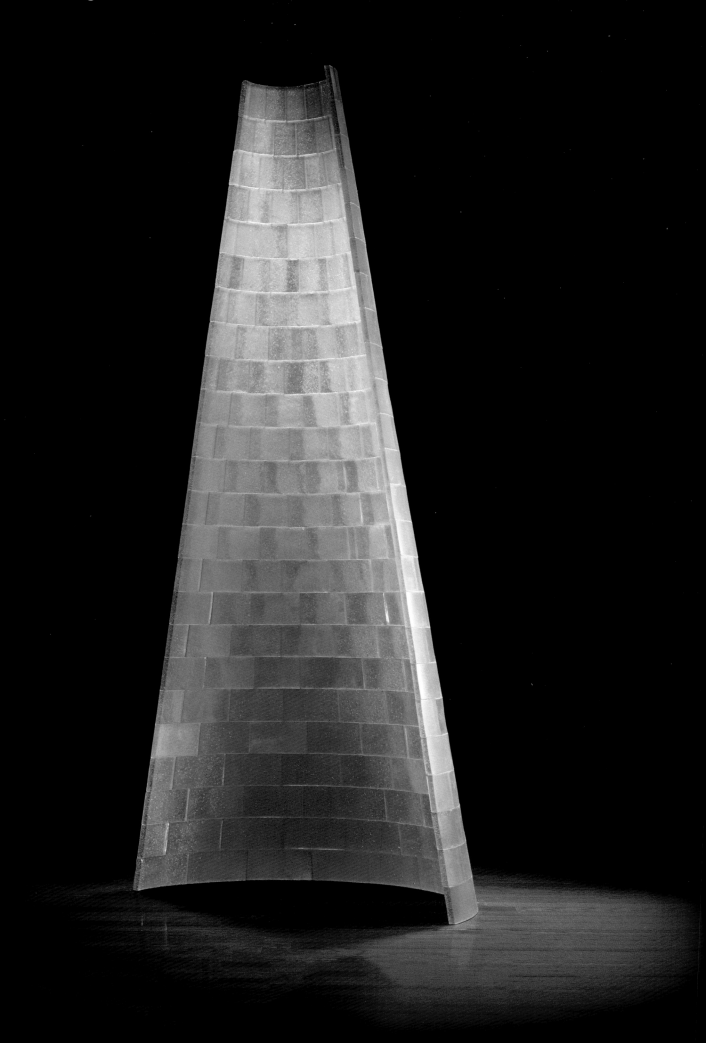

It all started one stormy night, driving up Seven Mile Road
through a blinding snowstorm...

And now it's almost twenty years later.

I am forever grateful for the friendship not only with Ferd
but, with the rest of the staff at Habatat Michigan.

- Daniel Clayman

**Tall Sliced Volume** - 2010
95 x 42 x 22"
cast glass
Photo: Mark Johnston

# Deanna Clayton

I took glass for the first time because I was a poor student. It was the only art studio class you could take at the time that had NO supply fees. How ironic - seeing it's one of the most expensive choices for artistic careers. But, that semester changed my life, cheap!

We were handed blow pipes and left with a furnace full of hot glass. There was instruction one night a week for a few hours and the rest of the week you could take anyone's blow slot who didn't show up and that's what I did. I was mesmerized by working with a medium that felt so alive. I moved; it moved.

The best part was I felt that glass had no rules (other than annealing). It was such a new medium for contemporary expression that it didn't hold to the confines of historical precedent. That might not be accurate but it's how I perceived it and the whole reason I pursued it. Glass was an exciting adventure.

I also met my husband Keith in that studio and we have been making glass together for over 22 years.

- Deanna Clayton

**Untitled** - 2012
13 x 12 x 9"
pate de verre and copper mesh

# Keith Clayton

My first meeting with Ferd was arranged to be held at the
Birmingham gallery. I was in Michigan visiting with my
wife's family around the holidays. The traffic was heavy with
holiday shoppers and I was instructed to take an elaborate
back route to the gallery. On my way, still about a half hour
from arriving, I approached an intersection. The light was
red and there were two or three cars ahead of me. Across the
intersection there was a black car on the side of the road. A
lone man stood next to it with a gas can in his hand.

As I looked closer the man appeared to look quite a bit like
Ferd. The closer I looked the more Ferd-like he appeared.
As the light turned, I crossed the intersection and though I
was in traffic I slowed. I did not want to stop and possibly
be roped into helping a stranger in distress on the side of
the road during the holiday season (which seems to be such
an admirable thing to do when you see it on paper). But as I
inched by craning to look out my passenger window, there
appeared the face of Ferdinand Hampson. He had run out of
gas on his way to meet me in his black Cadillac. That was the
beginning of my relationship with Ferd.

- Keith Clayton

**Cuff** - 2012
12 x 12 x 8"
cast glass and copper

# Matthew Curtis

M years Ferd was like a mythical and Omni-potent gallery director. The constant references to Habatat and Ferd placed him firmly at the centre of contemporary glass. Practicing far away in Australia, with exciting yet irregular trips to the US, this continuing myth and position of Ferd was constantly nourished. Consequently, meeting Ferd was rather like meeting a GLASSY version of the Dali Lama, calm and considered in the midst of setting up a major show.

Getting to know the Team at Habatat is wonderful, professional yet with a strong family business feel. Showing with Habatat is a real honor.

- Matthew Curtis

**Clear and Aqua Xylem** - 2012
32 x 20 x 4.5"
blown, constructed, carved glass
Photo: Rob Little

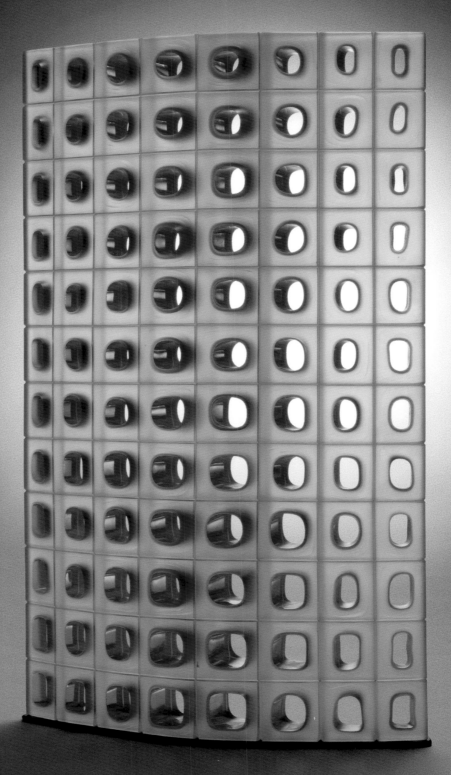

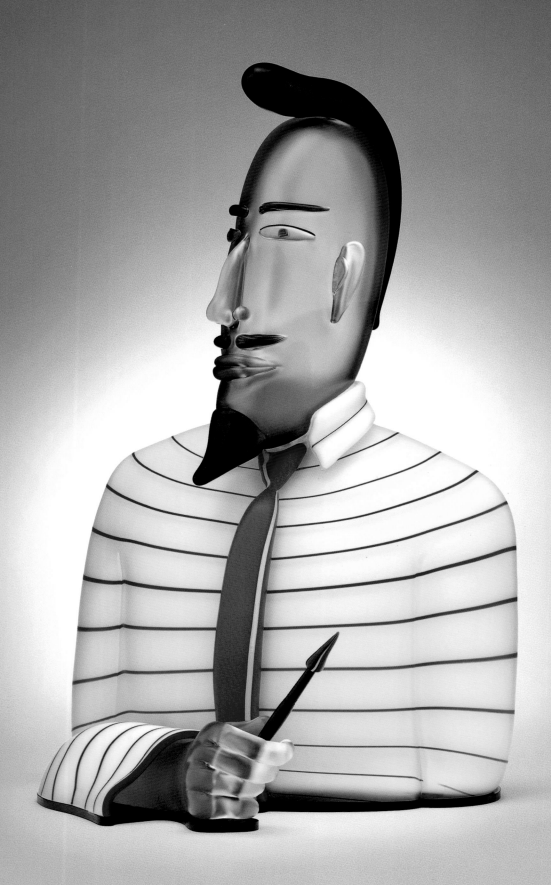

Years before there were numerous galleries showing dozens of artists work made from glass, as you would have observed at any recent SOFA show, Ferdinand Hampson, Linda Boone, and Thomas Boone who established Habatat Galleries, enthusiastically embraced glass as an artist's medium. In the early years of the movement they made great efforts to familiarize themselves with the artists. While we were gaining skills and experience with glass to achieve our creative visions, Habatat was establishing a regular schedule of exhibitions that provided a broad perspective view of artists' works in glass. They became a valuable part of the movement; getting to know the artists, educating the collectors, bringing everyone together for events in Michigan, and selling our work which allowed us to continue making what we imagined.

One particular aspect of Ferd Hampson's approach to representing artists has characterized Habatat from the start. He has a penchant for telling the artists' stories and documenting their progress in his catalogs. Even his earliest publications show a knowledge of the artists' ways of distinguishing themselves as they developed techniques and working processes; their material palette, unique in the contemporary art world. Ferd thoroughly embraced glass and artists who work with glass.

This commitment has resulted in a history of relationships Ferd Hampson has with artists, collectors, museum directors and curators, critics, and educators. His participation in the development of glass as an artist's medium over four decades is significant. Like Daniel-Henry Kahnweiler in Paris, 1907, representing the first Cubists, and Peggy Gudggenheim in New York, 1942, representing the early Abstract Expressionists, Ferdinand Hampson was among the few art dealers who recognized the artists working with glass as part of a distinct art movement. His persistent efforts to understand the artists, explain the importance of their work to others, place artworks in important collections, and publish annual catalogs of Habatat's large group exhibitions, has contributed in many ways toward the acceptance of glass in the contemporary art world.

- Dan Dailey

**Imagist** - 2011
24.5 x 14.5 x 13"
blown, sandblasted and acid polished glass with anodized aluminum
Photo: Bill Truslow

# Miriam Sylvia Di Fiore

I was sixteen and studied ceramics at the Academy of Mar del Plata ... I was the youngest student at the school, a sort of mascot, inquisitive and curious, that whenever I could, sticking my nose against the glass window of the stain-glass studios, that was a privilege of graduate students ... An autumn afternoon I went to school early, to finish a piece.

The school seemed deserted ... I saw from the window out of the furnace room the professor of stained glass windows and a spark of blue light shone in his arms. I ran out into the courtyard and called out: -"Professor, what it is?" He turned and said to me, trying to hide what he had in his arms: What are you doing here??? "Let me see", I insisted, touching the piece.... It was hot, was blue and turquoise ... -"Oh my God! It is glass", I cried, and it was done here! In the kilns for ceramic! ... please, please Professor, teach me!"

The glow of blue cobalt seemed more beautiful than stars in the sky and the intensity of turquoise inspired me of the Caribbean Sea...

If ever in my life I have had an "enlightening", it happened that day when I realized that the glass was not unattainable. That day marked my destiny. It was the beginning of a love that has lasted for thirty-seven years ....

When this happened, Habatat Gallery existed, but I didn't know that many years later in another fundamental day of my life, Ferdinand Hampson would give me the keys to the world, inaugurating my first solo show in America.

Thank you both, from the depths of my heart.

- Miriam Di Fiore

**They Said She Was a Painter** - 2012
11.25 x 12 x 14"
flame worked, multi-firing fused and kiln formed glass,
pate de verre, wooden old painter case.

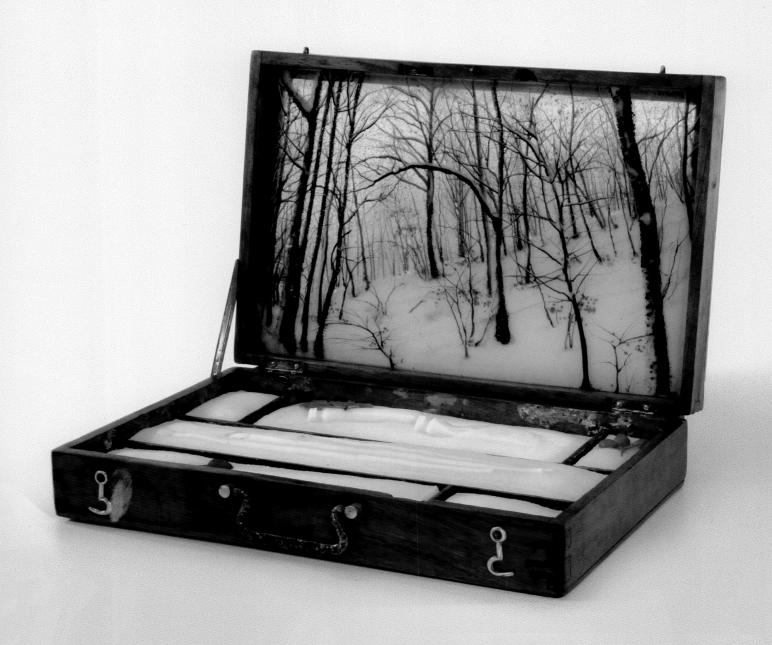

# Laura Donefer

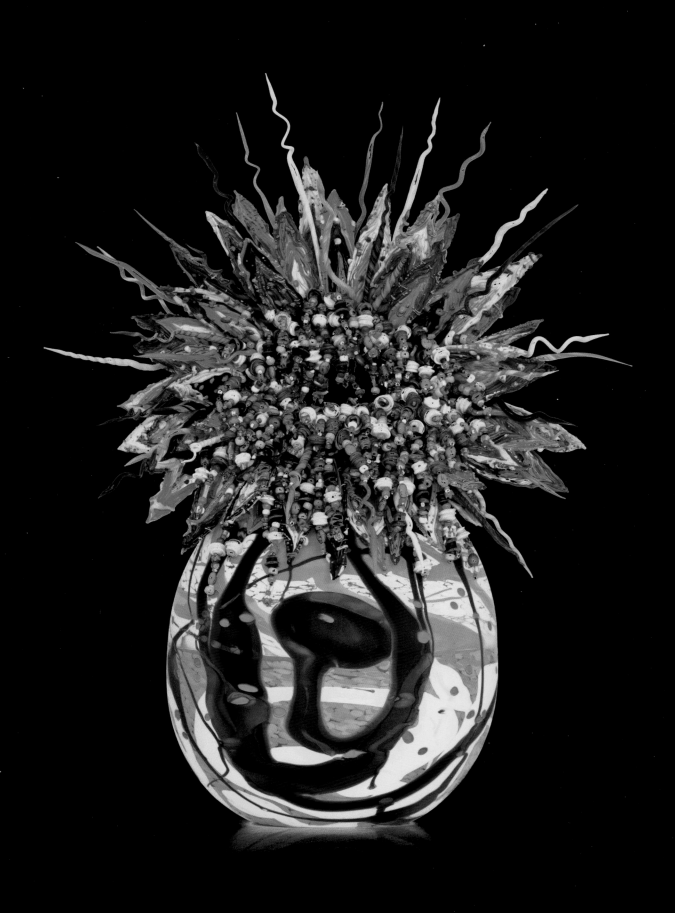

In 1993 I participated in my first International. What a thrill it was to have my work in a gallery that I had admired for over a decade. To think that I was going to drive from Ontario to Michigan and be able to mingle with the artists and collectors as an actual member of the show! Wow this was going to be a dream come true because I had been visiting Habatat since I began glass in 1982. Best thing of all! Ferd and Kathy asked me to bring my then two year old Ana Matisse along, extending an invitation to stay with them in their home. That started a tradition that lasted until Ana Matisse grew up and if you look at the group pictures taken in the gallery at each International, you will see a small red head somewhere in that ménage of artists!

The International represents much more than an extraordinary gathering of fabulous artists exhibiting their work while schmoozing with friendly fun collectors! It has become a family affair as I consider Ferd, his own family, and the people who staff the gallery as part of my clan, not to mention the glass artists and collectors who make up the rest of my kinfolk! Some of the most memorable moments come every year when after the big party a motley crew of pajamed artists hang out at Ferd'nKathy's drinking and eating and laughing hysterically (Oh DClayman and MBlank, you two could make a stone crack up!)

Reminiscing about the International makes me realize the great experiences Ana Matisse had while growing up, like the time some collectors asked the 6 year old Ana to show them her favorite piece in the show and she convinced them to buy it! She proudly showed off the $5.00 commission that Ferd gave her and Corey was incensed because it was more than he had ever received. Or when at 8 years old Ana, having a huge glass crush on Lucio Bubacco, decided to fiercely guard his extensive but very wobbly exhibit. Her hand printed signs that she scotch taped all around the pedestals read DONOT TOUCH or VERY DELICAT DONNT GO NEAR! The best part was that Ferd let her stand there all day and did not take down those crudely written penciled warnings. Of course we try not to remember a very little Ana stealing a tiny wine goblet out of an Emily Brock tableau, and NOT wanting to give it back.

Through being part of the International, I have made some fantastic collector friends as well. Having the show over 3 days with a few parties thrown (!) in, means that there is room for quality discussion time, or silly joke telling, or beverage indulging with people who truly love glass but are usually super busy. The International gives the luxury of time to the artists and collectors who can get to know each other better. That is one reason I go back year after year, it is like a mini schmoozathon of a vacation, so entertaining and refreshing after spending all those months alone in the studio.

In conclusion, every year I wait with baited breath for my invitation to the International, will I be worthy this year or will they dump me!!!!!!!!!!!!!!!! And every year I somehow get asked back, and cannot wait to get in my car and drive to Michigan for another fantastic meeting of the clan! Thank you Ferd and Kathy and the whole Habatat gang for making my glass life so rewarding. Congratulations on 40 years of the International. Kiss Kiss bang bang!

- Laura Donefer

**Mardigras Amulet Basket** - 2012
34 x 24 x 14"
yellow and orange encalmo blown glass with purple bitwork, torch worked
additions, also turquoise, african trader beads, seed beads
Photo: Stephen Wild

# Irene Frolic

The Habatat Family and Me

It has been my pleasure to have been invited to the Habatat
Internationals since 2000.   The faith that the Habatat Family
had in me, allowed me to grow in my work and to explore
new forms and materials.  Happy Anniversary!  May you
continue to grow and flourish, and take it into the next
generation.

- Irene Frolic

**Thirteen Monkeys** -2012
20 x 19 x 4"
lost wax kiln cast crystal
Photo: Rebekka D'Amboise

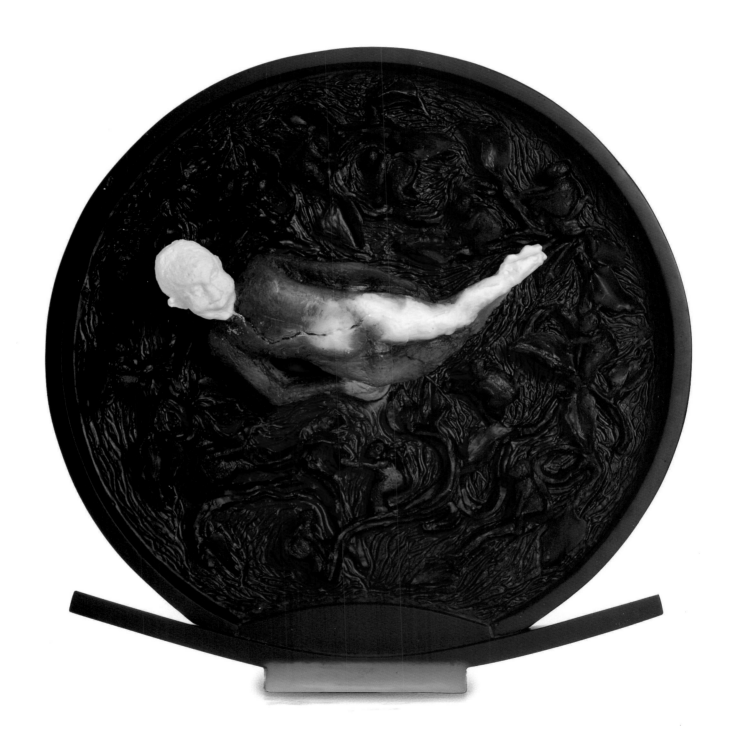

# Susan Taylor Glasgow

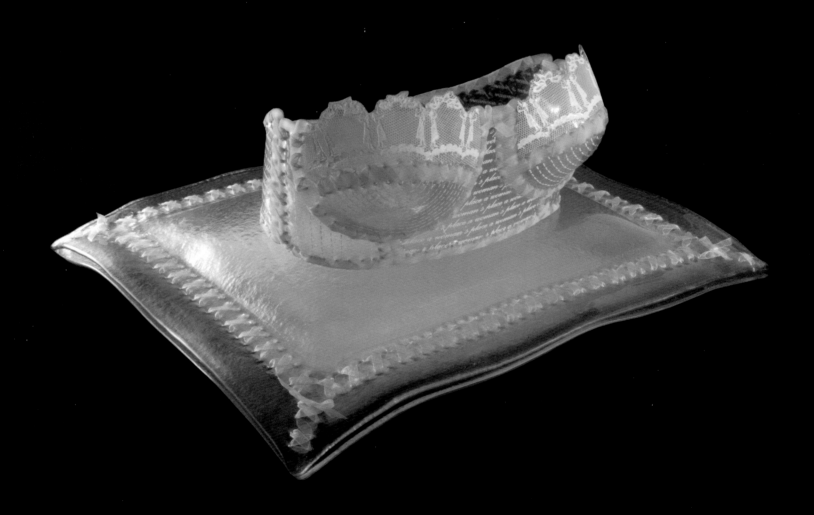

I haven't been showing with Habatat Galleries very long-
-only two years--but I already feel like one of the family.
The Hampsons have done a marvelous job representing my
work and are extremely gracious to both their artists and
clients. Back in the day before I was represented by such fine
galleries such as Habatat, I participated in shows like the
Philadelphia Museum and Smithsonian shows.

One year, and please remember I was much younger then, I
wore one of my glass corsets during the early preview night.
Even though this version was opaque and quite modest, I
received a lot of attention. One curious gentleman politely
asked if he could touch the corset. After I replied "yes" he
proceeded to grope my left glass-clad cup! I should have
made him buy it first!

- Susan Taylor Glasgow

**"A Woman's Place" Brassiere on Pillow** - 2012
9 x 19 x 16"
fused, slumped, sandblasted, enameled,
sewn with waxed linen and nylon ribbon

# Robin Grebe

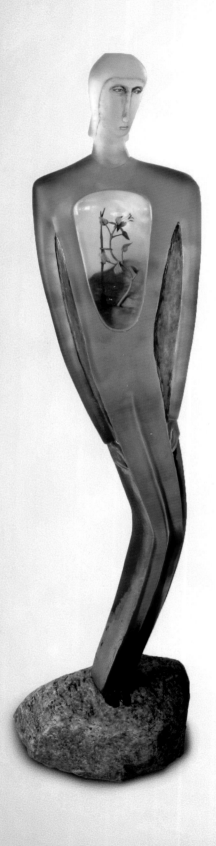

The first time I went to Habatat galleries it was located at the Triatria building in Farmington Hills. All the staff was busy setting up the Dale Chihuly exhibition. The Atrium contained a water fountain that was filled with Dale's Macchia sculptures and there was a new Chihuly wall piece that was being installed, I think it might have been one of the first ones.

It was an amazing beehive of activity and the excitement was palpable for the opening reception the following evening. What impressed me then, and still continues to this day, was the wonderful and hardworking gallery staff, and the relentless drive of Ferd at the helm. Happy anniversary Habatat!

- Robin Grebe

Nature can at times offer peaceful beauty but can also be a world of uncharted territory and the unknown. In my work, the figures are an avenue in which I try to understand our universal quest to make sense of the human condition. Using images such as earth's landscape and the process of growth as metaphors for the intangible as well as nature's forces, I am hoping to bring my personal searching into a more shared exploration.

**The Gardener** (left) - 2012
54" x 15" x 12"
cast and slumped glass, wood, resin, paper, paint, stone base

**Standpoint** (right) - 2012
34 x 17 x 7"
cast and slumped glass, wood, resin, paint, stone base

Photos: Michael Newby

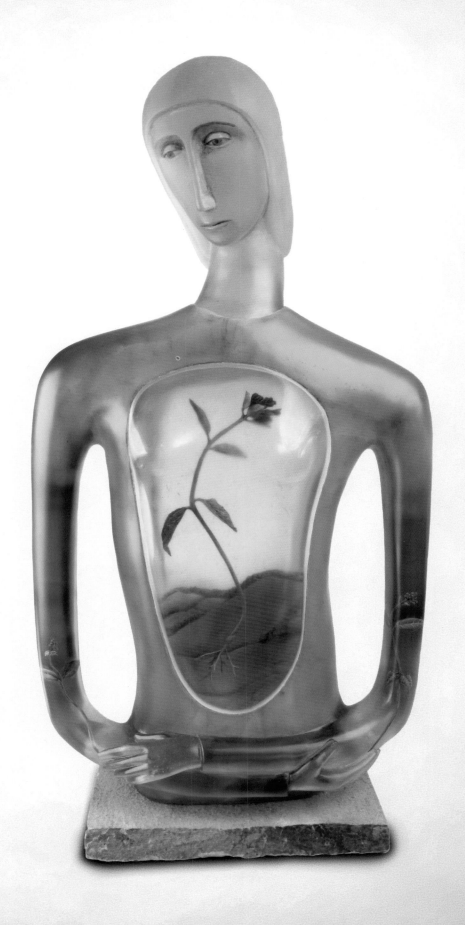

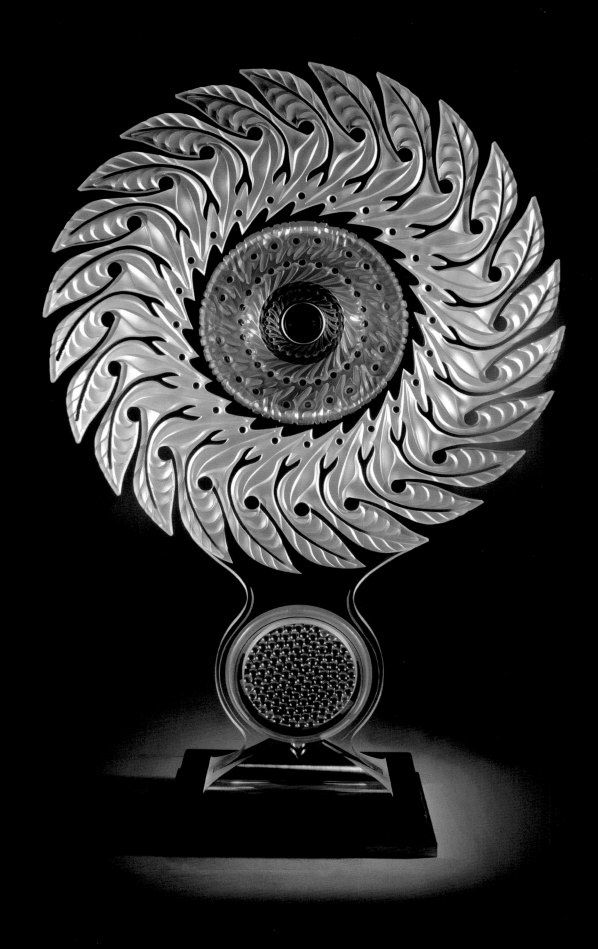

For all these many years I have been entranced and embedded in observations of our life force. In all its wondrous intricacies, our beliefs, our myths, our attempts to understand time and space from an artist's viewpoint. All of my work points in that direction encompassing illusion in what appears to exist and that which floats and taunts our imagination. Life is full of gifts if we can but see them, use them and be influenced by them in our creative selves.

Regeneration, it is concerned with the great spiral of life on our planet, The leaf forms are sculpturally modeled by sandblasting. The central disc is rounded outwards towards the viewer. Coloured dichroic filter is hidden within the disc.

- Eric Hilton

**Regeneration** - 2012
40 x 24 x 10"
cut and polished lead crystal and dichroic glass

I have always been interested in decoration which is almost everything we see around us even we do not realize it.

In my glass form I try to incorporate decoration in a simple format so that it does not overpower the object.

I let nature inspire in a matter-of-fact way. My sculptures are clearly reminiscent of waving grass, fallen autumn leaves and bionic shapes. I am interested in design too, and as a result many of my pieces are vases, bowels or cases.

This time I was inspirited by the birds.

- Tomáš Hlavička

**Dove** - 2011
24.5 x 9.5 x 6.75"
cut and polished fused float glass with silver leafing

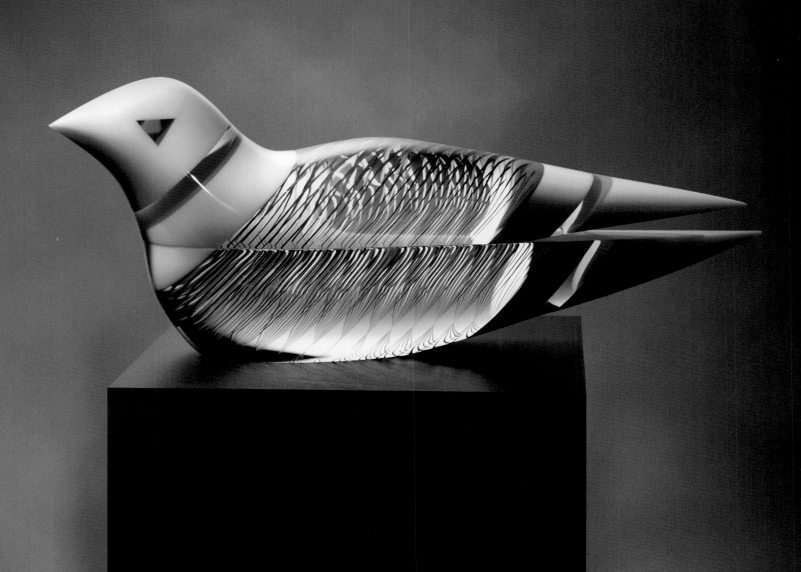

# Petr Hora

My first encounter with Habatat Galleries was when I was 50. From the first moment I felt that we have known each other for many years. Although everybody in the Gallery speaks a different language and I do not chat with them too much, they are like my second family. I do not speak English, they do not speak Czech, but there has never been a moment when we could not understand each other. One hug always says everything...

In our almost 20 years of association we have lived through more good things than bad things. It is mostly because of the perfect and professional work of all the people in the Gallery. I am grateful to them for everything they have been doing for me.

I would like to give my thanks to all the employees of the Gallery.

- Petr Hora

# David Huchthausen

I've been exhibiting with Habatat since 1975 and could probably fill a book with stories about the gallery, various artists of questionable stability and a staff that often resembled characters in a police line-up. Back in the mid 1980's Habatat was located in an old dentist's office on Southfield road, not an ideal layout for a gallery, but collectors were buying and life was good.

As usual, quite a few artists were in town for the opening of the "National" and the liquor seemed to be flowing at a pretty good clip. Sometime over the course of the evening one of the artists, who shall remain nameless, but I swear that it wasn't me, removed a $30,000 Tom Patti from its small pedestal and replaced it with a glass coke bottle. Everyone seemed to find this rather amusing, except for Ferd, who became extremely agitated as his blood pressure went through the roof !!

He was soon tearing through the gallery at a frenetic pace interrogating all of the usual suspects. Throughout all of this, the Patti was passed around between several of the artists, who cleverly kept it out of Ferd's reach.

Somehow, at the end of the evening, I ended up with the piece back at the hotel room and returned it to Ferd. Instead of showing his gratitude for it's safe return, Ferd went ballistic in a ten-minute tirade which won't be repeated here !! In any case, we all survived along with the artwork and have lived through many more adventures since then.

- David Huchthausen

**Eclipse** - 2011
10" diameter sphere
ground polished and laminated glass
Photo: Lloyd Shugart

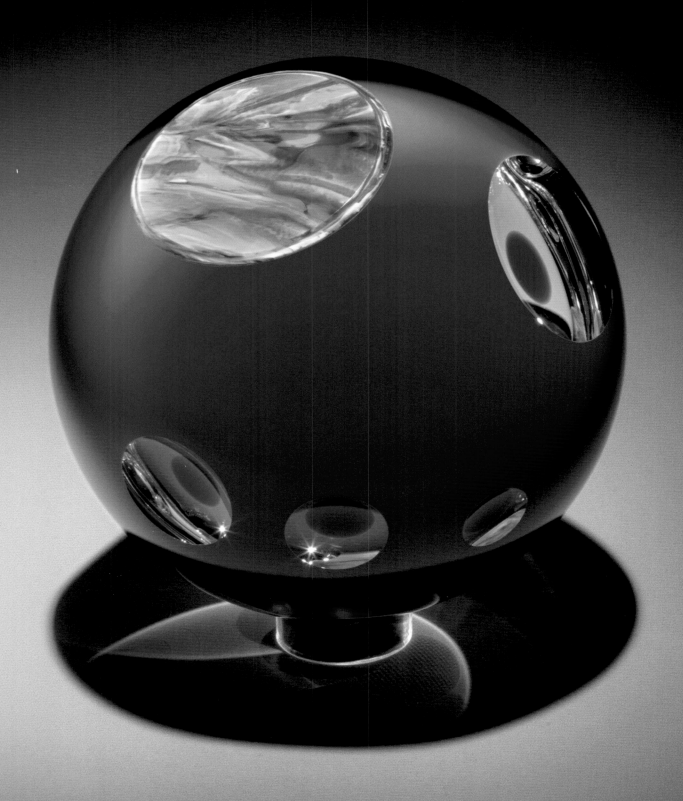

I did not receive an art education in U.S.A. but I have been very affected by American modern art and contemporary glass art.

At first I took interest in the works of Donald Judd and then those in '80's of Howard Ben Tre, Thomas Patti and Mary Shaffer, in which I found notable forms and textures I had never seen, and recognized the potentiality of glass art.

I began relationship with Habatat Galleries in the 24th International Glass Invitational 1996 and I visited Habatat Galleries in 1998 for the first time. Since then I have been to U.S.A. about 10 times including the Chinati Foundation on Texas for example.

Every time I visited the U.S.A., I noticed that we have to understand the American art in the context of its culture and its climate. Art works are born of a variety of values and points of view among the people. Such experiences reminds me of my Japanese heritage , my past work, and have influenced my current work.

I think Habatat Galleries gave me a chance to reach a turning point.

- Toshio Iezumi

**M 120201** - 2012
63 x 8 x 8"
carved, polished, laminated float glass and mirror
Photo: Toshio Iezumi

Using hyper-realism to sculpt the human form is a technical exercise; however, that alone was not what has compelled me to create this work. As I look around I notice that random people everywhere have a story. They all have lives with burdens, and histories that they carry with them. I see people who have overcome their obstacles, and continue to live. I hope viewers can look at these sculptures of everyday people and imagine the life within each of them. Their story of overcoming obstacles, daily burdens, their history, then, appreciate them for the heroes that they are.

- Martin Janecky

**Untitled (from Series "Heroes")** - 2012
16 x 11.5 x 6"
hot sculpted glass

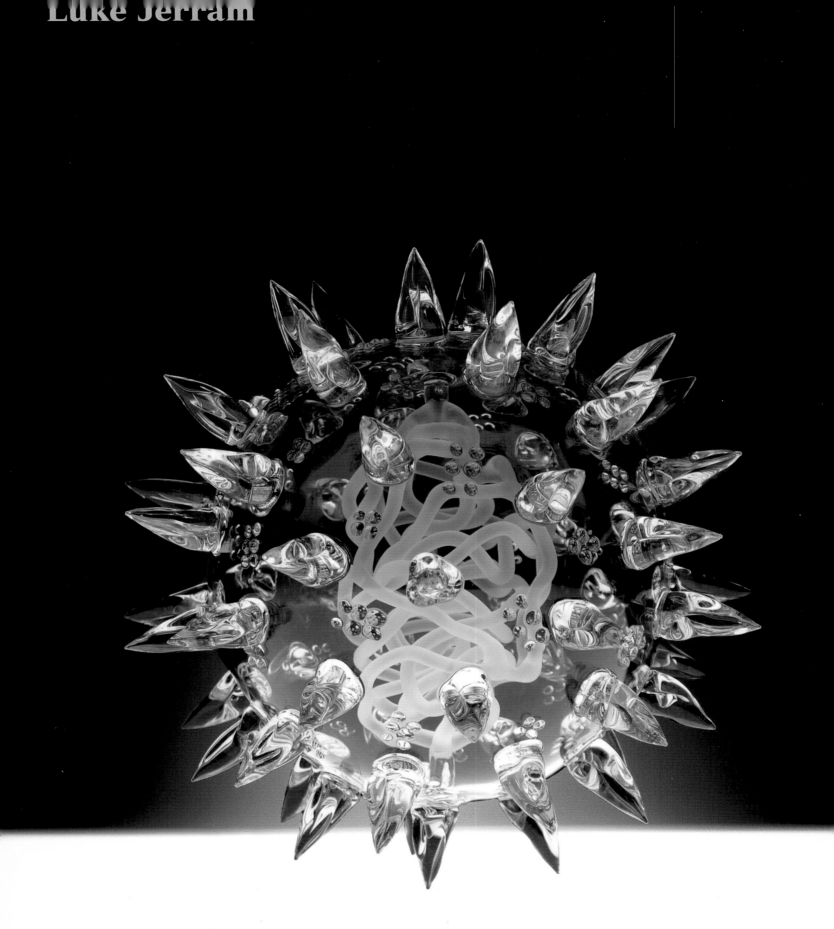

## Experiments of the Physical Urge: Strange Invitations

When I stand on a cliff, there's a part of me which always wants to jump off. It's the same feeling as when you pick up an open tin of paint with both hands, there's the small urge to throw it everywhere. Whilst at art college in Wales, as a way of exploring these feelings, I used to collect old TV sets and store them at home under the stairs. It meant that if ever I felt the necessity to throw one I would always have a handy supply ready for use.

I would sometimes make an evening out of it, walking the narrow streets of Cardiff waiting for the right space and time on which to act. I would carry a television set to throw as well as a broom to tidy up afterwards. One such evening, after throwing quite a large television, I was happily tidying up the mess with my broom when I was suddenly surrounded by a group of five men. They had just watched me throw the TV quite dramatically against a concrete wall and were wondering which drugs I was on and perhaps that I might share? They then politely invited me to join them for their evening out. They were about to rob the local corner shop and thought that I might be 'fun to have around'.

It seems that by presenting yourself in a particular way, people will open doors for you and will invite you to enter a new position which will, in turn, lead to further possibilities and decisions. Needless to say, I declined their offer, but often wonder what would have happened if I had accepted their invitation?

Note 1996

**Untitled Future Mutation** - 2011
4 x 4 x 4"
lamp worked glass

# Richard Jolley

Reflecting on 40 years:

The first thought that comes to mind is where did the time go and can it really be 40 years? Maybe there is some mistake.

Habatat Galleries and the Studio Glass Movement seem to have travelled almost parallel courses give or take 10 years, but who is counting.

It was a leap of faith for a gallery to take on a new medium and that matched the same spirit that still embodies the studio glass movement. American studio glass was in many ways a youth movement and took place during a time that rewarded risk taking and innovation much in the way that Habatat first started taking a chance by starting a gallery devoted to showing only works made from glass. It is probably best to be young and energetic to take on these challenges and to have no fear of failure or the future or maybe it is just best to always have that attitude and plug along and then before you know it 40 years have gone by and you realize that there is still so much you want to accomplish and there is always another challenge to be met. I feel certain it is rewarding for Kathy and Ferd to support established artists and bring not only the next generation of artists to the gallery but also have the next generation of their families, Aaron and Corey, be involved in the gallery

There are many stories to tell about Habatat Galleries and the staff and things that happen at the International but those are best told over drinks. One constant is Ferd's directional challenges and his ability to get lost while driving which is balanced by his intense focus on the direction he wanted to take Habatat and his commitment to glass.

- Richard Jolley

**Amber Doves Green Branches Yellow Peonies** - 2012
38.5 x 63 x 10"
hot sculpted glass

# Vladimira Klumpar

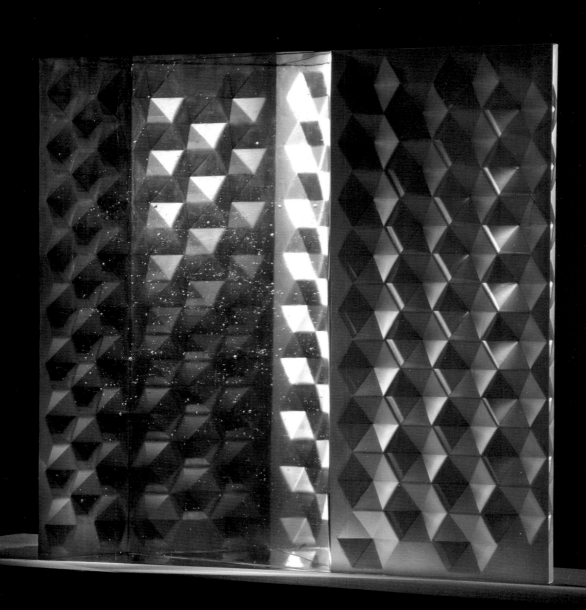

My first meeting with Ferdinand was in 1989 under quite dramatic circumstances. It was going to be my first exhibition with Habatat Gallery at their new location in Chicago. I arrived at the gallery a day before the opening to see the installation and to help if necessary. Suddenly, while we were working, we had to evacuate the building because it was on fire. By the time it was put out and we were able to get back inside, it was clear how devastating it had been to the gallery - water was running all over the walls and the floor. I thought, The opening is ruined. I should change my flight and go back home. Ferdinand, along with the rest of the people at the gallery, told me to stay by saying, 'Do not worry, we will make it happen.' And they did! I could not believe it when I returned the next day. With the help of huge heat blowers, the walls were dry and freshly painted and there was Ferdinand, in the middle of finishing the installation. Incredibly, that night there was the opening. Afterwards, we were celebrating this resilience and outcome. I have tremendous respect for all the people working at Habatat Gallery, especially Ferdinand who knew how not to panic. I was very thankful to them.

The next day, I planned to see Ferdinand at the gallery. I was going to pick up some things I had left there as well as meet with the photographer who was going to take some pictures of my work and the installation. I found a cab and gave the address. The driver told me, "There is a huge fire there." I said, "Yes, it was, a day before yesterday." He said, "No, right now." As we arrived to the site, the entire block of beautiful old loft buildings was gone. It was not just Habatat Gallery, but a lot of other galleries, too. We were all shocked, standing outside and hopelessly looking on as the fireman finished their work. It was hard for me to imagine how difficult the situation must have been for Ferdinand. Many personal tragedies happened. For me, my work was gone. My glass was melted again. I don't have a single picture from that exhibition. I took it as an omen and stopped working in the technique of fused glass. After I moved to Massachusetts, I got back to kiln casting, as I wanted to.

Ferdinand did open another Habatat Gallery in Chicago again. I have a big respect for his 40 years of promoting the studio glass movement in the United States and internationally. I do not have a chance to see him very often, but when I do, I always see him as a special man and a friend.

- Vladimira Klumpar

**Rhythm and Reflection** - 2010
28 x 29 1/8 x 9"
cast glass
Photo: Sva Heyd

# Jenny Pohlman & Sabrina Knowles

From our earliest collaborative efforts we have explored the feminine fluidity, curvature, strength and plasticity inherent in glass. The innate three-dimensionality of molten glass assists with our design visions and we often see new forms within the forms we're attempting in the hot shop. These glimpses into the next possibility fuel our enthusiasm and the direction of our designs.

Our inspiration is derived directly through our own life experience, whether that be day-to-day life, or from our travels (with a boots-on-the-ground approach), or our studies of both ancient and contemporary cultures with an emphasis on women.

It is our intent to create sculptural forms and assemblages that evoke the sensuous curves of the feminine and provide a narrative that embraces our common humanity.

-Sabrina Knowles
Jenny Pohlman
February 2012

**Tapestry series** - 2011
82 x 62 x 13"
off-hand sculpted glass, ferrous and non-ferrous metals,
natural materials, found objects, beads, antique west african findings
Photo: Lynn Thompson

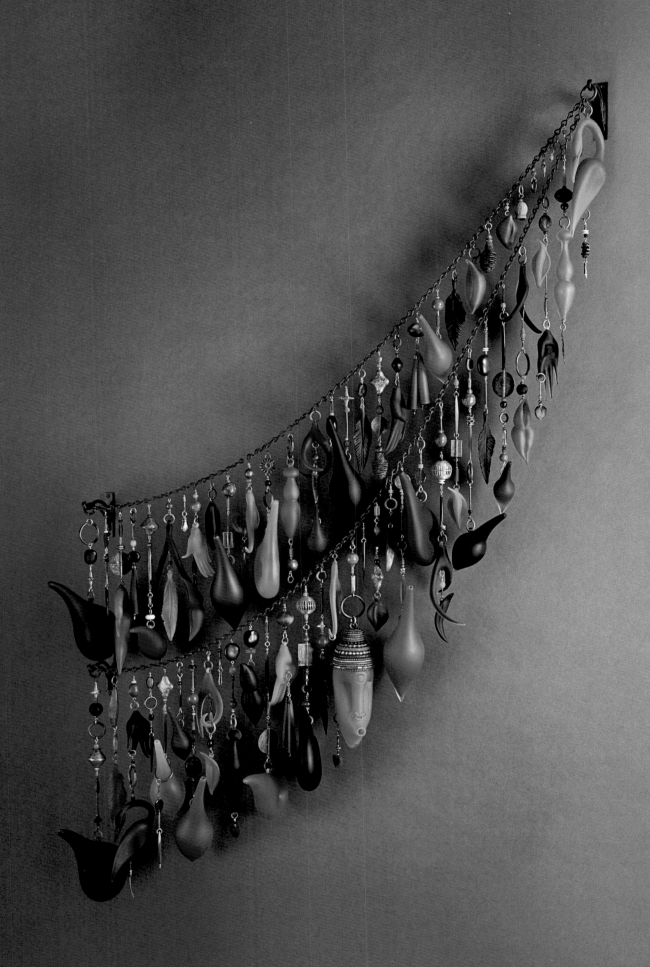

# Judith LaScola

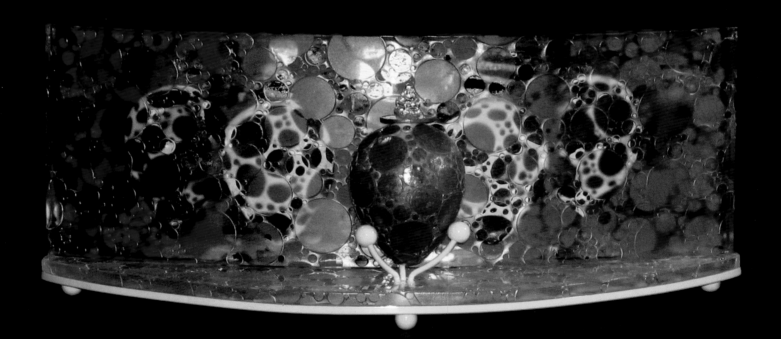

The first time I met Madeline Baer, she bought one of my early pieces. It wasn't long after that Pilchuck tour that we began corresponding. The last communication I received from her was a postcard. The front of the postcard has a photo of an interior done by the artist Guadi and on the back is a message I cherish still.

In the message Madeleine told me she had just returned from the glass show at Wheaton in New Jersey where she was having terrible headaches. She said she was going to have surgery and thought it might be a brain tumor. She went on to tell me how much she loved my work and that she knew I would be a successful artist. She told me never to forget that. She promised me she would be sure to talk to Ferd about putting my work in the invitational because she felt it belonged in the show.

This postcard has hung on the wall of every studio I have ever worked in for the last twenty years.

I traveled from Seattle to Pontiac for my first show at Habatat in 1997. I was nervous hungry and arrived too late to eat before the opening. I ran out and bought a bagel, took a few bites and put it in my coat pocket. Went to the opening, had a great time. I had planned on catching a plane right after the opening to go to Europe. The opening ran late and I was short on time, said my goodbyes, grabbed my coat with the bagel still in pocket and went to the airport. I was going through security and a security guard asked me what was in my pocket and I said a bagel. Two additional security guards were called to come and search me. They asked me to go to the back room and continued to ask me, now with my hands over my head, "What is in your pocket". I said a bagel, I insisted, but they didn't like that answer and before I knew it I had four security guards escorting me with hands up in the air behind my head into the back security room. Finally one of them reached into the pocket and removed a cell phone. I was totally shocked, I didn't even own a cell phone but I could tell I was in deep trouble. I realized that I had taken the wrong coat, Ferd's coat. I explained that I truly thought it was a bagel and in tears asked them to please call the gallery and ask for Ferd. They did. Ferd had the bagel. After almost missing the plane they took the coat, cell phone and allowed me to proceed onto the plane without a coat in freezing February weather.

- Judith LaScola

**Now** - 2012
9.5 x 25 x 9"
blown, hot worked and enameled glass

When I was 5 years old, my family moved from Syracuse, New York to San Luis Obispo, California. Each year the local university, Cal Poly held an open house in which the whole town could come and tour the university. I had serious-minded parents, responsible and always planning for the future, so as part of our indoctrination, my parents took me there when I was 6. The college kids put their best foot forward with performances and tours of all the departments (boring stuff to a kid), but they also had parades, and a carnival row, where you could play games and win things. I tolerated the tours in order to gorge myself on cotton candy and spend an hour playing games that would win me goldfish which could have gone down in the Guinness Book of World Records as the longest living fish ever.

According to my parents, I had shown promise as an aspiring artist, so one year when I was 7 they took me into the art department for a tour. I had my bag of goldfish with me which took me a half hour to win, and we walked into the sheltered studio space that was the glassblowing lab. I was so little that my dad had to lift me up to see everything, but I remember the roar of the furnace, and the clanking sounds of tools. What I saw in that moment changed everything for me. I saw students playing with fiery orbs, blowing into them, and lots of fire everywhere. I had always been a little too interested in lighting things on fire as a kid, and my dad soon realized his mistake in showing me the lab but it was too late. We left that day, but each year as I grew up, I went back to watch the glassblowers and win more of the everlasting fish. I vowed that I would blow glass one day, and I would be the one putting on the demo.

After high school, I decided to stay in San Luis to attend Cal Poly solely for the glass program. It wasn't my major, but it was the first class I signed up for. Each year after that, during open house, I put on demos and got to watch the little kids whose fathers held them up look at the fire with the same awe that changed my life.

- Shayna Leib

**Crevice** - 2011
72 x 18 x 6"
hot sculpted glass and metal

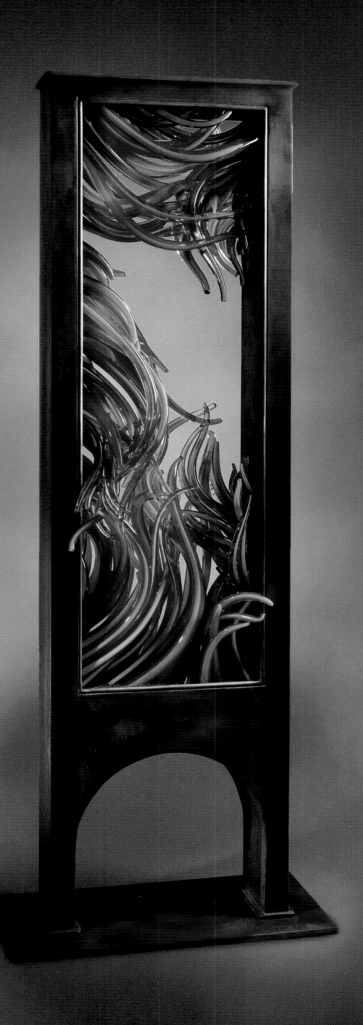

# Antoine Leperlier

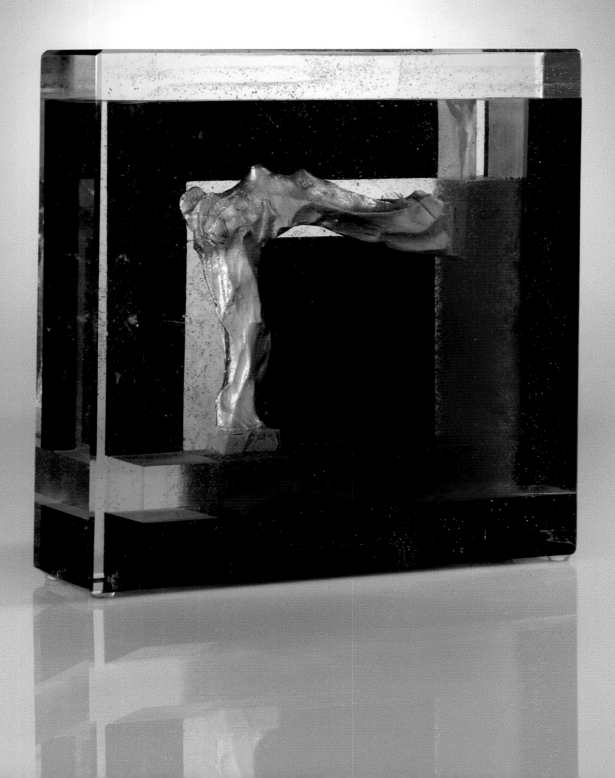

## THE LESSON OF THE ANCESTOR

During May 1968, when I was 14 years old, my parents sent me to spend the summer with my grandfather who was then 88. I spent my days working with him in his pate de verre studio replacing an assistant who had died earlier that year.

I remember a particular day during that summer. We had to put into the kiln a mold about one meter square, filled with different colored glass to make a stained glass window. We had worked on this for about a month and it weighed about one hundred kilos.

My grandfather had brought in extra help to help us push the mold into the oven. It was very tricky because it had to remain perfectly flat so as not to place too much stress on the very fragile mold.

Unfortunately, the helper made a sudden movement during the placement into the oven and the mold broke in two. My grandfather violently dismissed him and there we were with the broken mold half in and half outside the oven.

Later, after the efforts of the clean up and with the broken mold on the table my grandfather looked me straight in the eye and with a little smile in his eyes said, "Well, we have to do it again".

I have long thought about that experience in moments of discouragement. I understood at this period that no failure could undermine an artist determination to pursue his work, even if it is at the very end of his life.

<div align="right">

- Antoine Leperlier
February 2012

</div>

**N°2111213 Flux Et Fixe-VIII** - 2011
9.25 x 7.25 x 9.25"
pate de verre

# Jeremy Lepisto

I grew up just down the road from Royal Oak in the west end of Toledo, Ohio.

As a child, I was not fully aware of glass. I was subtly aware of the studio glass movement, the Toledo Art Museum and Toledo's connection to the glass industry. It was not until I went to Alfred University that I began a personal relationship with glass.

After being introduced in Alfred, glass took me back to Toledo for a short moment to blow glass at a local studio and work as a salesman at the Libbey Glass Company.

From Toledo, glass took to me the Olympic Peninsula to cast hot glass for two generous artists for five short months.

From Washington State, glass relocated me to Portland, Oregon to learn more about its physical characteristics at the Bullseye Glass Factory.

Glass kept me in Portland for a while. It introduced me to my wife, was the basis for starting a career and business, increased my contacts and friends and provided opportunities to travel domestically and abroad. It also got me involved with an international non-profit in order to give others similar opportunities.

Some years ago, (along with the aid of other accomplices) glass moved me to my current home in Australia. From here, glass serves as a way to connect to the local community and also stay in touch with the one back home. It is also has become the basis for beginning my PhD.

In 2012, and after 15 years, glass will bring me back to Toledo fully aware. I will help produce and attend a conference to celebrate its relationship to other artists over the past 50 years. Glass will also begin a new relationship for me with a gallery celebrating its first 40 years and that just happens to be down the road from where I grew up.

- Jeremy Lepisto

**Familiar Setting (from the Crate Series)** - 2011
18 x 12 x 6"
kilnformed and assembled glass with fabricated steel
Photo: Rob Little

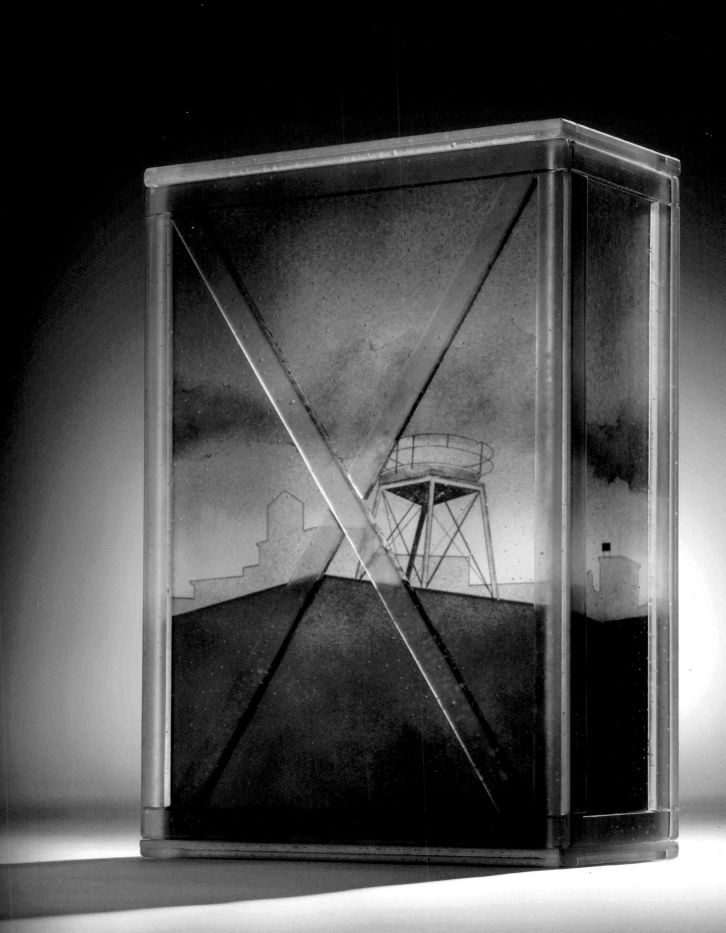

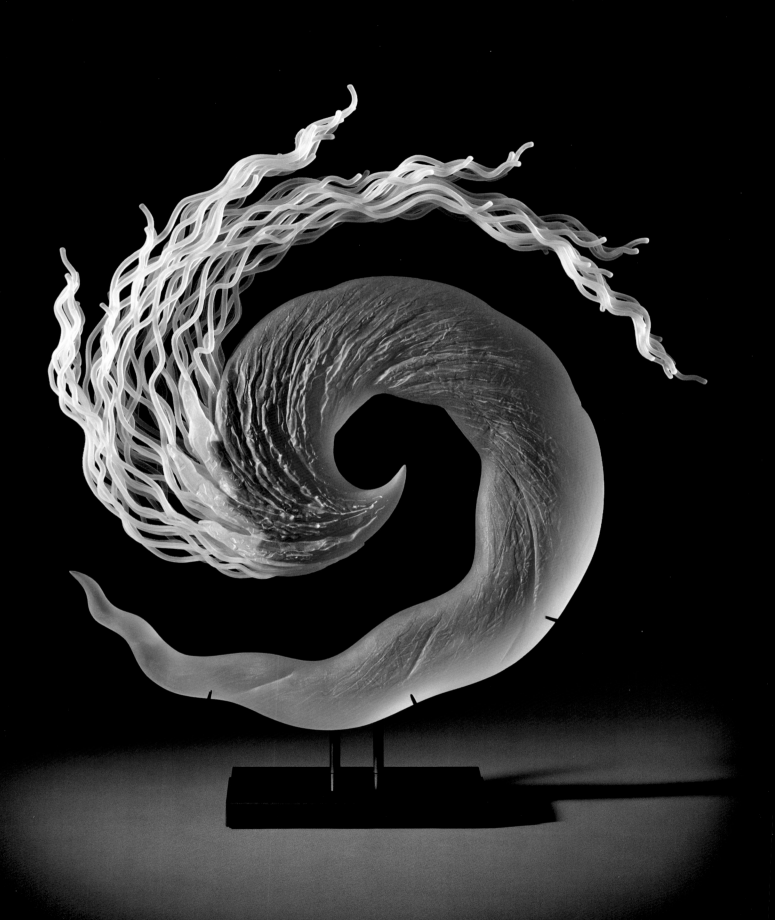

My first exhibition with Habatat Galleries was in May of 1984. The exhibition was not with Ferd in the main gallery, but with David Jones and Venture Gallery on the bottom floor of Habatat's Lathrup Village location. I had wanted to show my work at Habatat for a while and Dave's offer for a solo exhibition of my work was an opportunity to get my foot in the door. Mark Peiser, an internationally known glass artist, was having a show of his new cast sculptures in the main gallery upstairs. The opening for his show was on the same night as mine, so I knew I was in good company.

A month and half before I was to send the work to the gallery, I called Dave and told him I decided to change my whole style and introduce completely new work. Dave was expecting the hand blown glass bowls carved with sandblast-etched geometric patterns that I had been making. The new work, brightly colored blown and sculpted glass forms were reminiscent of colorful sea creatures and other natural forms. At the time, I was a bit nervous about the late change of direction, but Dave thought the new work would be an exciting addition to the exhibition.

On the morning of the preview, I left my studio in Vermont for the airport. The pieces, already shipped to the gallery, arrived days before I left my studio. I hand carried one remaining piece onto the plane wrapped in a towel inside a small cardboard box and stuffed it into the overhead compartment above my seat.

The flight to Detriot was quite uncomfortable. I had been on an airplane only one other time and didn't realize the forward bulkhead seat I reserved was a poor choice on a small plane. With my head bent over to accommodate the curvature of the fuselage, I sat in a window seat with no window. I was too far forward. A very large woman sat in the seat to my left and I was wedged in my seat, trying to fend off nausea and claustrophobia.

In Detroit, Dave arranged to pick me up from the airport so I wouldn't have to rent a car. He drove to the gallery at an average of 75mph, constantly switching lanes on the highway while alternately stepping hard on the gas pedal and then the brake as he came perilously close to the driver ahead of us. I was still suffering from the plane ride and now wondering if I should just end it all by opening the passenger door and jumping out into oncoming traffic.

Late in the afternoon that same day, I hadn't eaten anything all day and was feeling sick with a headache from the stress, the plane ride and the hair-raising trip to the gallery. At the main gallery I was overwhelmed by the variety and quality of the work displayed by other artists. I felt intimidated and unsure that my work belonged with that group, but I kept those thoughts to myself. After making my way downstairs to the Venture Gallery, I was surprised to find that my new work was already getting a lot of attention. During the preview and the days that followed, many of the collectors who had come for the Mark Peiser exhibition and were curious about my work wandered down to the Venture Gallery. Their interest in my work was apparent by the red dots applied to many of the pedestals indicating a piece was sold or reserved. Ferd had even picked out a piece for himself. I was starting to feel more confident about the show.

Prior to the exhibition, I had never met with David or Ferd; we had only had conversations over the phone. After the preview, Ferd invited me to stay at his house instead of getting a hotel room and we got to know each other a little better.

I was impressed with the relationship Ferd had with the other people who worked at the gallery. Everyone seemed like they were part of a big family, and they did their best to make me feel welcome. Over the next few days Ferd and I talked and he encouraged me to continue to pursue the direction I was taking with my new work.

When I think back now on the first show with Habatat, I believe the friendships I made that weekend influenced the development of my work and contributed to the success I have had in the years since.

- K. William LeQuier

**Cabriole** - 2012
24 x 21 x 2.25" (with base)
laminated plate glass, sandblast and diamond wheel carved.
laminated, polished and acid etched black glass base with a painted steel armature
(base footprint is 8.25 x 4.25")
Photo: Gerard Roy Photography

# Steve Linn

When I think of Habatat I think of the partnership we have established over the years.  My pieces, being somewhat apart from what was the traditional path that glass artists took, required that the gallery take a leap of faith and show work that did not fit on a shelf or table top.

In the 1980's we showed "Gandydancer", a glass bronze and wood piece that measured 7feet high by 19 feet 6 inches long by 7 feet wide, at New Art Forms, the predecessor to SOFA, in Chicago.  This helped establish both for the gallery, and artists, that glass art was indeed sculpture, and glass was a medium for ideas and not just a material for well-crafted objects.

- Steve Linn

**Lowdown Shakin' Chill (Robert Johnson)**
40.75 x 45.5 x 10"
cast glass, carved glass, bronze, wood

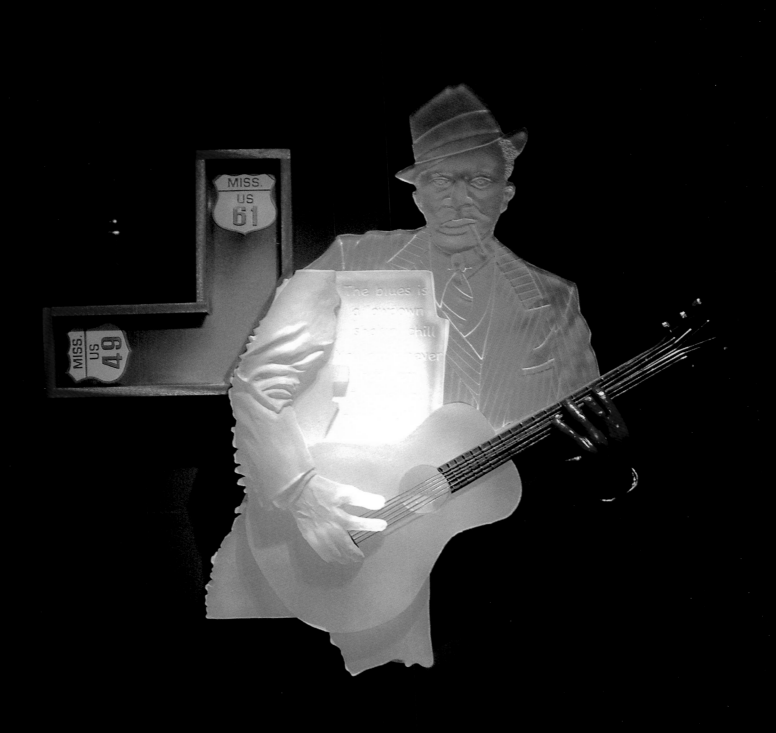

# Marvin Lipofsky

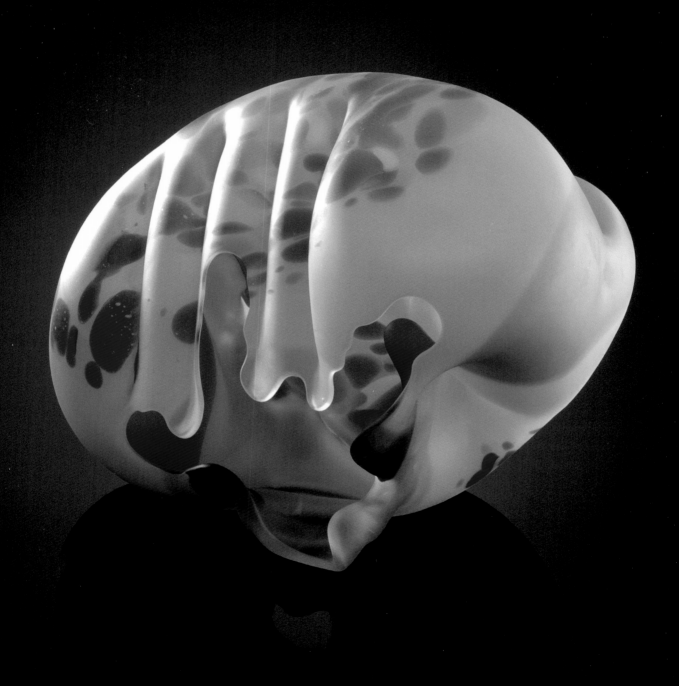

Ferd,

I am sending this California Loop in honor of your 40th Gallery Anniversary. This was made 40+ years ago, in 1970, and shows how much we've changed over the years.

This series was a turning point in my approach to making glass sculpture.

- Marvin Lipofsky

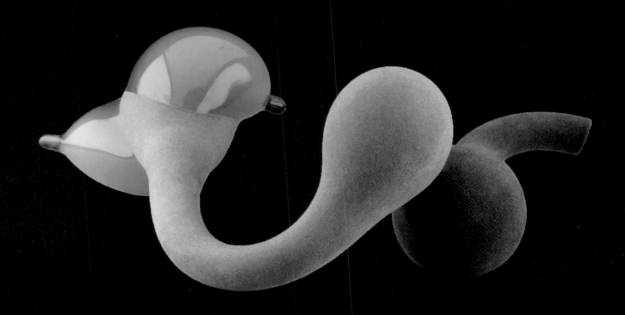

**California Loop Series #17** (above)- 1970
9 x 27 x 18"
Blown at UC Berkeley, Berkeley, CA finished by the artist in his Berkeley studio

**IGS II 1985 - 93 # 3** (left)- 1985-1993
15.5 x 20"
blown at Crystalex Hantich, Novy Bor, Czechoslovakia with help from Stefan Stefko.
finished by the artist in his Berkeley studio

Photos: M. Lee Fatherree

# Susan Longini

I recently completed a residency at North Lands Creative Glass Center in the small village of Lybster, County Caithness, Scotland.

The journey to Lybster, perched on a bluff overlooking the North Sea near the top of Scotland, took two days. On arriving at North Lands, it became clear why it has a mystical reputation; the isolation of this area is profound. I was overwhelmed by Caithness: treeless, windswept, mist, fog, ancient castle ruins perched on the North Sea cliffs. Typical gray skies and rain blended the colors into an indistinct overall tonality.

The history of the Caithness area is deep, from the pre-Roman Picts to the Vikings, and later the great British landowners. In the late 18th century "The Clearances" occurred in the highlands, when large landowners, realizing that it was more profitable to have enclosed pastureland for sheep and cattle, forced the small tenant farmers, known as crofters, off their land. Many of these small farmers emigrated to North America and Australia, but some managed to resettle and become fishermen in this very wild environment by the North Sea. Today Lybster has lost most of its population. The fishing industry dried up when the currents shifted away and so did the herring.

The *Caithness* series is a response to this experience, delving into the history, walking the cliffs and hiking down to the shoreline. Ultimately each of us must stand looking into the mist at our personal cliff's edge and to find the courage to move ahead.

- Susan Longini

**Caithness Coast #8** - 2010
35 x 41 x 1.5"
pate de verre, assembled
Photo: Keay Edwards

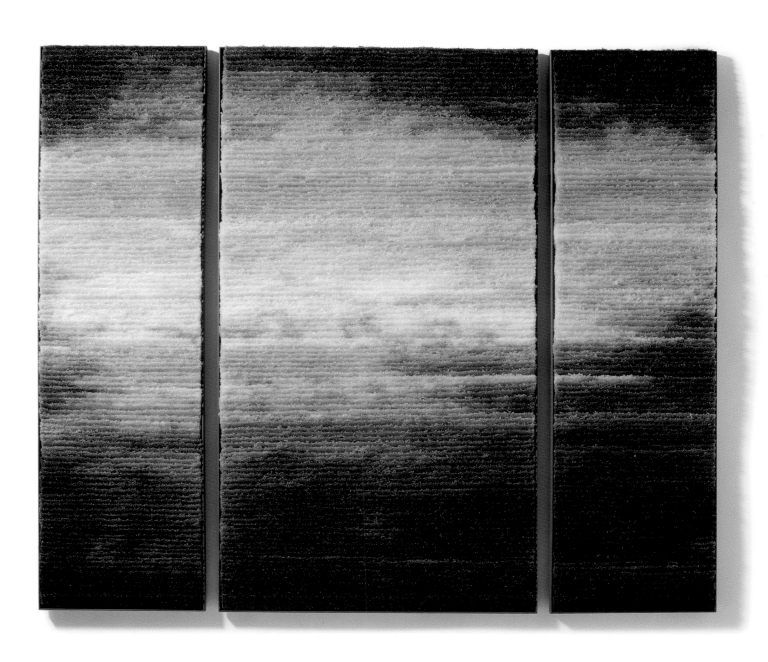

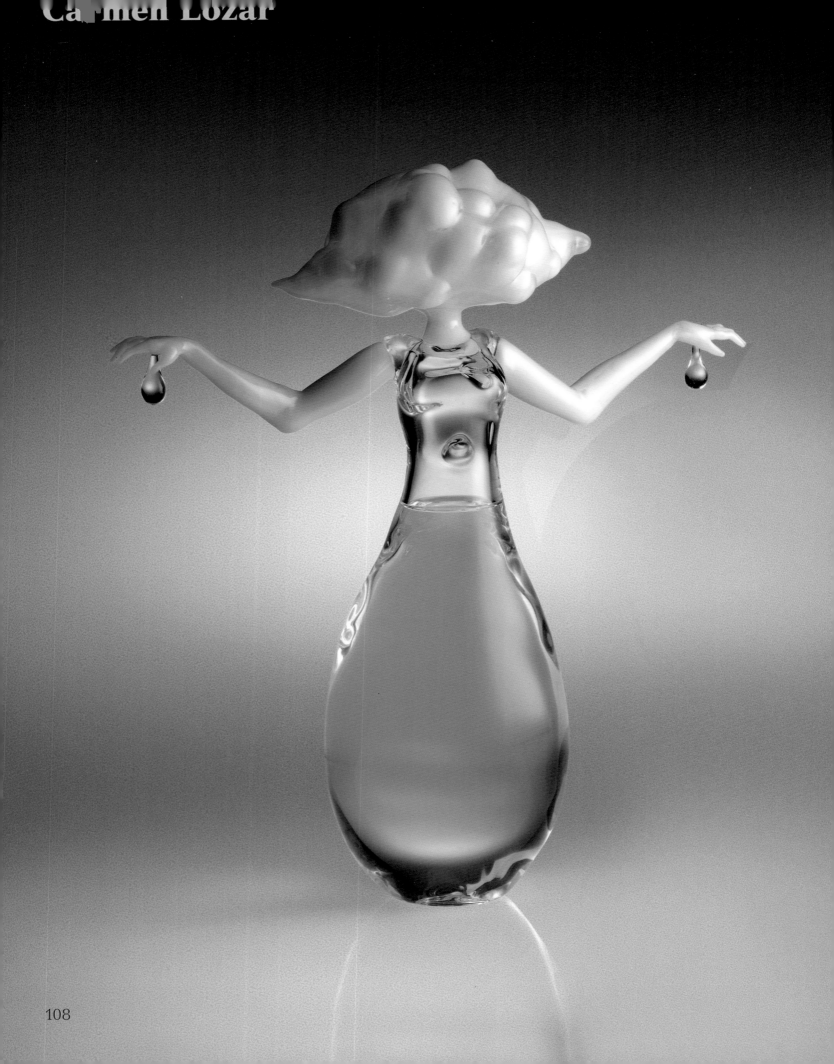

One day, out of the blue I received a phone call from Paul Stankard. I had never met Paul and would have never presumed that he even knew my name. But all of a sudden, I was talking to one of the most pleasant, gracious and incredibly talented glass artists working today. He told me that he had been paying attention to my career and following the works I had been making with interest. He then told me to call the manufacturer that produces the glass I use and to place a ridiculously large order that he, Paul, would be paying for. It was a "materials scholarship" in a way but to me it was so much more. To be recognized and encouraged by an artist, like Paul Stankard, at that point in my career gave me the drive to keep pushing and exploring. I will always strive to emulate Paul in the quality of his work, his tireless commitment broadening the flame-working field but most of all his generous spirit.

- Carmen Lozar

**Cumulus** - 2009
10 x 9.5 x 5" (single figure)
flameworked glass

# Maria Lugossy

I am fascinated by amazing forces and phenomena of nature for a long time.

My "Blue Bay" is a non-existing, imaginary landscape from my dreams, formulated on the language of glass. Please, stay with me on this fantastic journey.

- Maria Lugossy
24, February 2012

**Blue Bay** - 2011
7.25 x 32.5 x 32.5"
laminated, sandblasted cut and polished glass
*(detail shown at right)*

# László Lukácsi

## TIME IS MY FRIEND, DEADLINE IS MY BIGGEST ENEMY

You would think that an artist whose career that has lasted 35 years would  know the amount of time needed to create and finish a piece.  I am a perfectionist and I work alone without any assistance.  Yet, something always happens, a problem here, a change there.  I could use more time, just one more day.

I can imagine the embarrassing situation at the International Exhibition or the SOFA Chicago Expo when the staff of Habatat has finished setting up the exhibit.  All being superbly dressed, ready for the opening night VIP's, with cocktails in hand being confronted by a Fedex courier with my sculpture in a colossal box….

I am really a fortunate to work with the patient staff of Habatat Galleries.  Thank you for that.

- Lukácsi László

**Jewel** (both images) - 2012
7.25 x 14.5 x 5"
cut and laminatd glass

# Lucy Lyon

For years, now sculpting the figure has been a constant
revelation to me.  As I have learned to see the nuances of
the human form more clearly, my figures have become
increasingly unique.   The larger scale has made it possible
to include more information in each form.  On the other
hand, the environments or settings for the figures have been
reduced to the essential elements.

Each figure has always had a story and in some way I feel
intimately connected with each one.  They are alone, in
relation to another, or in a group, yet each one is individual.
The narrative in each piece is open to interpretation.

- Lucy Lyon

**Languid** - 2010
38 x 13.5 x 10"
cast glass figure, fabricated steel base
Photo: Addison Doty

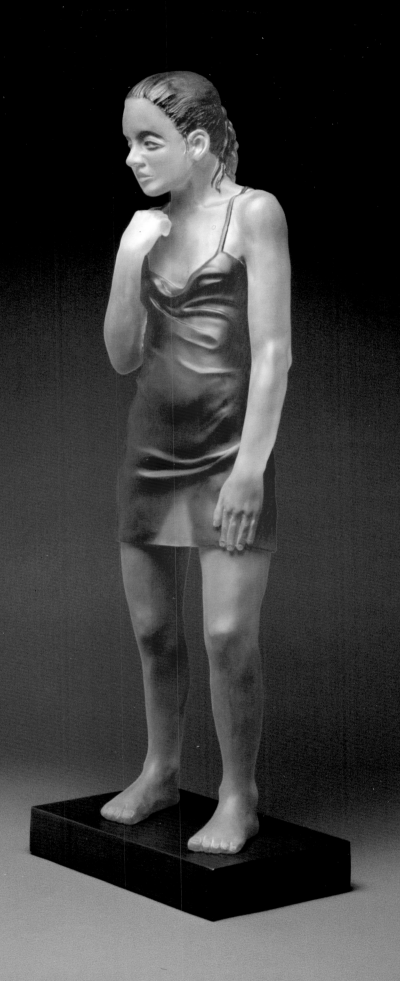

# John Miller

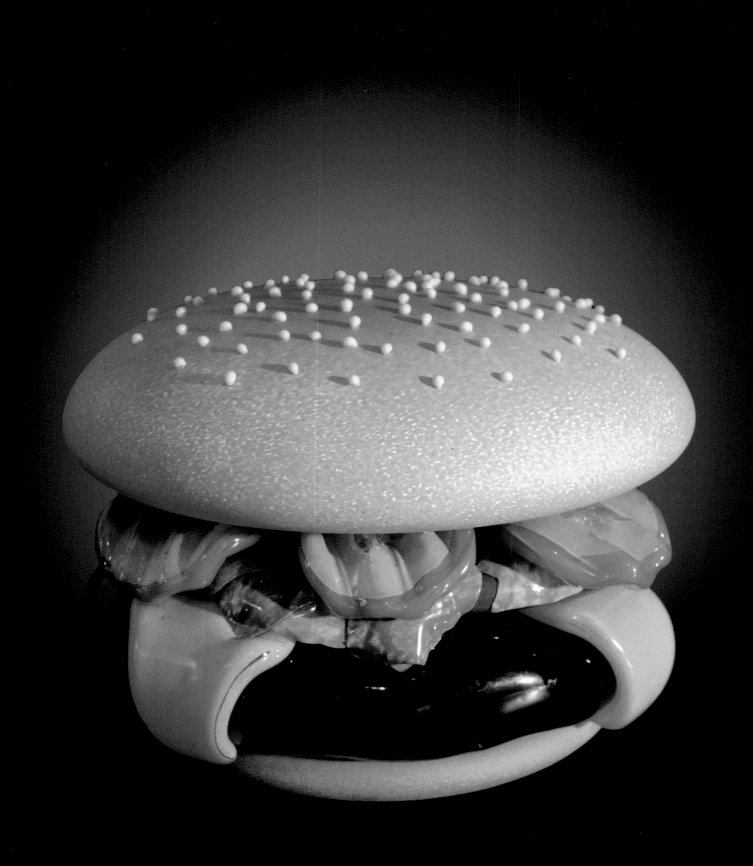

In 2000, I finished building my first hot shop and jumped in head first into the contemporary glass movement. I cashed in all my chips and made the call to Ferd Hampson at Habatat. I told him about this incredible body of work that I had just finished. FIVE FOOT TALL VENETIAN GOBLETS! Mr. Hampson loved the idea and wanted an image immediately.

Well, the next day I went into the hot shop and began working on the FIVE FOOT TALL VENETIAN GOBLETS that as of yet did not exist. I made the parts, got them out the next morning and assembled them on the marver table and took a shot with my 35 mm camera. I developed the film and sent an image next day to the gallery. He loved it and wanted three colored goblets to include in the Habatat International that opened in four weeks. Four weeks! No problem. I can make ten of them in four weeks!

I made three beautiful cups and began cold working them together. I came up with the idea to have the goblets come apart for shipping purposes. Michael Scheiner had told me that you could core drill large blown forms with a hand drill. If it worked for him, it will work for me. No problem. Three days before the opening I managed to break two out of the three cups in the cold shop. I had exactly enough color to re-make the cups. One came out on Wednesday the other on Thursday at six a.m. on the day of the opening. I cold worked the last cup at 7 a.m., threw it in the van and drove from Champaign, IL. to Pontiac, MI. in record time.

When I arrived at the gallery I got my placement from John Lawson and u.v. glued the last two cups together on the pedestals. I finished at 4:30 p.m. for 5:00 pm opening. No problem. I went down stairs to the restaurant for a few pops and when I came back fashionably late, the piece was sold and is now in New York City in the permanent collection of the Museum of Arts and Design. No problem.

- John Miller

**Slider** - 2012
11 x 14 x 14"
blown and hot sculpted, cold worked glass

# Debora Moore

One of my favorite memories of Ferd and Corey happened during a colletors' tour of our studio (Benjamin Moore Inc). A client asked about how my orchids are made. For years, I had been correcting collectors who insisted that my flowers were lampworked. I could not figure out why they were so sure about this, until I overheard Ferd telling a client that they were lampworked. When I cleared up this misunderstanding, Corey, listening nearby yelled "I told you, dad! They were blown and made from the furnace." It shows how close the Habatat family can be.

- Debora Moore

**Pink and Red Epidendrum** - 2012
16 x 14 x 7"
blown and sculpted glass
Photo: Lynn Thompson

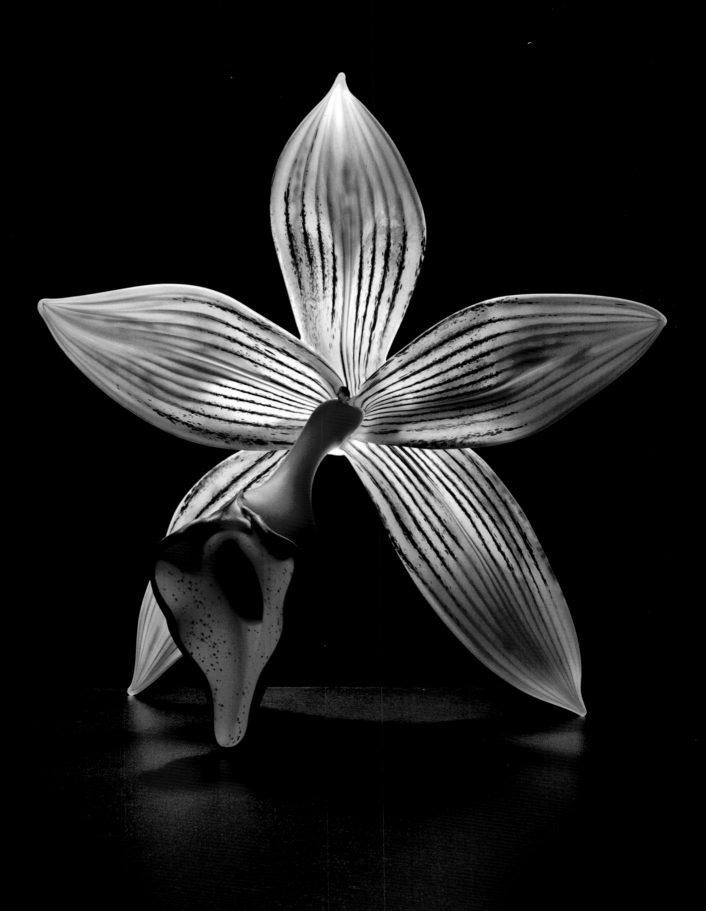

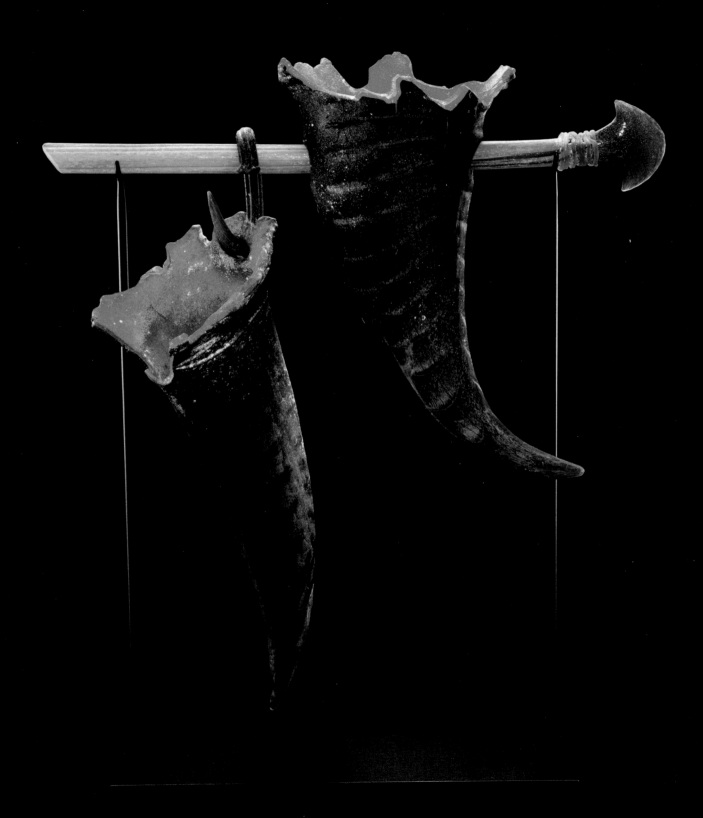

People want to hear about other people's stories, because they provide such a great metaphor for reflecting on one's own life. My journey is only my journey. I struggle with it every day. It is also a blessed life for which I am incredibly grateful. But I am convinced that many people have more blessings than they actually ever realize.

The term artist is a funny thing. Creativity floods all aspects of a life; it characterizes how everyone approaches anything. I think that glass offers a great life loaded with opportunity. There is still so much to be done with the material. I believe there will continue to be a lot of work. Those who are still making glass art have my best wishes.

- William Morris

**Suspended Artifact** - 1993
27 x 23 x 8"
blown glass and steel stand
Photo: Rob Vinnedge

# Kathleen Mulcahy

Water is essential to life, both sustaining and fragile, yet we take it for granted in its seeming bounty. It has become my bank of savored forms and thoughts, my muse. I am refreshed by the pure flow, beauty and expression of the moving water. For the past seventeen years, I have been canoeing the rivers of western Pennsylvania with a lively group of women. We pack the canoes for a three-day journey, setting up tents along the riverbanks, cooking remarkable feasts from common matter. We are alchemists; the water is our gold.

One of my favorite spots on the Allegheny for contemplating the river is just at the furthest point upstream on a tiny island, as the water sluices around me. This confluence draws my thoughts deep into the gorge and back to those who find solace in this rolling retreat on the reach. Each drop in my work becomes a moment of stillness, listening and remembering on the river.

- Kathleen Mulcahy
2012

**The Alchemist's Story** - 2012
48 x 96 x 3"
bent and etched glass on stainless steel with glass drops
Photo: Jim Judkis

# Paul Nelson

My first experience with Habatat Galleries was during the Toledo GAS conference in 1993. I rode the party bus up from Toledo for the opening at Habatat with Steve Powell, Fritz Driesbach, and a bottle of Jack Daniels. What a wild ride! As a recent undergraduate, the experience was quite impressionable. Here I was, at Habatat Galleries, getting to meet all of the glass artists I had been studying and admiring as a student. The professional and inviting experience at Habatat made me realize my career goal, to work with Habatat Galleries.

- Paul Nelson

**Marcel Duchamp: The Bishop** - 2012
35 x 12 x 12"
kiln-cast glass and oil paint

# Bretislav Novak Jr.

Forty years is not such a long time in art history but in the case of contemporary glass it is quite significant. Glass as a material was for centuries useful only as a commercial product and not as a sculptural one. This changed in the 20th century and I had a firsthand experience from my father who was also an artist and sculptor.

Habatat Galleries founders, Ferdinand and Kathy Hampson, were just visionaries when they started to cooperate with artists in the cradle of contemporary glass formerly known as Czechoslovakia and my association has been very pleasant. I have been very happy when I could host collectors that have accompanied Habatat Galleries on several trips to my atelier. Their enthusiasm and excitement about my work is encouraging. I am always honored to be a part of the International.

Our cooperation has lasted about 30 years and I hope the next thirty will bring the same success! Ak.mal.

- Bretislav Novak Jr.

**Love** - 2011
32.5 H"
cut and assembled glass
Photo: FotoHilger 2012

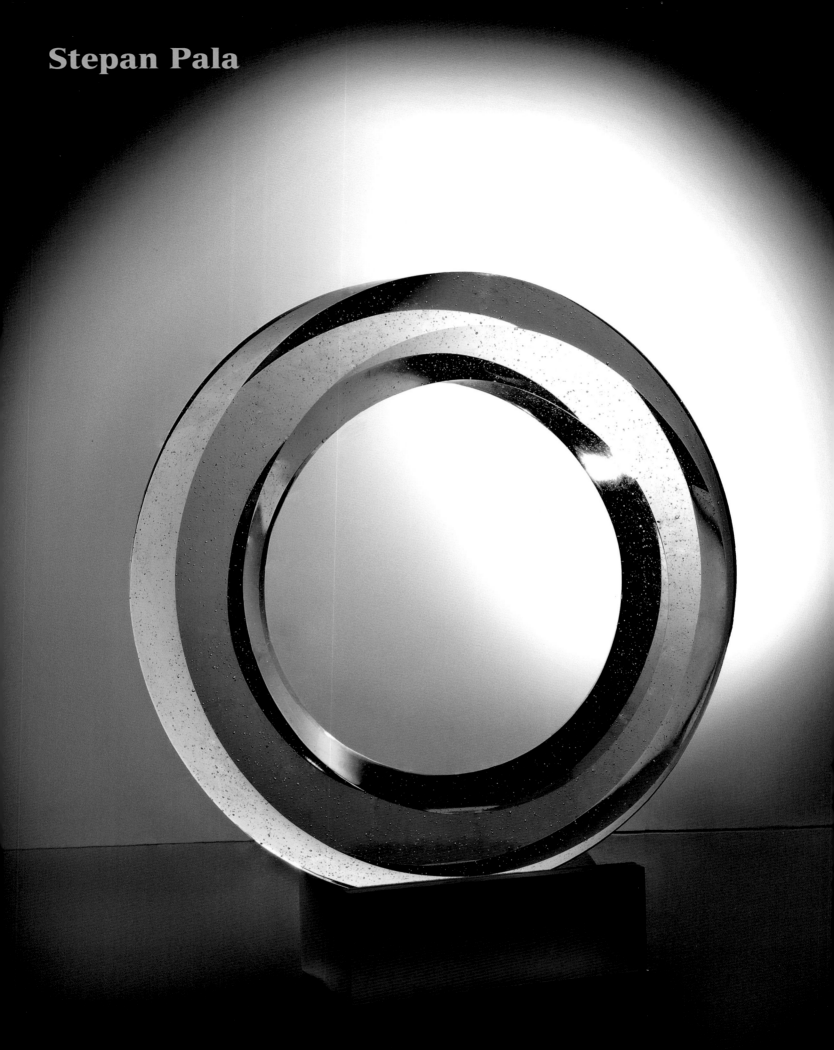

Stepan Pala is now devoting his attention to pursuing a series to which he has given the preliminary title: "infinity". He already considered this problem long ago. It first found embodiment in spiral glass objects, which he began to create a few years ago. Their essence is the mathematical module of the so-called Moebius strip, already exploited a number of times by visual artists, for example, the famous representative of Concrete art Max Bill.

However, in this case, it is not a matter of a flat form. Stepan Pala has given it spatial development. His infinite spirals with lens-shaped cross-sections have two sides and four edges. The three-sided formation turns and is sufficient in its self and outwardly, its profile changes from every point of view, with flowing dynamics and rhythm.

They are sculptures of "infinite" architecture, structures offering endless possibilities for immersing oneself and opening one's mind to infinite utopian ideas. Mathematics and geometry, poetry and play are the main constants of his recent creative work.

In one part, the work connects with earlier starting points and takes them further, while in another part, the strict rationality is relaxed and the wings of fantasy appear. In the spiral rings, sharpened disks and infinite columns or stelas, he works much more than before with contrasting means of expression: with lustre and matt, finesses, with colour and its emphasis, with static and dynamic forces, with the internal and external structures of glass.

- Excerpt from the artist

**Infinity** - 2012
43.5 x 43.5 x 7.25"
cast, hand ground and polished crystal
Photo: Valika Zacharova

# Albert Paley

**Arc** - 2010
21.5 x 31 x 22"
formed and fabricated mild steel, stainless steel and cast glass
Photo: Bruce Miller

I am pleased to have had a long relationship with Habatat Gallery, they have afforded a significant presence and prospective to the evolution of the field of art and design.

- Albert Paley

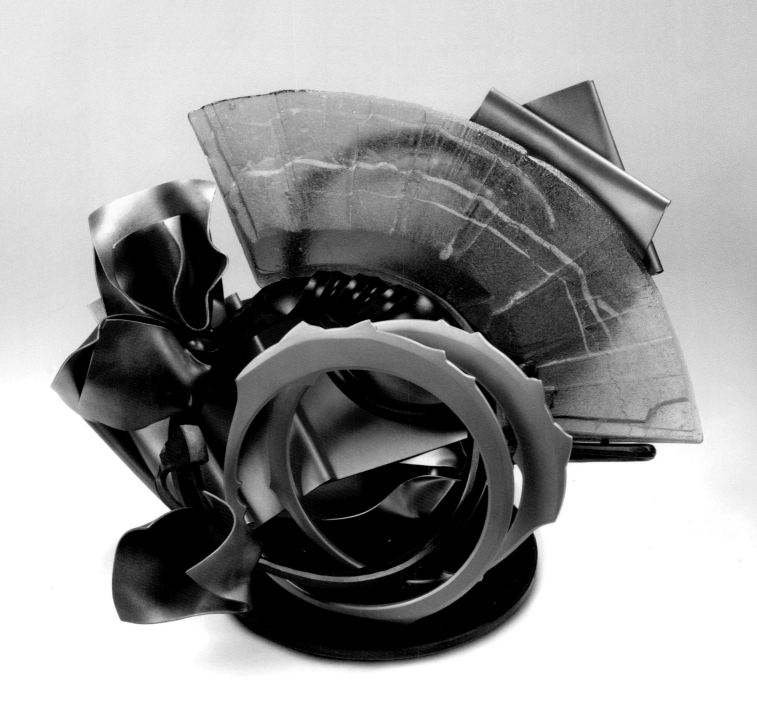

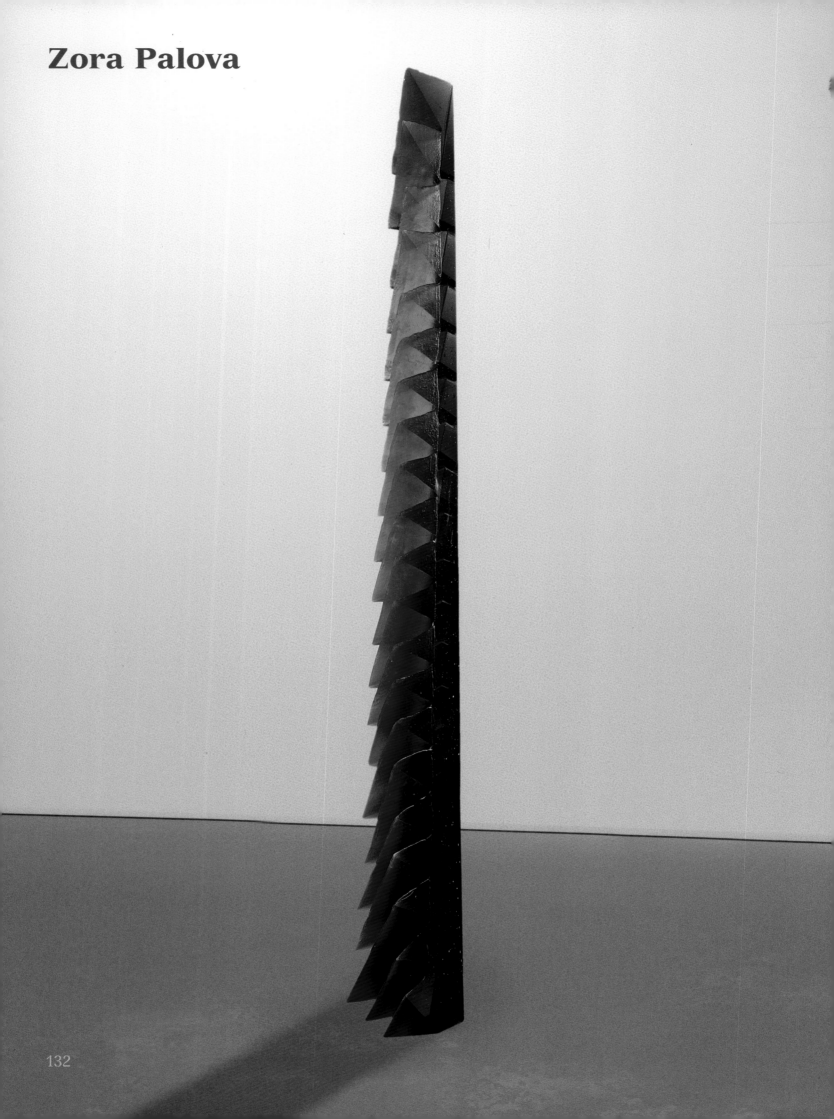

Zora Palova

Zora Palova remains faithful to her tactile creed of "hand" modelling of sculptures. The results are powerful, often fully plastic masses or structures, whether they are ships, bridges, seas or shadows, as she often names her creations. They incorporate traces of her often totally experienced and deeply felt physical and emotional actions.

In the most recent period, she has internalized not only the format, form and artistic idea of the work, but especially her personal preoccupation and engagement as if it is really "about everything". Her latest works radiate a high degree of participation and personification in the process of creating a work. She can put the whole physical and spiritual tension into her stubborn struggle with which her ever dissatisfied personality lives and breathes into her determined efforts to create forms and transpose them from clay or plaster into glass.

The essence of her sculptural thought was never "literary" or epic, but rather metaphorical and pictorial, and now it is becoming ever more evocative. Through associative ideas, she mediates a whole range of the feelings and states accompanying our earthly existence, hopes, joys and sorrows, real and imagined, conscious and unconscious.

Since she understands glass from all points of view, she can, so to speak, breathe life into this material. The personally experienced is transformed into the universally understandable, the visually effective into the magically spellbinding. These properties of the latest works of Zora Palová speak mainly of the synthetic character of her artistic gesture.

- Excerpt from the artist

**Totem** - 2012
78.75 x 11 x 7.25"
cast, ground topaz
Photo: Valika Zacharova

# Mark Peiser

In 1967, when I started with glass, there were less than a handful of shops in the country that exhibited the works of the emerging craft resurgence. Then, the few existing outdoor "art" fairs began to include "craft". And then, new fairs began popping up all over and they became the marketplace for craft. I was the first guy to hit the "circuit" with glass. For some shows, for some years, I was the only one exhibiting glass. I had one hundred percent market share, but it came at a price. Countless people with perplexed expressions would look at my work and ask " What is that stuff?" "Glass ", I'd say. Then, after a pause, came the question I dreaded most- "How do you do that?"

Well, I was young, conscientious, and enthusiastic to share my excitement. So I began, "You have a furnace full of molten glass-". In a few minutes I'd get to "you heat the end of a long metal tube-" In a few minutes more their eyes would glaze over and they'd shuffle off. Then the next person said " What is that stuff? Is it wood?" "Glass." I'd say, and start over again. I must have done it a thousand times, or more.

In 1971 I was at one of the Florida shows, and the explaining had gotten pretty old, when up walked two guys. They said they were Ferd and Tom and that they had a frame shop in Detroit, and they wanted to start a gallery for glass. We exchanged names and numbers and as they walked away I thought, " Oh yeah, a glass gallery. I wonder how that'll work out".

A few years later I'm still doing the fairs. I envied the jewelers who could bring their whole exhibit in a suitcase in a plane, not a truck. So I built a slick stand of oak and black formica that would fold and fit as air cargo and blew a shows worth of iridescent miniatures that would all fit into a steamer trunk, and got on a plane to Coconut Grove.

 It was a good plan, but by evening I'd gotten to Miami and the work went to LA, and the show opened next morning. I spent a sleepless night tracking it till it arrived about dawn when I discovered it wouldn't fit in the trunk of the downsized rental car that was available. Well, I did get to the site, and set it up. I'd never seen the stand with work on it before. Each of the pieces sat on a small square mirror which doubled the colors and forms. I thought it looked pretty good. Actually I was kind of proud.

And I got it ready by opening time. But, by evening, after another day of explaining, I was getting a bit short with people. And another lady asked, "How do you do that?" My brain went dead. I looked at my display and answered, "Mirrors, it's all done with mirrors". Her eyes lit up, her face registered a thoughtful recognition and she said "Oh, I see". She looked a while longer and left. It felt the only time anyone ever actually understood what I said about my work.

Later, as I packed up for the day, I thought, "I wonder how that glass gallery thing is coming along?"

- Mark Peiser
2012

**Reflection (Palomar Series 013)** - 2012
27.25" x 12" x 9.75"
cast phase separated glass, aluminum
Photo: Steve Mann

# Sibylle Peretti

In my work I explore the lack of harmony between human beings and nature and our inability to become one with the natural world. My sculptures and paintings exemplify the tension between beauty and disease, intimacy and distance, innocence and knowledge.

For the last five years I have worked on THE SILENT CHILDREN SERIES, where I take children's images out of medical books, remove them from time history and any social environment to place them in a diaphanous, dreamy world to let them play in mysterious dramas.

The children I express are healed through an intimate and mystical connection to nature.

My wish is to create pieces that are sensitive, magical and touching, forcing us to ask questions of our identity and the way in which we experience ourselves in the world.

For some time I have been fascinated by several cases of Feral Children who grew up only with the companionship of animals or as confined children who lived with little or no contact to other human beings, or social civilization.

They keep our fascination because they function as a transmitter between the human and the natural world. They are full of wonder, mystery, sensibility for senses we have lost and may provide answers for how we see ourselves and our connection to nature.

- Sibylle Peretti

**Mosquito Girl** - 2009
10 x 6 x 6"
cut, engraved, painted glass

# Marc Petrovic

My Avian series has been germinating for some time. I made my first effort at a murrini roll-up bird for a demonstration at the 2009 Glass Art Society conference in Corning, NY. During the summer of 2010, I completed two more while teaching at the Penland School of Crafts. It was not until January of 2011 that I began working on the Avians in earnest.

The blown and sculpted birds are physically formed much like we are metaphorically built; one piece or experience at a time. Brick by brick our experiences are assembled and our identity is formed. In envisioning the pattern necessary for the tablets to be rolled up and sculpted into a dimensional bird, I picture the final form of the Avian, and then mentally deconstruct and flatten the three dimensional image into a two dimensional pattern. This allows me to create flat two dimensional tablets with the coloration placed exactly where needed in order to hot sculpt the glass pattern into one of my three dimensional Avians. Conversely, in my mind, the abstracted tablets are fully realized birds... birds deconstructed.

I begin the process by choosing colored sheet glass and making patterns by stacking up sections of sheet glass. Much like the sketch lines in the beginning of a drawing, every line formed by a layer of sheet glass will be present and visible in the final piece. The stacks of colored sheet glass are fused, heated, and then pulled into lengths of 12 feet or more. After they cool, they are chopped into small slices called murrini. Compositions are made by placing the murrini one at a time with their interior design visible. Even the slightest change in the orientation of a murrini can make a dramatic difference in the final piece. These assemblages are then fused together into a single tablet. These tablets are the 2 dimensional deconstruction of the 3 dimensional form. The flat tablets contain all of the color information for the final bird, with the exception of the beak and eyes.

- Marc Petrovic

**Avian Pair #5** - 2012
12 x 15 x 12"
hot sculpted and blown glass murrini roll-up, fused murrini

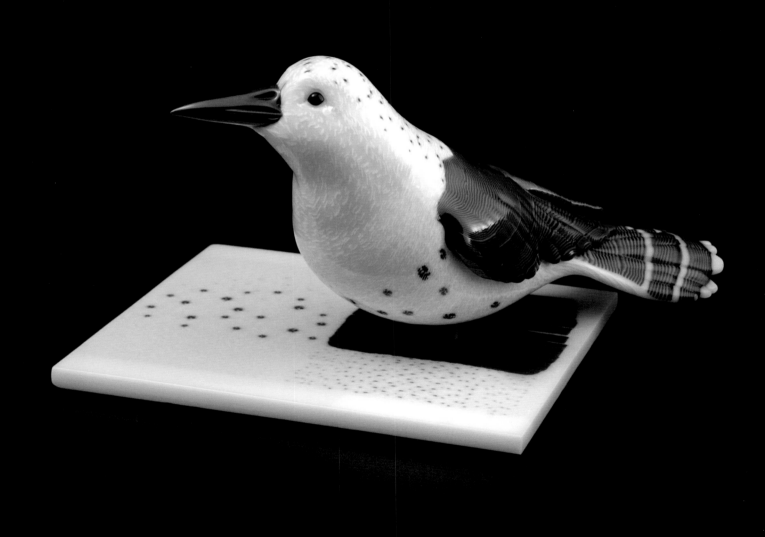

# Stephan Rolphe Powell

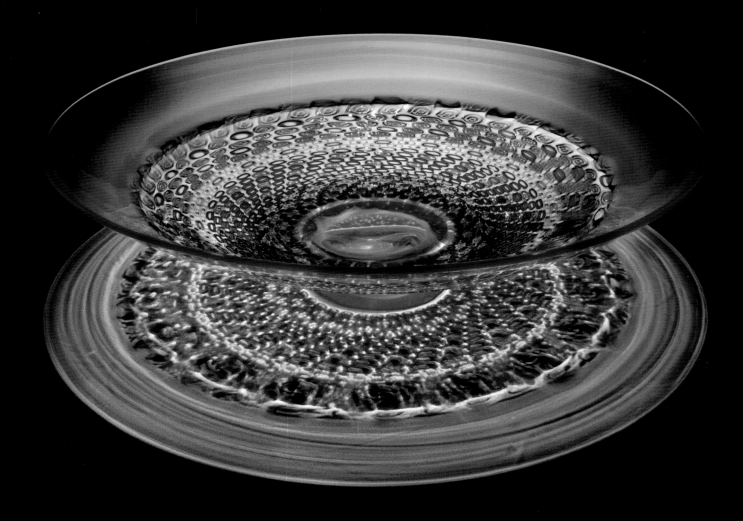

These new murrini bowls I am making represent a return to more traditional glass making techniques, hopefully still allowing for my continued exploration of expressive color. Return really might not be the right word, for I never really worked in a traditional way with glass. I am truly a product of the American Glass Movement as my introduction to glass came from watching Marvin Lipofsky, Fritz Driesbach, Richard Ritter and Gary Beecham. I was fascinated by finding my own techniques and discovering what glass could do by trial and many errors.

It was only after I had established my career and through bringing Lino Tagliapietra to Centre College, where I teach, that I began to understand and appreciate more traditional ways of working with glass. I have learned so much from Lino and I value his friendship more than I can express. In fact, the bowls that you see in the Habatat International this year represent a very strong influence from Lino. Lino came to Kentucky last fall on a private visit, no public fanfare, where he helped me develop this bowl shape and helped me understand how to make the colors more dynamic. On the previous five trips to Kentucky, Lino's visits were huge public events celebrating Lino's work. This private time with Lino in the studio was an experience of a lifetime.

Looking back at how all of this started for me, I have to give my greatest thanks to those pioneers of the American Glass Movement, certainly Harvey Littleton for getting it all started here in the United States. And , of course, to Lino for all of his  inspiration and influence.

In addition, I want to thank Habatat Galleries, especially Ferdinand Hampson and Linda Boone, for their support from way back. I remember my first encounter with Ferd; it was at my first major one-person exhibition at the Kimzey Miller Gallery in Seattle during the Glass Art Society conference in 1992. Ferd came in the exhibition and seemed wowed and surprised by my work. While flattered by his enthusiasm for my work, in the back of my mind I was thinking that he did not remember that I had sent him images of my work several times before with no encouraging response. I liked the fact that Ferd seemed to think that he had, in a way, discovered me. I let him think that and never mentioned the earlier rejections.

From that point on, I have enjoyed my relationships with Ferd, Kathy, Linda, Lindsey Corey, John, Debbie, Jacquie and Aaron. I must say that Ferd is a true gentleman and I consider him not only a business partner, but a real friend. Thanks Habatat, I have enjoyed my involvement with you for at least half of your forty years. Congratulations!

- Stephen Powell  2012

**Citron Yelling Cyclone** - 2012
7.25 x 25.5 x 25.5"
blown glass and murrini
Photo: Stephen David Finney

# Clifford Rainey

**Back to the Future...**

Away back in 1984 whilst teaching a casting class at the Pilchuck Glass School I was sharing a few drinks and a good conversation one evening with my friend and fellow artist Dale Chihuly.

At that time I was still living and working in London and spending time in New York. It was good being so tucked away in the northwest woods and most welcome. That day, in Dale's hillside cabin, still resonates as a pivotal point in my development as a professional practicing artist.

I remember our conversation centered on the value of drawing and of course glass and its place in a contemporary fine art context. We talked about life, love, friends, getting ahead and at some point I mentioned my desire to show my work to a larger audience in the U.S.A.

Dale, always generous, reached for the telephone, dialed a number, told the recipient to give me a show, and then handed me the receiver to speak to this chap called Ferdinand Hampson who had some gallery in the middle of America.

P.S. The really good and juicy stories are best kept between my long-suffering friend, Ferdinand and me.

- Clifford Rainey

**Olympia Decoy** - 2012
16 x 20 x 18"
cast glass and paint
Edition of three
Photo: Rachel Riser

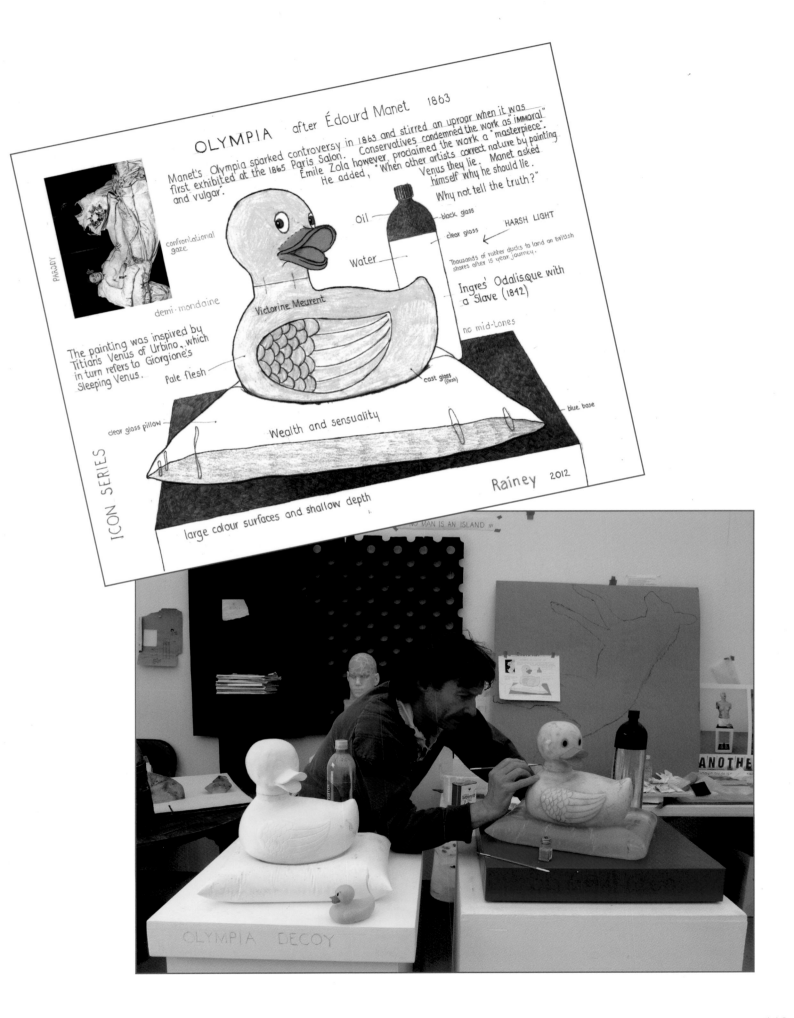

OLYMPIA    after Édourd Manet    1863

Manet's Olympia sparked controversy in 1863 and stirred an uproar when it was first exhibited at the 1865 Paris Salon. Conservatives condemned the work as "immoral" and vulgar. Émile Zola however, proclaimed the work a "masterpiece". He added, "When other artists correct nature by painting Venus they lie. Manet asked himself why he should lie. Why not tell the truth?"

PARODY

confrontational gaze

demi-mondaine

Victorine Meurent

The painting was inspired by Titian's Venus of Urbino", which in turn refers to Giorgione's Sleeping Venus.

Pale flesh

clear glass pillow

Wealth and sensuality

Oil

Water

black glass

clear glass    HARSH LIGHT

Thousands of rubber ducks to land on British shores after 15-year journey.

Ingres' Odalisque with a Slave (1842)

no mid-tones

cast glass (flesh)

blue base

ICON SERIES

large colour surfaces and shallow depth

Rainey    2012

NO MAN IS AN ISLAND

OLYMPIA DECOY

143

# Colin Reid

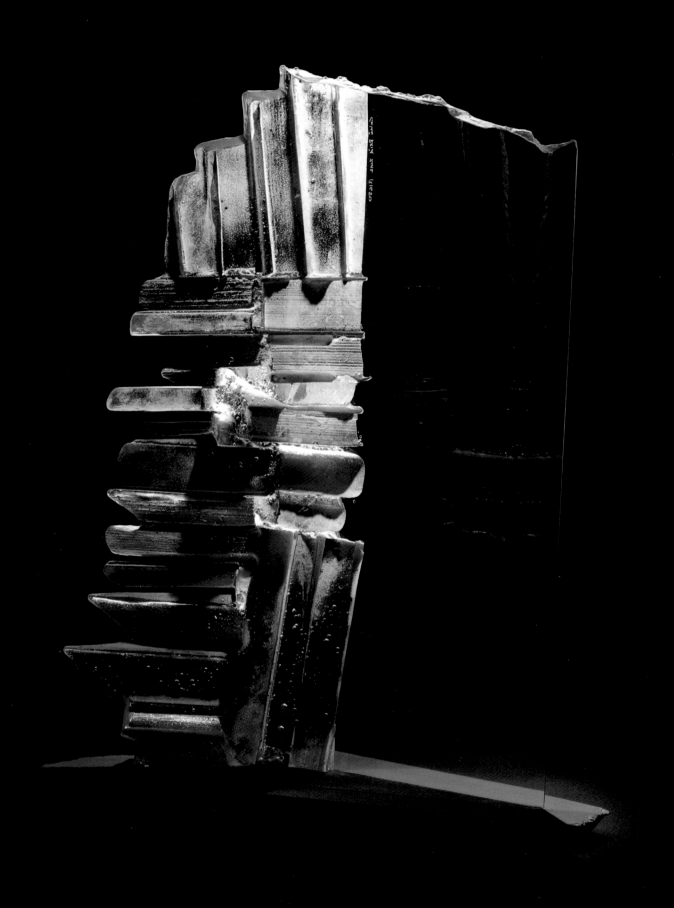

**Last sight of an extraordinary figure.**

In 2000 I was invited to work at the International Glass Symposium, Novy Bor, Czech Republic. It was an incredible few days, working in the factory with a team of superb blowers helping me realize my piece. Post communist Novy Bor was transformed from the previous time I was there for the 1988 symposium. Then, the impression was of polluted air, communist food, and the notorious Grand Hotel. Grand in name only, it featured shared rooms, one bathroom per floor and it was almost worth going just for the sight of the international glass set queuing for the bathroom in their pyjamas, toothbrushes in hand.

In 2000 the symposium delegates were invited to a special showing in Prague of Professor Stanislav Libensky's exhibition of his latest and final series of works.

The work was extraordinary, monumental, a technical tour de force. The smokey grey sculptures stood well over head height, affecting not least because of the obvious allusion to X-rays; we knew he was suffering from lung cancer. But I will never forget the presence of Libensky himself. The glass mega star, standing smiling and humble with his wife and artistic collaborator Jaroslava Brychtova, beaming a welcome to everyone. And so approachable. I didn't know him well, was rather in awe, flattered that he had come to my slide talk during the symposium, but he couldn't have been more friendly and engaging.

His talent is unsurpassed, his work a defining beacon in the world of glass. But his human warmth was palpable, infectious. What a man.

- Colin Reid
February 2012

**Still Life with Books R1650** - 2012
25 x 17 x 6" plus slate base
kiln cast optical glass by lost wax technique, ground and polished

# Richard Ritter

As luck would have it, I grew up in rural Michigan, attended a great art school (now the College for Creative Studies) and fell in love with glassblowing. Several forces present in my home state in the early 1970s helped to give the studio glass movement momentum.

Most important were the artists that gave life to glass art and the galleries that showcased the best work each year; most notably among these was the Habatat Galleries. Ferd Hampson and his extended family became a driving force in the promotion of our medium. More than any other gallery, they focused early on education, established connections with museums, and published catalogs and books that today provide a stunning annual record of the history of studio glass.

Detroit's proximity to Toledo and the support that arts schools and museums in the Midwest gave by including hot glass programs in their curriculum and studio glass in their collections and exhibitions contributed greatly to the movement. In addition, an educated compassionate collector base bought faithfully for decades. My hat is off to everyone who played a part in the past 50 years..... I have been honored to share this journey with them.

- Richard Ritter

**The Fruit's Quadrille III**  - 2011
12.5 x 12.5 x 7"
hot sculpted glass with murrini on etched base

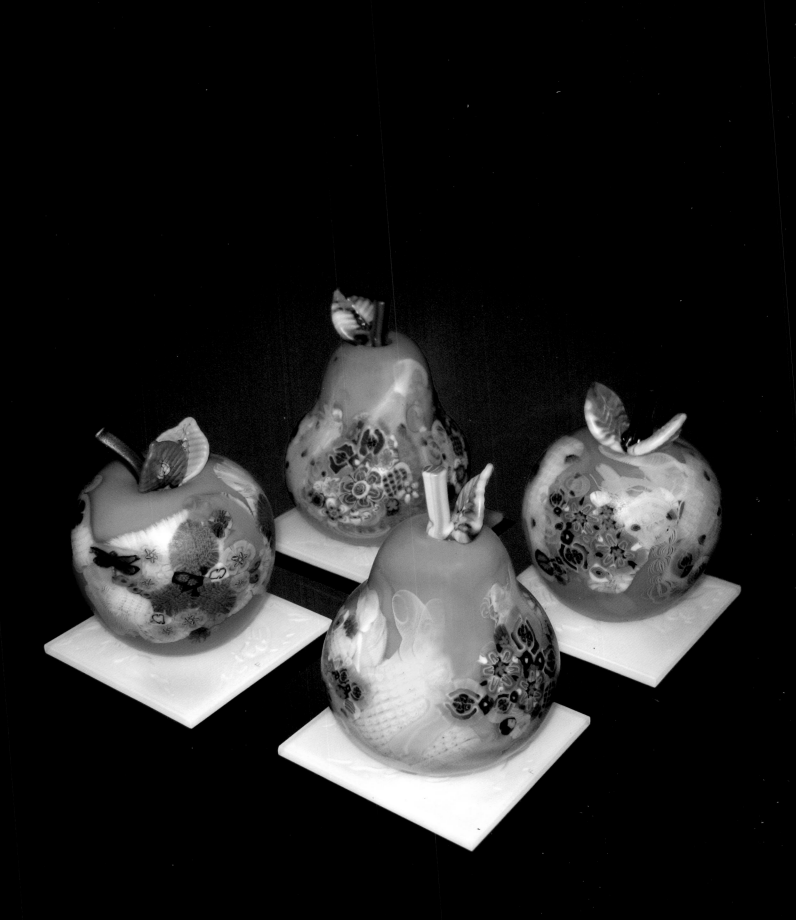

# Marlene Rose

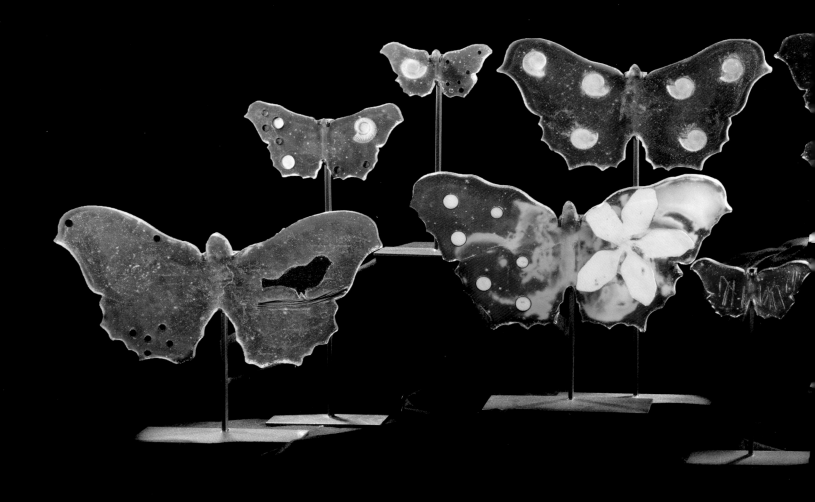

Habatat became my family and my gallery a number of years ago, and I was honored to be almost immediately invited to the Invitational. I attended regularly but one year had to miss it because, well, I was giving birth. I had been in the studio up to a few days before so I could not understand the fuss when the airlines refused to fly me...

Anyway, with me away and in labor, Habatat sold more of my work than they ever had before! The solution, obviously, was to have more children...! My girls and I and my husband are very proud to have Habatat and everyone there as part of our extended family.

Here's to the next 50 years!!! Let's make more glass!!!

- Marlene Rose

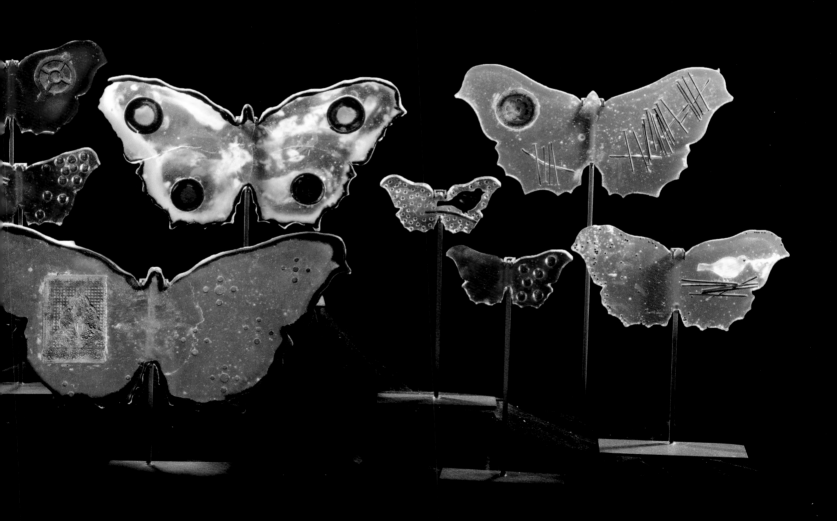

**Butterflies** - 2010-2012
14-34 x 10-32 x 5-7"  Various
sandcast glass
Photo: David Monroe

149

# Martin Rosol

I found artistic freedom in the United states which I did not have back in communist Czechoslovakia. Galleries like Habatat which believe in my work help me to my successful career.

I wish The Habatat Galleries happy 40th Anniversary and lot of successful years to come...

- Martin Rosol

**Nauticos (blue)** - 2011
17 x 17 x 4.5"
optical glass, cut polished and laminated by colored Hxtal epoxy

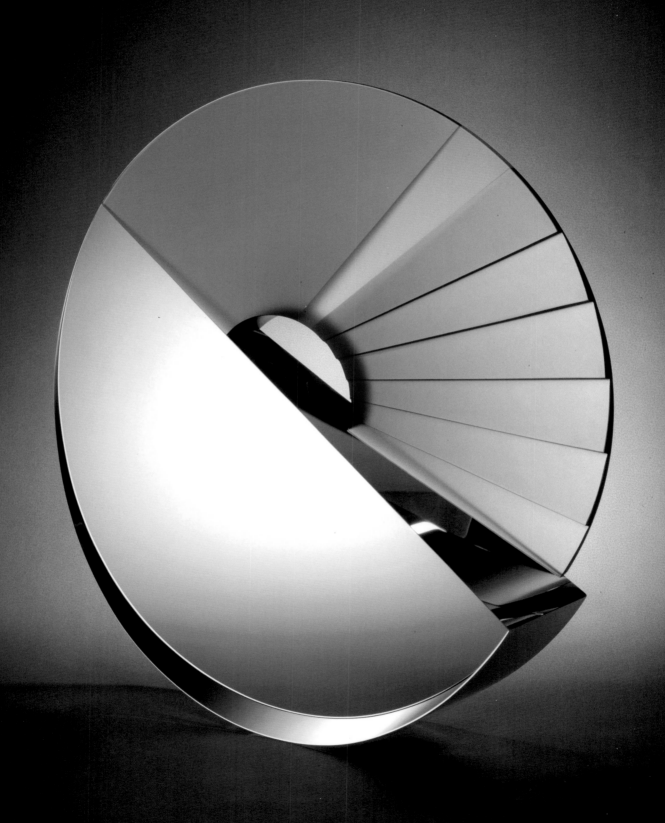

# Kari Russell-Pool

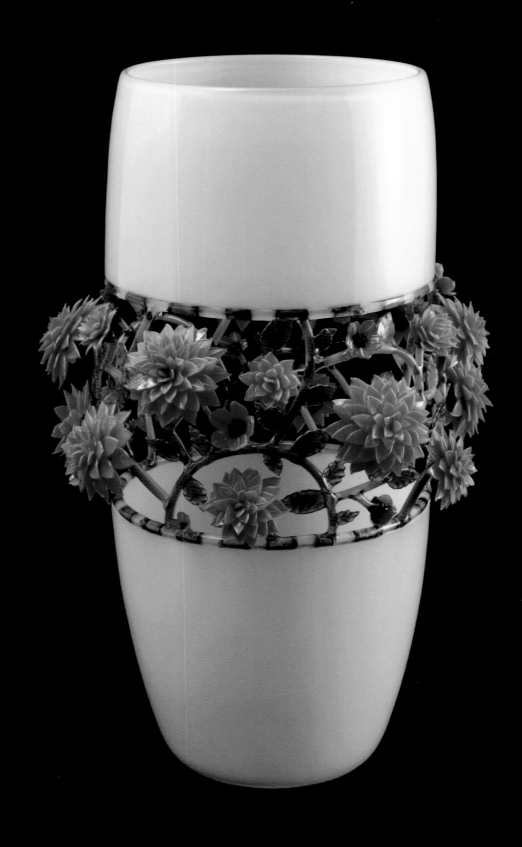

The Tacoma Series stems from my residency at the Tacoma
Museum of Glass when I had the opportunity to tour the
Metro Park Trial Dahlia Garden. Early in the process of
developing the series, I had an epic oven failure. My first piece
in the series was literally melted flat. As I joked that I should
name it "Killing Frost," I had to reluctantly admit that there
was something vexingly lifelike about the failure. I've tried
to incorporate some of the success of that failure in the work
moving forward. While I've not been working for 40 years,
I've been working long enough to know you need to be open
to the surprises and curve balls that glass will always throw
your way.

- Kari Russell-Pool

**Ivory Tacoma Series with Red Dahlias** - 2012
17 x 11 x 11"
blown and flame-worked glass

# Davide Salvadore

When Davide was in his youth his mother had an elaborate bead and jewelry business with many employees that kept her busy and allowed him to spend time with his grandfather visiting glass studios in Murano.

Davide's grandfather was an innovative furnace builder and was well known in Murano. He had a high demand for his services since he would use his experience and ingenuity to build and maintain elaborate furnaces that would fit the desires of his many clients. Davide would travel with his grandfather all day visiting all kinds of studios and see the different processes and productions that each studio had to offer. This was a rare occurrence since most of the glass workers at the time were only were able to see and work in a few studios their whole career.

Davide kept this pattern, of visiting multiple studios, going in his 20s as the demand for glass workers increased at the time. He would pick up work in a studio for awhile to make the funds he needed and then, after a break, would pick up work at a different studio. He would train and learn what the studio had to offer while employed and store the information away for the day he would open his own.

Davide was in the military for two years and after his release he continued in his glass work and opened his own studio. Using what he had learned, and having the same innovative spirit like his grandfather, Davide designed and built most of his own equipment and developed some of the most amazing glass processes in the world. It is something you have to see to believe.

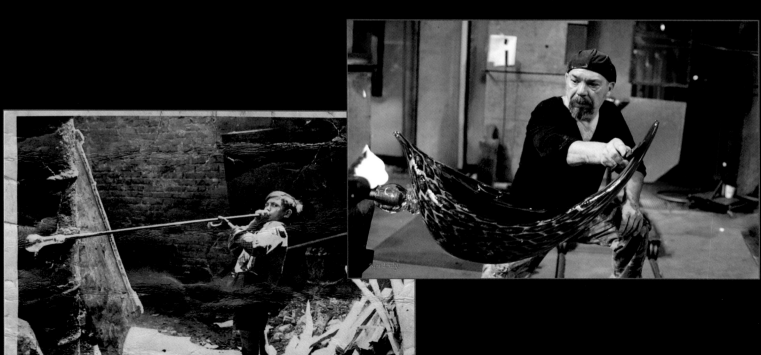

**CoCoe Grande** - 2011
30 x 10 x 16"
blown and carved glass
Photo: Douglas Schaible

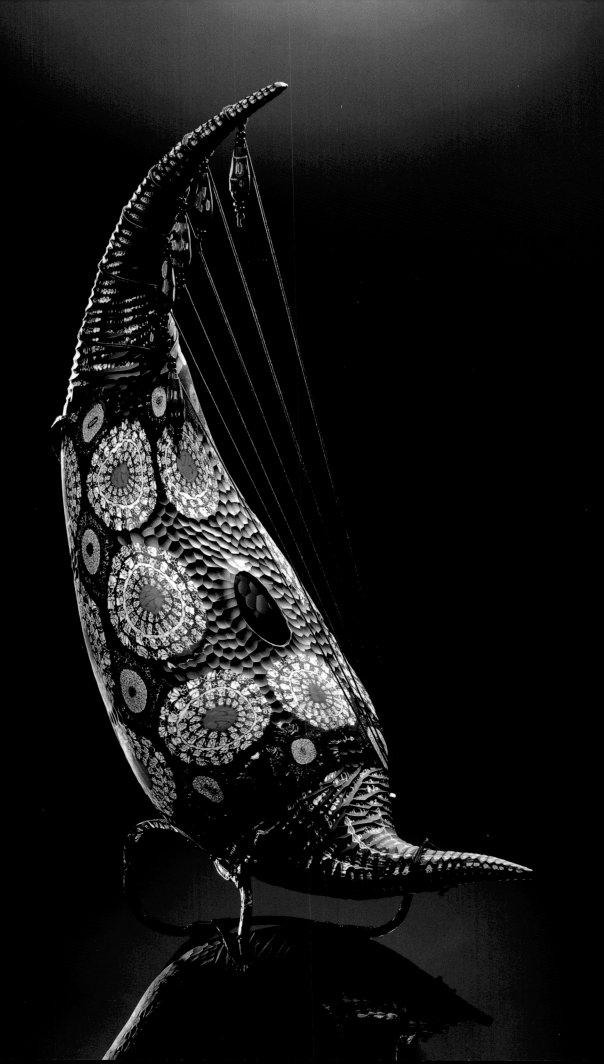

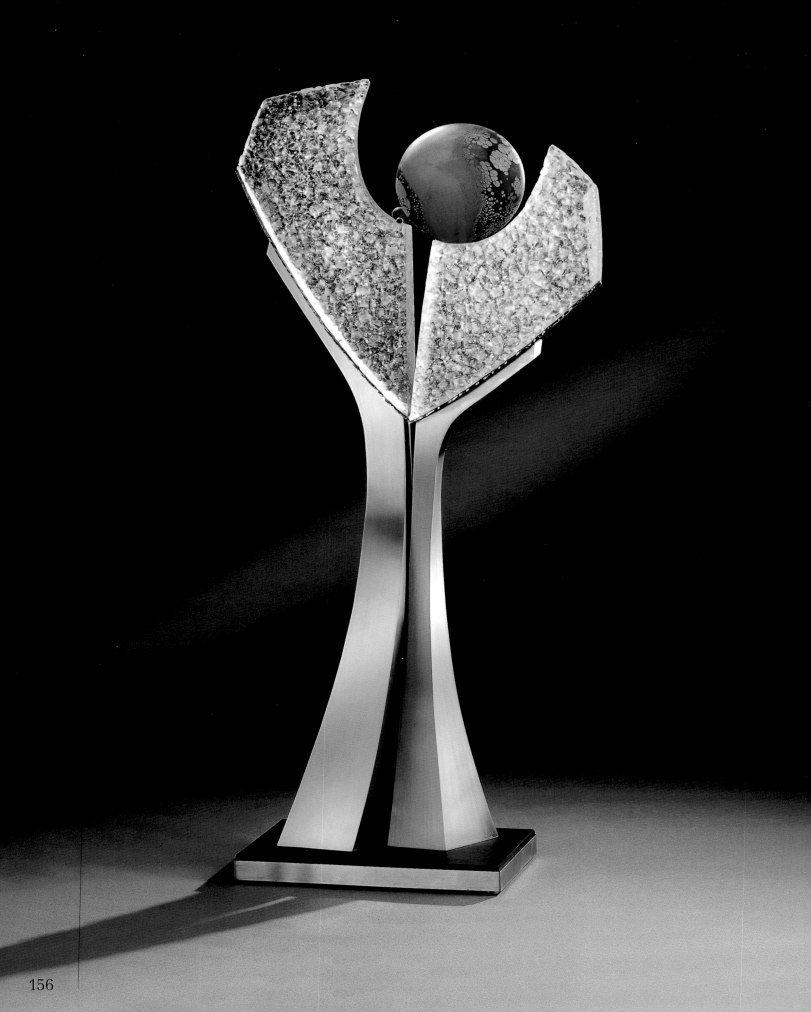

I walked into the Habatat gallery at their first location on Telegraph Road in Dearborn, Michigan in the mid 70's with three or four pieces and wondered if this is where I wanted to be. Did these people know anything about glass? I remember part of the gallery was devoted to a frame shop but in another area was a wall of blown glass pieces. I don't remember just who's work I was looking at. Could be there were some Dick Marquis pieces, a Ritter or two; maybe even a Herb Babcock, but no sculpture. At least sculpture as I defined it. People were making paper weights and other non-hollow pieces and calling them sculpture which I had a hard time relating to. But remember, glass was in its infancy and many artists were wrestling with the whole "is it art or craft" issue. The identity as an artist was a loftier label than that of a craftsman to some and a great deal of time and energy was wasted on the discussion. Good work is good work. Craftsmanship however, is another matter.

The long and short of it for me was that I was trying some new things with glass, combining rigid stainless steel forms with heavy tinted beveled panels of plate glass and these guys were interested in the work. Thus began a long fruitful relationship with Ferd Hampson and his staff. After all these years going to a Habatat opening in Detroit, the Berkshires or Florida is almost like going to a family get together. Maybe better.

Thanks to all you at Habatat.

- JACK A. SCHMIDT

**101** - 2011
57 x 27 x 11"
cast and blown glass with bronze
Photo: Doug Schaible

I started showing with Ferd, Linda, Carol, and Tom, in 1977 when it was the four of them together. It was a funky little gallery in the middle of nowhere. It was unlike any gallery I had experienced.

What they lacked then, in gallery aplomb, they made up for with sheer enthusiasm. It was all four of them emoting passion and eagerness for a new material--glass--that completely captivated me.

Then I introduced Ferd saying he was from the Halibut Gallery--English not being my first language--I didn't realized I made a mistake. I remember how Ferd took that and 'ran' with it, cracking one good joke after the other. It was then, that I decided that I wanted to show only with galleries that made me laugh--and that promise was fulfilled over and over again with Habatat--while Ferd turned the gallery into the première glass gallery worldwide.

- Mary Shaffer

**Wall Wave #529981** - 1999
73 x 18 x 31"
slumped glass
Photo: Doug Schaible

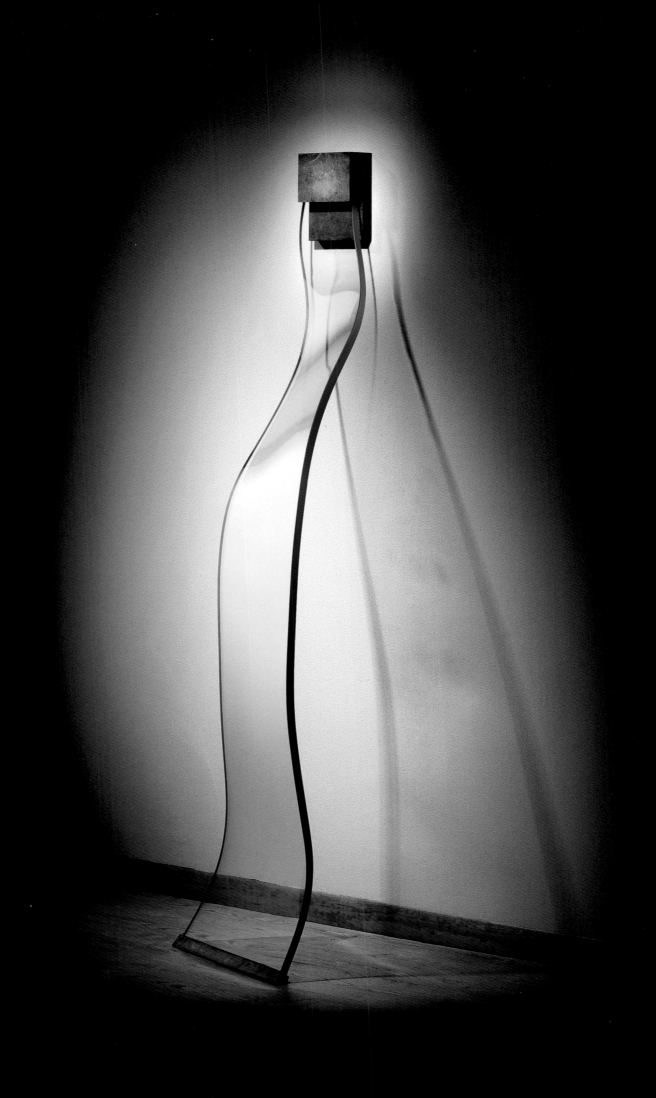

# Paul Stankard

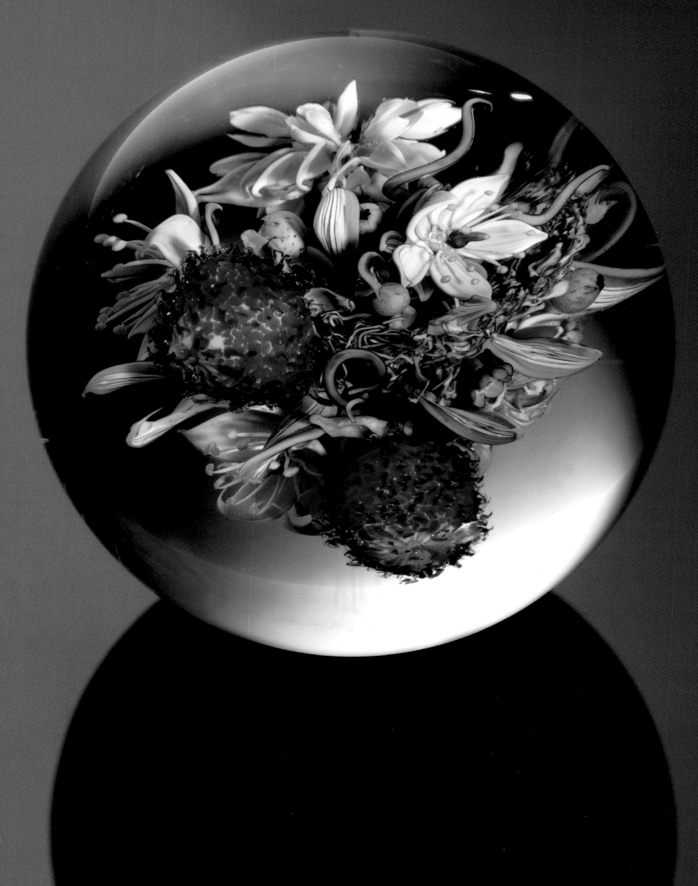

My first gallery exhibition was held at Habatat Gallery -
Michigan in 1977 as part of a contemporary paperweight
survey featuring over 150 artists. The exhibit went well, and
Ferd invited me to have a one person show the following year.
This expanded my exposure beyond paperweight collectors
to glass enthusiasts, which, looking back was a significant
development in my career.

- Paul Stankard

**Bouquet with Prickly Fruit** - 2011
D: 4.0 inches
flame worked glass
Photo: Ron Farina

# Therman Statom

Ferd is one of my favorite people. Most people think art dealers are a form of the devil, and they can be, but he has taken my best and my worst, and has remained steady throughout.

- Therman Statom

I once did an educational workshop in Mozambique scheduled for thirty five kids. When I arrived only six kids had shown up and then quickly ran off only to return with over three hundred friends.  I know this because we counted up to two hundred and seventy five and then gave up.  None of these kids spoke English and we had only four pints of paint, thrifty five pieces of paper and thirty five pencils - nothing stopped these kids.  We made paint, brushes, and artwork and danced for two days.

**Trellis/Four Colors** - 2008
59.5 x 32 x 8.5"
painted and assembled glass

# Ethan Stern

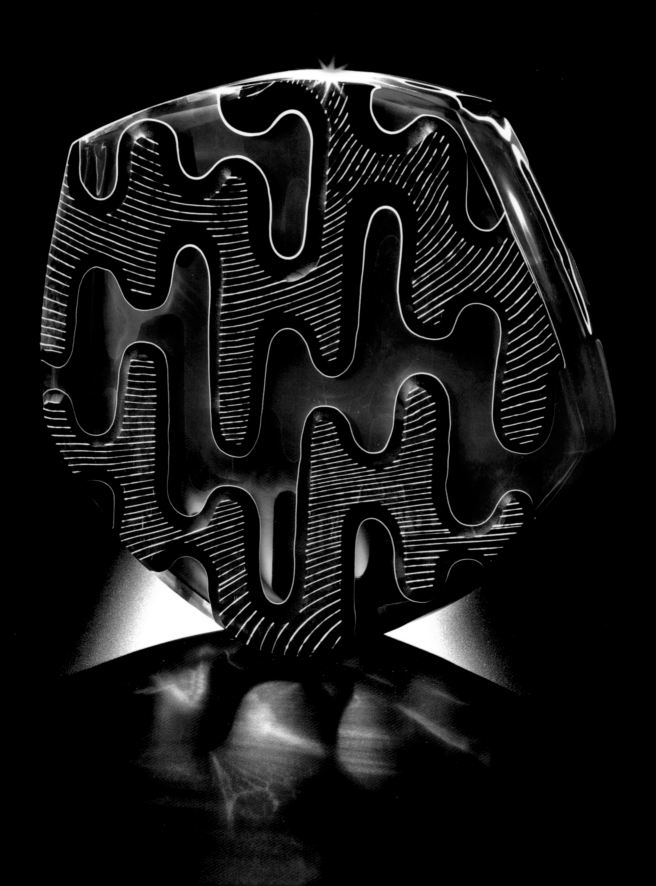

## Why Glass?

Though this is my first experience with Habatat Galleries, I feel a kinship to people that have a profound love of glass. There is something about the history of the material and its journey into the hands of creative people that only glass lovers really understand.  The 50th anniversary of the studio glass movement and the 40th anniversary of the Habatat Invitational this year has me thinking about my place in this short history, and how I can contribute to its future. It seems more important now than ever before for artists, patrons, curators, galleries, and students to be educated about the past while working towards a sustainable future.

I started making art at a young age, and like many of my predecessors were first drawn to ceramics, in which I earned a BFA from Alfred University. I was introduced to various sculptural materials during my studies, and it was at Alfred that my interest in glass was piqued. My education in glass has been furthered by my involvement with Pilchuck Glass School, where I have acted as a staff member, a student and a teacher for the past twelve years.

Initially, my interest in glass grew from the natural collaboration and teamwork required to blow glass. My ceramic work, which was mostly functional, lacked a certain intensity that the objects born from the roar of the glass furnace could provide. From my very first gather I felt something that I knew had been felt before - the rush of 2,000 years of history combined with a sense of being on the edge of innovation. Through all this fervor I soon realized that unlike the surface of wet clay, glass couldn't be manipulated by the swipe of a finger or the touch of a palm. My investigation of surface and texture and the need to leave evidence of my own hand in the process led to cutting and engraving the glass after it had cooled, as a direct way to alter the material. The mark left by each pass of the cutting wheel becomes a fingerprint, carrying information like the stroke of a paintbrush or the pressure of a finger.

Glass as a sculptural medium is relatively young, and many artists have experienced the transition from ceramics. People like Harvey Littleton and Dale Chihuly started in clay and eventually found their voice in glass. Their initial experimenting in the 1960's paved the way for glass to move from the factory into the artist's studio, pushing the confines of the designer/maker system.

The studio glass movement has given the individual the opportunity to be free and boundless with the material; the creative floodgates have been opened for future generations to use glass to materialize new conceptual ideas, while traditional techniques can continue to inform their work. Through experimentation, collaboration and education glass can remain a vital sculptural medium.

- Ethan Stern

**Inky Algae** - 2011
16 x 15 x 3"
blown and engraved glass

# April Surgent

The transformation of a photograph into a relief engraving
on glass takes a passing moment and makes it permanent in
a way that reminds us of a dream or distant memory. The
long and meticulous work of carving through layers of glass
to reveal an image brings me intimately close to the subject
and the initial moment caught through the camera lens.
Ultimately, I am making records of our time.

- April Surgent

**Market Rest Court** (above) - 2012
17 x 21.75 x 1.75"
cameo engraved glass

**Public Market** (right) - 2012
14.5 x 20 x 1.75"
cameo engraved glass

Photos: Spike Mafford

One of the big moments that I can identify that gave me my "big break" is when I showed my work many years ago at the Smithsonian Craft Show.

The juror that year was Michael Monroe, former chief curator at the Smithsonian's Renwick Gallery. During that time he also gave a talk at the Smithsonian on the basics of how to collect to a large audience of established and would be collectors.

During the talk he projected an image of one of my pieces to the audience. He then said, "When I first saw this piece, I was repulsed. But then I realized that I was looking through the eyes of 1985, but in the 21st century, this is the future of glass. This is what you should be collecting".

Not only did I sell out my booth that weekend, but got picked up by a major glass gallery at the same time. All in all...a good day. :)

- Tim Tate

**Man With No Heart (But Still With A Burning Desire)** - 2011
16 x 8 x 8"
blown and cast glass, found objects, electronics, video
Photo: anythingphoto.net

# Michael Taylor

For a number of years, my work has been about geometry, mathematics and optics, the symbols in my work focusing on the actual language of science which is mathematics.

As I delve into the future possibilities in various scientific arenas, my exploration is enhanced with a fascination of theoretical physics and its future accomplishments in areas of computer intelligence, antimatter, invisibility, immunology, and parallel dimensions.

I try and look at these new horizons from the perspective of my grandfather when he first saw an automobile. I can envision and relate to his feelings the moment the new invention rattled over the hills of his farm, his disbelief turning to astonishment at the sight of the "impossible".

My interest in scientific topics leads me to question the social consciousness of my work. How does it make an impact or what influence does it speak to other than historical design and modernist sculpture? How does my work address contemporary social consciousness?

My work uses visual symbols, materials, and abstract narrative information that speaks of contemporary thought, without becoming blatantly obvious.

My intension with these visuals is to bring attention to the ethics of theoretical scientific research, both good and bad. One can assume much of scientific development is about utopian altruistic goals rather than militarist ones, however reality can emerge in the opposite direction. For example, the discovery of Radium by Marie Curie in the early 1900's had a progressive vision for a beneficial source of energy. HG Wells' novel, The World Set Free predicted the eventual outcome of this research, years before the actuality of Hiroshima & Nagasaki. This theoretical scientific discovery changed humanity for all time.

- Michael Taylor, 2012

**Twist Radius** - 2012
32 x 34 x 24"
machined laminated optical glasses
Photo: Brian Sprouse

# Margit Toth

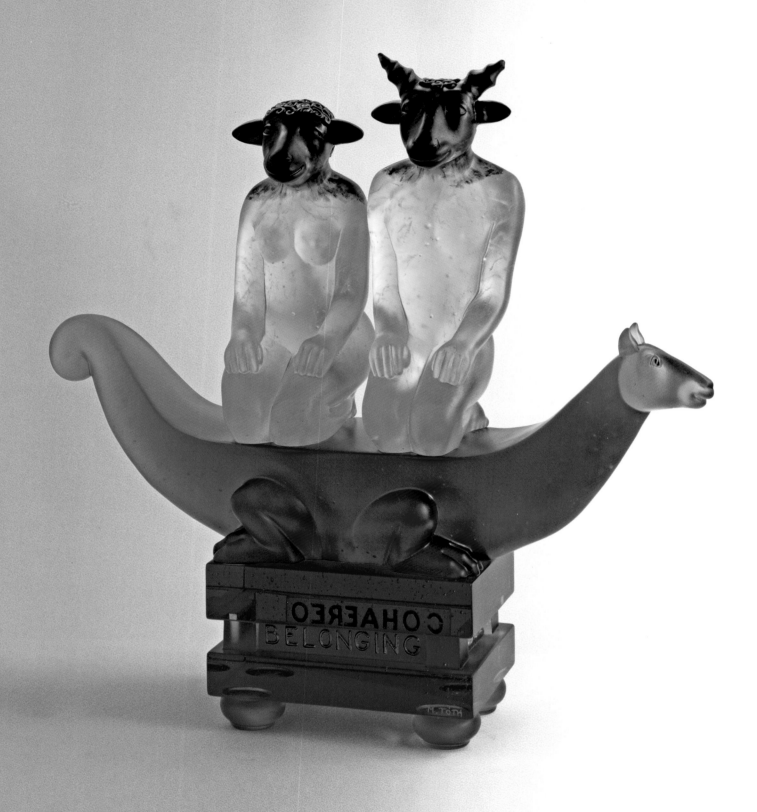

Human existence is a continuous struggle against erosion,
while trying to create objects that will eternally survive.
Actually, the kinds of objects that seem to master erosion
have been born throughout history but their endurance
remains a mystery.

- Margit Toth

**"Cohaereo" Belonging** - 2012
21.5 x 20.25 x 7"
pate de verre

# Brian Usher

**From there to here: My journey to glass – Brian Usher**

All of us in some manner stand on the shoulders of the people that have come before us. It may be the learning of accumulated knowledge, or a single seminal moment that changes our perceptions forever. Either way we are indebted to our past and our pasts past.

Continuum. I like this word. It gives me a sense of place. I liken this notion to being among a labyrinth of dominoes; one that from within you can neither see the beginning nor the end; just the endless sound of dominoes nudging the next one onward echoing around us. Most times we are knocked forward. Other times, perhaps ones of great inspiration, we are knocked off center, thus creating a new line, a new direction.

I like to think of my place in the continuum. Of those that have come before me and of those that might come after.

When I applied to The Royal College of Art my portfolio was a ceramic one. I was accepted into the Masters program with the full intention of doing installation pieces. It was while there that my glass odyssey began.

Angela Thwaites was a part of a international research project looking into refractory mould making. One day she announces that she is going to be making a trip to Prague to meet and interview many of the Czech glass artists and wants to know if anyone would like to come along. I said yes. I cannot remember all the names but if you make a list of who's who in Czech glass, we met with them. One afternoon we meet up with Ivana Sramkova and Angela says that we are going to see an exhibition by Jaroslava Brychtova and Stanislav Libensky. I did not know who they were. It was a retrospective at the Karolium. I met them both, met their work and was changed forever.

I went back to the RCA and informed Martin Smith that I was no longer going to do clay and that, in fact, I was switching to glass. He said, "Impossible, there is not enough time for you to learn what you need to learn". But I had seen what was possible and had met the people who would help me realize my vision. I showed the drawings of what was to be my first casting, along with mould design, and firing schedule to Martin. Another teacher said it was to big, the risk was to high and most likely it would not work. I asked Martin if he knew who Libensky and Brychtova were and he looked at me in that way only an English professor could and said nothing. Which of course meant please do not insult me with stupid questions. Well he of course knew who they were, so when I told him that Zdenek Lhotsky and Angela had come up with my plan, and that in fact Zdenek had realized many of Libensky and Brychtova's works, he said yes. My journey into the world of glass had begun.

There are many people in my continuum whose energies and faith in me have brought me to this place. People whose knowledge and passion I have tried to build upon. I can draw a straight line from Angela through Zdenek ,Gemma, Zafar, Scott and Amy, Konrad and Suzanne, Dennis and Barbara, Corey and finally Ferd. Habatat Gallery, THE International, 40 years and counting, a labyrinynth, a continuum..........

So here I am standing upon the shoulders of giants, looking to the future, and hoping, like them, to be a part of the foundation of someone else's journey. To be THAT domino for the next person who just needs to say yes.

**LISSIL XV** - 2012
17 x 35 x 3.75"
cast glass

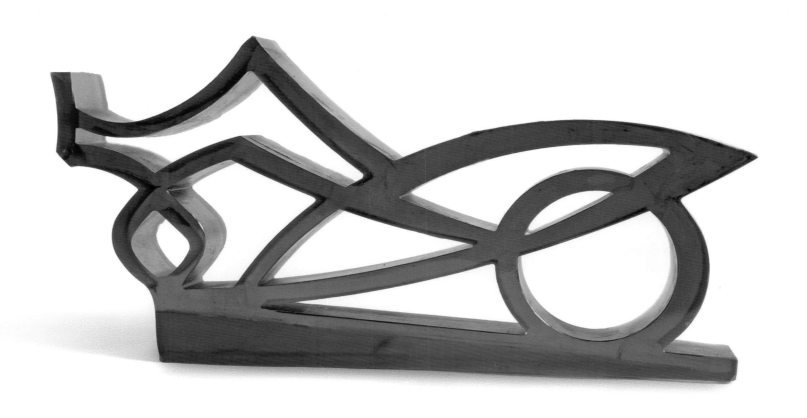

# Bertil Vallien

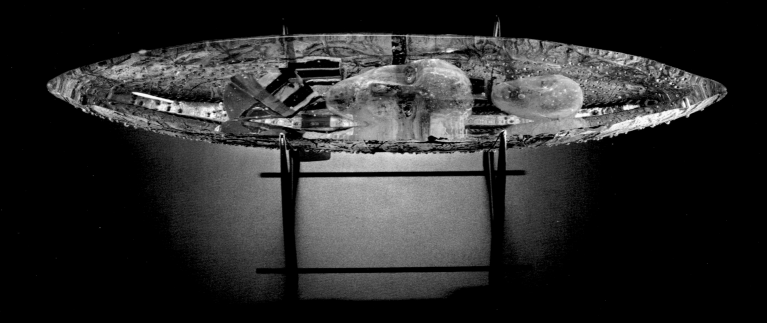

I do remember how happy I was when Ferd visited Pilchuck 1980. It was my first visit (I was young then). He picked out 3-4 of my works which were carved colorful bowls. Probably my first representation at a US gallery with USA made pieces.

After that I picked mushrooms with Ferd's sister Linda in Sweden. She was a marvel to find chanterelles, so I traded mushrooms for a piece of glass with her.

They are good pickers those siblings.

All the best

- Bertil

**Precious Cargo** (detail above) - 2011
9 x 24 x 4"
sandcast glass
Photo: Russell Johnson

# Janusz Walentynowicz

**Humble beginnings.**

In the summer of 1982, I had completed my studies at the school of applied Arts in Copenhagen, Denmark, and was working at Finn Lynggaard's Studio in Ebeltoft. That summer, Joel Myers came to visit Finn, and eventually offered me the opportunity to come study under him at Illinois State University, in Normal, IL.
A week or so before the start of the semester, I arrived in Bloomington, IL and met some of the other graduate students.
Coming fresh from a the school in Copenhagen, with state of the art equipment, such as computerized kilns, etc., my expectations for the program at ISU were extremely high, since the USA , after all, was "the land of technology".

A couple of days passed, and finally, I was to be introduced to the glass studio.
I was led to the ISU campus, then off campus, eventually to end up at a shed with GLASS written on the roof, in bold white letters on a red background.
All around the shed were scattered and, more or less, disintegrated cardboard barrels with glass cullet, and a good number of various other items that made the place take on an appearance of a junk yard, rather than that of a university glass program.
Let me just end the description by saying that the inside of this, former golf cart repair shed, did not, in my eyes, improve the overall impression.
Horrified, I learned, that this was indeed no practical joke played on me by the graduates; this was indeed the ISU glass program.

I was ready to turn on my heel and catch the next flight home, but ended up staying and getting in to working.

Today, I consider myself lucky; that this is where chance had placed me.
The program out of this "golf cart repair shed" (later to move to the chicken coop), gave its students the aesthetic tools for their work, and also the practical tools to both build and maintain a glass studio, It encouraged students to think out of the box, and forced them to be inventive in a way that a "have-all" program could not duplicate.
Should I have to make the choice today, I would most certainly again choose - "the Shed".

Thank you Joel.

**Blue Garden** - 2011
26 x 45"
reverse painting on cast glass, welded steel
Photo: Janusz Walentynowicz

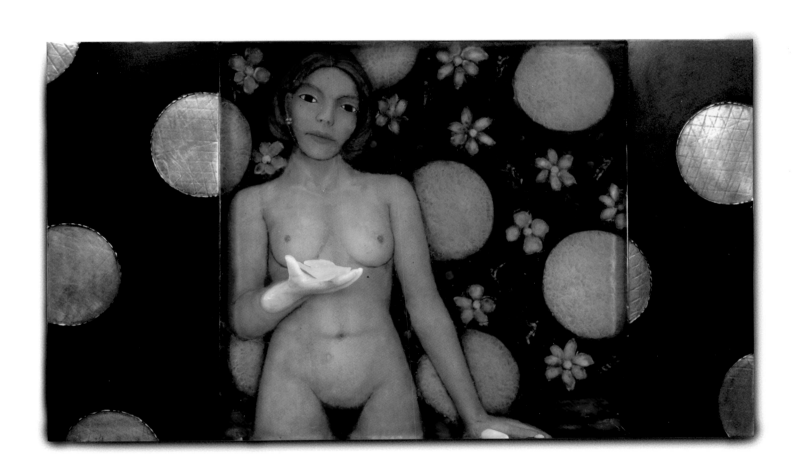

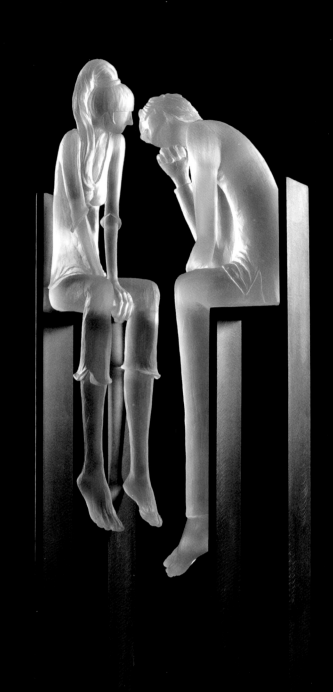

I'd have to say that some of my fondest memories over the years with Ferd have involved cars. Whether it's bouncing around in a jeep in the jungles of Mexico or a Pontiac parking lot, it's never dull. Many a night I've wandered parking lots with Ferd looking for his car. Naturally I would have assumed that Ferd, being a Detroit native, had a more sensitive connection to his cars. Following Ferd home, "the shortcut way" gave me a wonderful tour of the entire Birmingham suburb - beautiful tree lined streets, lots of turns, lovely houses.

Modern technology will work wonders in concert with Ferd's natural homing instincts. I envision his GPS "Emilin" in his car, calling "Siri" on his smart phone and the 2 of them giving him step - by - step instructions back to his car. Of course, "Siri" would have reminded him to pick up his briefcase off of the sidewalk (I had to do that in Chicago).

This little threesome may not be the menage a trois he's always dreamed of, but he'll get home safely.

- Leah Wingfield

For Ferd...

"It is one of the benefits of an old friend, that you can afford to be stupid with him." - Ralph Waldo Emerson

- Steven Clements

**Conversations... #15** - 2012
45 x 19 x 10"
cast glass and steel
Photo: Robert Jaffe

clarify things for myself.

I feel as a human being OUT of TIME. The notion of `Self`, and hence identity, grips me, disturbs me and motivates me. Everything comes from that. My interest in the `Self` includes the Others and is guided by constantly developing inner insights. The insights can be very unclear but can still be the inspiration behind a work.

I am testing out old questions of identity: be it inside-outside, symmetry, layers and core, number two and the double, the goat and the monkey. . Moments of recognition are what my work needs, that propels me forwards. Collected moments of clarity become knowledge. I think that´s good.

In the early eighties. I think it was 1984. I had my first exhibition with the Habatats. Since then Habatat Galleries has been exhibiting my work and has had a big part in promoting my career.

Ferdinand's enthusiasm combined with his engagement in the art glass business allowed me to go on and work in new scales. Thank you so much Ferdinand.

And thanks to all of you at Habatats around Ferd.

- Ann Wolff

**Performance** - 2010
26 x 33.5 x 9.1"
cast glass

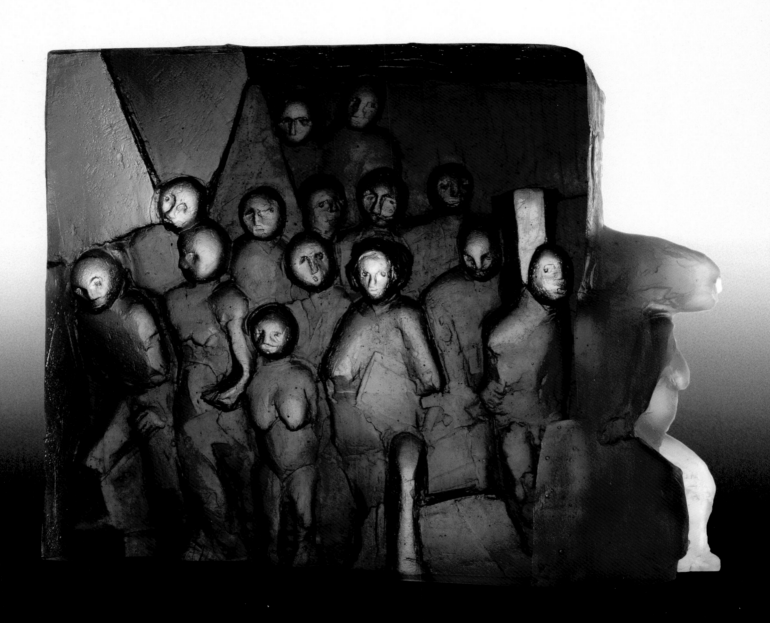

# John Wood

## The Meaning of "Winning" a Habatat Lottery

Most lotteries work on the simple premise that you buy a ticket, get lucky, and then the lottery pays. You Win; They Pay! Simple! You typically don't win very often (or more realistically not at all), but if you do win, you collect vast multiples of the dollar amount you initially "invested".

At Habatat they have a slightly different lottery concept.

Here is my story about "winning" the Habatat lottery:

In 2000 we were on one of Habatat's international geo-glass tours to Prague in the Czech Republic visiting the Libenskys. This was when Prof. Libensky was still alive and producing some of his most significant work.

We got to tour the Libensky glass foundry where his work was being cast and polished, and eventually were shown to a room containing 15-20 of his most recent pieces – some maquettes, and some massive columns -- all stunning.

We were informed that, despite the fact that all the pieces on display were already spoken for, up to 5 of the pieces were "available" to us at "very attractive pricing" because he liked Ferd and our group so much. (Apparently he did not like other galleries or groups as much, because they certainly did not get delivery of these pieces!)

Now came the moment of truth. There were 20-30 collectors on the tour, and most if not all were fans of the Libensky's. How could one possibly allocate the available product?

So Ferd came up with the solution: "We will have a lottery!" he said gaily. "Put your credit cards in a hat and we will draw the lucky winners!" So most if not all, including me, dutifully put our credit cards in the hat and hoped for the best.

The first piece was designated and the hat consulted for the drawing "winner". If the winner did not want the piece (foolish choice!) or thought the price excessive, he could take his card back, exit the lottery, and the next credit card "winner" would be drawn. All perfectly fair and reasonable under the circumstances.

But let's examine the result: Essentially what the winner got was the right to transfer a large amount of cash to Habatat (and the Libenskys --admittedly for some great glass). Or simply put: You Win; You Pay, i.e. a Habatat Lottery!

Thus the story of how I won the Habatat Lottery for "T Head" in the Czech Republic in 2000. And I couldn't be happier about it!

- John Wood
Feb 2012
Artist and Collector

## The Ancient One
21.75 x 22 x 3.5"
cast lead crystal, bone, braided cord
Photo: Ann Cady

# Hiroshi Yamano

The first day I visited Habatat, I was amazed so many artists were showing their works.  The gallery was filled with so many beautiful pieces!  It's been 30 years since that time and I still tell people how I felt when first seeing the space.  I was really amazed by it, and still am.

My country Japan has four seasons, which are very distinct. For people in Japan, seasons are very important to enjoy, each one. Spring is the season for cherry blossoms. Summer is the season for water. Fall is the season for red leaves. Winter is the season for white snow. Each season has its own flowers, birds, fishes, foods etc. I so appreciate Japanese seasons, which cause me to reflect on life. When I am taking walks at the forest near my house with my dog, my mind is wandering and has quietness and peace.  This is time I cherish.  I would like to share my precious moments of the time in Japan with others. So, I am creating my new series of works, Scenes of Japan, which I hope everyone can enjoy.

- Hiroshi Yamano

**From East to West "Scene of Japan" #82** - 2012
20 x 13.5 x 13"
blown and hot sculpted glass with leafing and metal

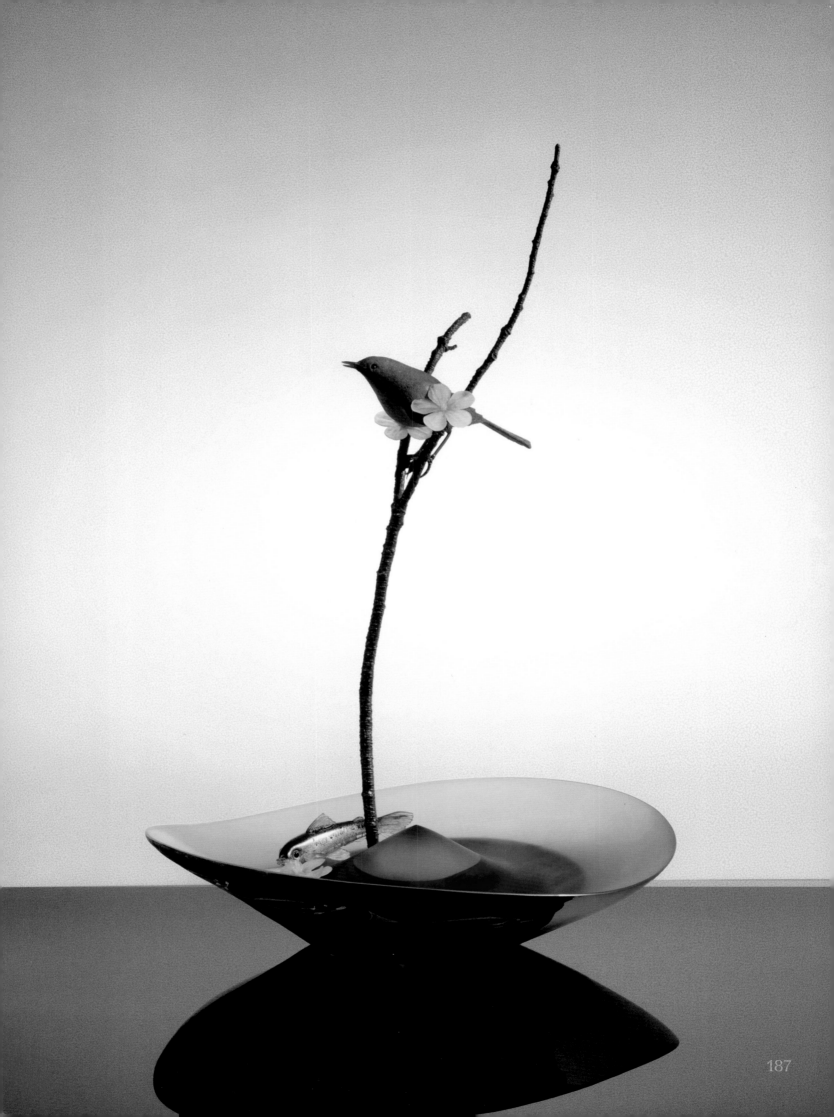

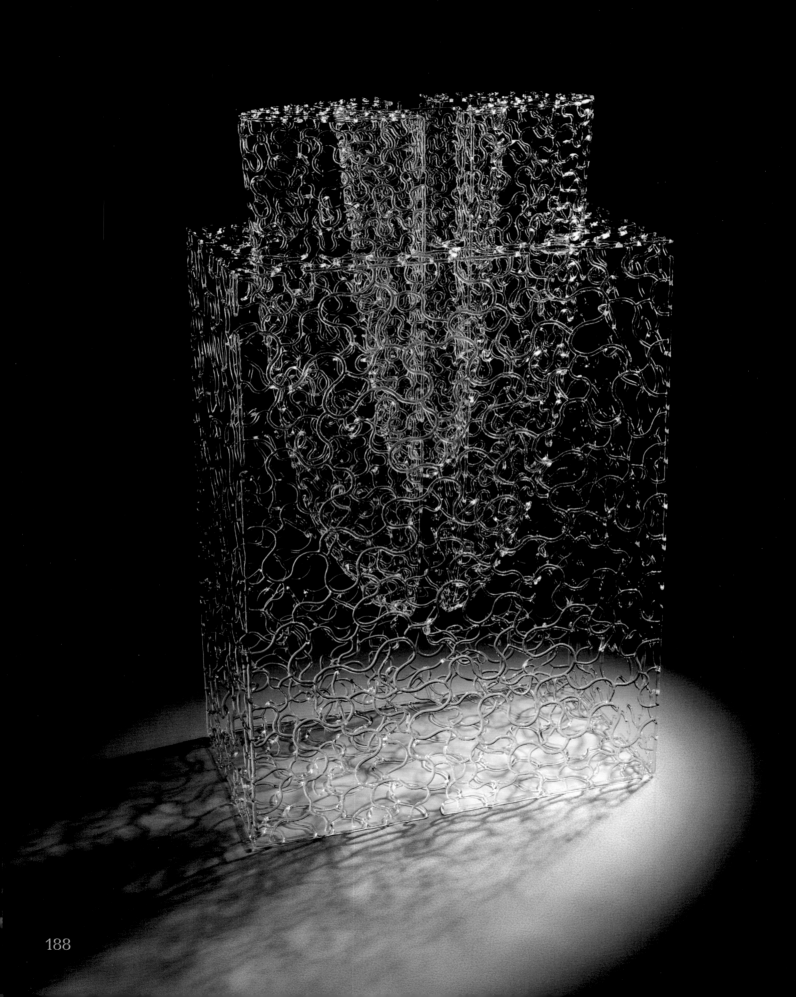

Time and Idioms

While in Japan to begin the glass studios at Aichi University,
near Nagoya, I often engage students about their culture.
One question that I asked was about idioms and that if
there were sayings that were similar in their culture and
ours. For example a "Bird in the Hand... etc." A student
astutely answered that yes, there are similar proverbs but
somehow the meaning may be different. "Can you give me
an example?" I asked. Yes, "A rolling stone gathers no moss".
In America, the "stone" is important; not being tied down,
and free to do what it wants. However in Japan, the "moss" is
important because it takes time to develop a relationship that
is meaningful and lasting.

I mark my career working with glass to the Ann Arbor Street
Art Fair in 1974, just out of graduate school and teaching
at the Cleveland Institute of Art. This is the 40th Annual
Habatat Invitational and the 50th year marking half a Century
of Studio Glass in America. Ferdinand and I met at that show
in '74. Habatat Galleries has encouraged my inquiries and
work in glass from the beginning and it continues to this
day... moss and stones.

- Brent Kee Young,
February 2012.

**Matrix Series: Elliptical Catanoid...Split** - 2010
39 x 22 x 12"
flame worked borosilicate glass
Photo: Dan Fox

# Albert Young

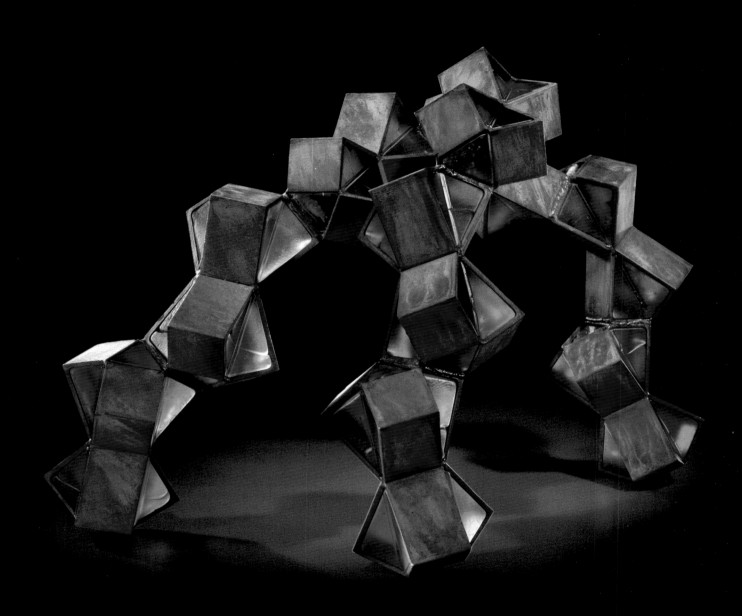

**Kat** (both images) - 2012
18 x 29 x 18"
cast glass and welded steel
Photo: Leslie Patron

Ok here's my story, it was 1986 I think and I was on my way to West Springfield to do the ACE wholesale show (my first and last) and on the way out the door I just happened to grab a bag of rolled dimes. Little did I know then that they would be my salvation.

The show was a bust. I sold absolutely nothing and ended up cashing in the dimes to buy gas to get home. I was crushed because I really liked what I was making and thought the world would as well.

Upon my return I immediately called Ferd to get some advice he said to come on in let's see what you're doing. Well, he loved what I was doing and then made a visit to the studio. Six weeks later I had my first exhibit at Habatat and I've never looked back. Thanks Ferd.

- Albert Young

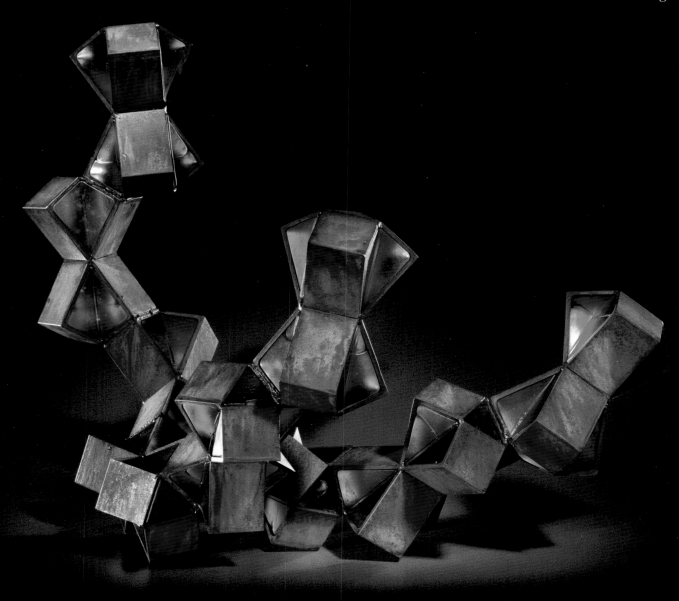

# Udo Zembok

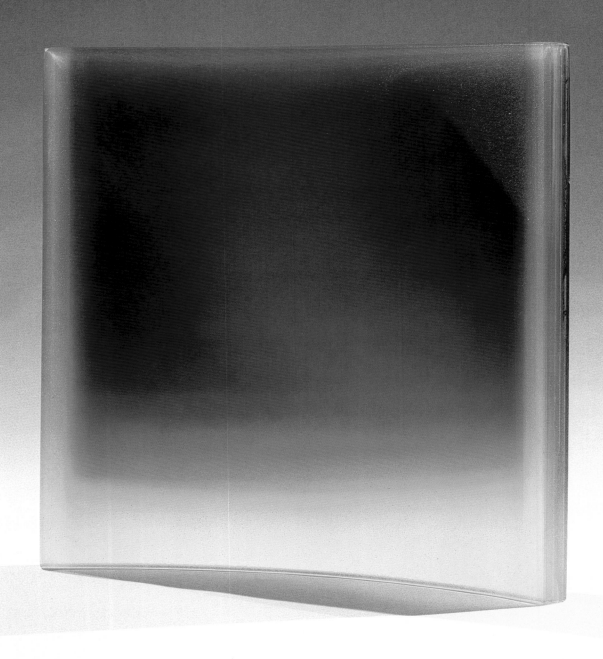

Udo Zembok belongs to that generation of artists between the age of 45 and 65, who I feel are not well represented in the U.S., though he is far from being a newcomer or unknown in France, Germany and other European countries, his work deserves to be presented on an international stage more often.

Udo Zembok's glass monoliths, sometimes brought together as a diptych, are the result of a rigorous and exacting process using industrial float glass as a raw material. Several sheets –here up to eight- are fused and thermoformed, initially giving a simple, minimalist curve that allows these "thick veils" to be self-supporting and the screen to be independent of any structure. This absence of heterogeneous support is vital for achieving an unimpeded perception of the effect of material – light – colour. These diverse colours and textures are distributed at each interface between the plates and thus in the thickness of this new material which, as it is being processed, becomes something other than industrial glass and reclaims the sensual and mythical richness of glass hand-crafted by an artisan. Even though compositions magnifying the horizons often pay homage to the work of Rothko – a homage that is clearly assumed - the perception when seeing the work live (as opposed to photographs) is completely different, particularly with regards to their luminosity and the three dimensional transition between colours. Finally, we have here a special and completely new material with a subtle range of transparent colours and majestic and monumental forms, echoing craftsmanship traditionally associated with stained glass.

Extract: Catalogue Coburg Glass Price 2006
for contemporary glass in Europe

Author: Jean-Luc Olivié
curator Musée des Arts Décoratifs, Paris

**Colorfields 27a** - 2007
24.5 x 24.5 x 4.5"
multi-layer kiln formed glass, inclusion of pigments,
slumped and partly polished

# Toots Zynsky

A BIG thank you to everyone - colleagues, assistants, friends, family, teachers, collectors, galleries, curators, museums, schools, writers and critics around the world who have encouraged, supported, cajoled, criticized, helped in so many ways for all of these years - couldn't have done it without you all (nor would it have been half as much pleasure!)

With much love,

- Toots

**Sorpassare (to pass)** - 2012
10.5 x 18.75 x 9"
filet du verre

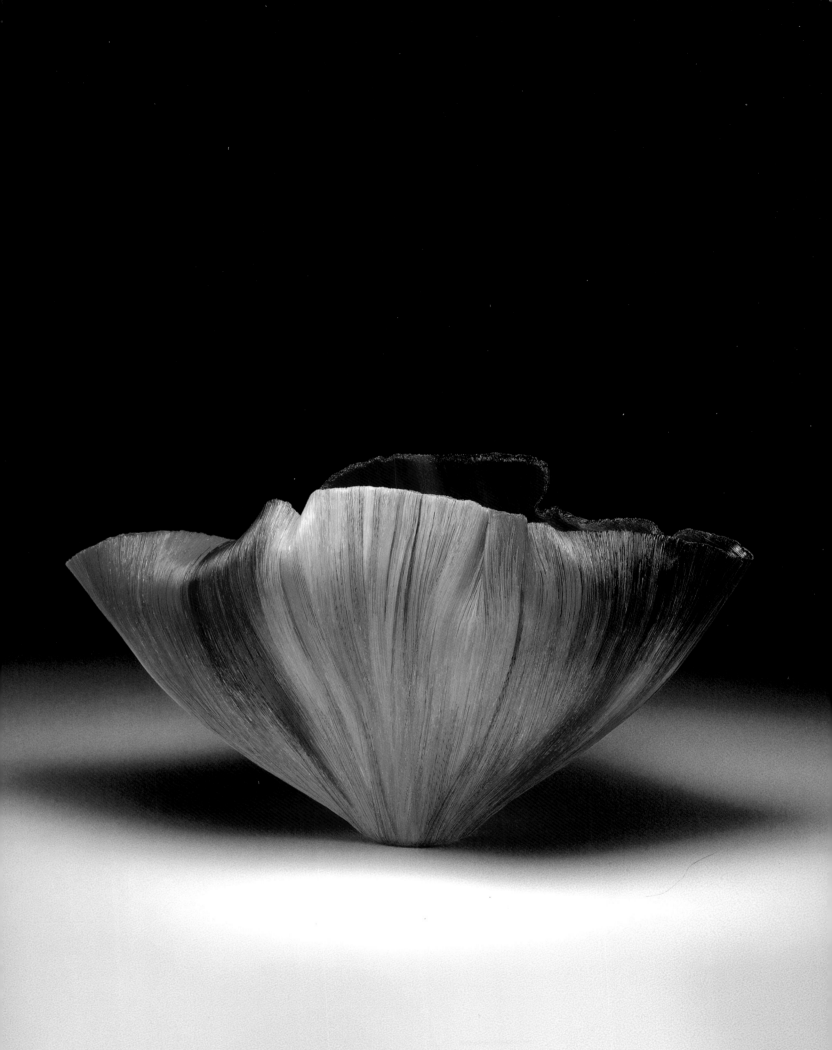

# Résumés

## Rik Allen
Born: Providence, Rhode Island, 1967

Selected Collections:
Museum of Glass, Tacoma, WA
Eugene Roddenberry, Los Angeles, CA
Spark Museum of Electrical Invention,
  Bellingham, WA
Blue Origin Aerospace, Kent, WA
Montgomery Museum of Fine Art,
  Montgomery, AL
Boeing World Headquarters, Chicago, IL
Toyama Institute of Glass, Toyama, Japan
Paul Allen Family Foundation Collection, Seattle, WA
Flying Heritage Collection, Everett, WA

## Shelley Muzylowski Allen
Born:  Manitoba, Canada

Selected Collections and Exhibitions:
Toyama City Institute of Glass Arts,
  Permanent Collection - Toyama, Japan
Solo Exhibition – Traver Gallery, Seattle, WA
SOFA NY – Blue Rain Gallery, NY, NY
"A Natural Order" Solo Glass Sculpture
  Show – William Traver Gallery, Seattle,
  WA
"Effigies in Glass" Collaborative Exhibition
  w/Tammy Garcia – Blue Rain Gallery, Santa Fe, NM
Invitational Exhibition – Nuutajarven Galleria Osuuskunta,
  Nuutajarven, Finland
SOFA NY – Blue Rain Gallery, NY
38th Glass Invitational – Habatat Galleries, MI
37th Glass Invitational – Habatat Galleries, MI
SOFA West – Blue Rain Gallery, Santa Fe, NM
Glass Unexpected – Center for the Living Arts, Mobile, AL

## Herb Babcock
Born:  Bloondale, Ohio, 1946
*36th Int'l Glass Invitational Award Winner*
*34th Int'l Glass Invitational Award Winner*

Selected Collections:
Columbus Museum of Arts, Columbus, OH
The Detroit Institute of Arts, Detroit, MI
Glasmuseum, Ebeltoft, Denmark;
Glasmuseum Frauenau, Frauenau, Germany
Glasmuseum Lobmeyr, Vienna, Austria;
Morris Museum, Morristown, NJ
Museum Fur Kunst und Gewerbem, Hamburg, Germany

## Rick Beck

Selected Collections:
Asheville Art Museum, Asheville, NC
Columbia Museum of Art, Columbia, SC
Fletcher Barnhart, White Corp., Charlotte, NC
Glasmuseum, Ebeltoft, Denmark
Hickory Museum of Art, Hickory, NC
McDonald's Corporate Collection
Mint Museum of Craft and Design,
  Charlotte, NC
Mobile Museum of Art, Mobile, AL
North Carolina State University, Raleigh, NC
Ogden Museum of Southern Art, New Orleans, LA
Wustum Museum of Fine Art, Racine, WI

## Michael Behrens
Born: Dusseldorf, Germany, 1973

Selected Collections:
2010 Uroboros Glass Studios, Portland,
  Oregon, USA
2009 Glass Museum Immenhausen, Germany
2009 Museum Ajeto, IGS Symposium 2009,
  Novy Bor, Czech Republic
2008 Glass Museum Alter Hof Herding,
  Coesfeld, Germany
2008 Museum Kunst Palast, Glass Museum
  Hentrich, Düsseldorf, Germany
2007 Museum of Modern Glass, Öhringen, Germany
2006 Glass Museum Alter Hof Herding, Coesfeld, Germany
2006 Artista-Forum, Grünenplan, Germany

## Robert Bender
Born: New York, New York, 1962

Selected Exhibitions
40th Annual International Glass Invitational
  Awards Exhibition, Habatat Galleries, MI
Glass Invitational 50 Anniversary Studio
  Glass Movement, Blue Spiral, NC
Selected Writings and Illustrations
Lima Beans Would be Illegal: Children's
  Ideas of a Perfect World, Dial Books, 2000
Ribbit Riddles, Dial Books, 2001
Never Eat Anything that Moves: Good, Bad, and Very Silly Advice
  From Kids, Dial, 2002
The Baobab Tree by John Archambault, Childcraft, 2004
The Christmas Witch, Holiday House, 2005
Mail Monkeys, Childcraft, 2006
Polar Bear Pirates, Childcraft, 2008

## Howard Ben Tré
Born: Brooklyn, New York, 1949
*39th Int'l Glass Invitational Award Winner*
*38th Int'l Glass Invitational Award Winner*
*37th Int'l Glass Invitational Award Winner*
*36th Int'l Glass Invitational Award Winner*
*34th Int'l Glass Invitational Award Winner*

Selected Collections:
Corning Museum of Glass, NY
Metropolitan Museum of Art, NY
National Museum of American Art, Washington, DC
Detroit Institute of Arts, MI
High Museum of Art, Atlanta, GA
Hirshhorn Museum and Sculpture Garden, Washington,DC
Hokkaido Museum of Modern Art, Sapporo, Japan
Huntington Museum of Art, WV
Musée d'Art Moderne et d'Art Contemporain, Nice, France
Musée des Arts Décoratifs, Lausanne, Switzerland
Philadelphia Museum of Art. PA
Royal Ontario Museum of Art, Toronto, ON, Canada

## Alex Bernstein
Born: Celo, North Carolina, 1972
*38th Int'l Glass Invitational Award Winner*
*36th Int'l Glass Invitational Award Winner*
*34th Int'l Glass Invitational Award Winner*

Selected Collections:
Philadelphia Museum of Art, PA
Museum of Fine Arts, Boston, MA
Palm Springs Art Museum, CA
Corning Museum of Glass, NY
Glassmuseum Frauenau. Frauenau, Germany
Royal Caribbean – Oasis of the Seas, FL
Deloitte & Touche, Boston, MA
Burchfield-Penny Arts Center, Museum of Western New York Art,
  Buffalo, NY
Wallace Memorial Library, Rochester Institute of Technology, NY
The Dean of Liberal Arts, Rochester Institute of Technology, NY
Mellon Financial Corporation, Harrisburg, VA
Wachovia Financial Group, Greenville, SC
Bascom-Louise Gallery, Highland, NC

## Martin Blank

Born: Sharon, Massachusetts, 1962
*38th Int'l Glass Invitational Award Winner*
*33rd Int'l Glass Invitational Award Winner*

### Selected Collections and Exhibitions:

Naples Museum of Art, Naples, FL
Chazen Museum of Art, Madison, WI
Cantor Arts Center, Stanford University,
    Stanford, CA
Steninge Palace Cultural Center, Sweden
Museum of Glass, Tacoma, WA
Montreal Museum of Fine Arts, QC, Canada
Bergstrom-Mahler Museum, Neenah, WI
New Britain Museum of America Art, CT
Corning Museum of Glass, Corning, NY
Museum of Fine Arts, Boston, MA
Krannert Art Museum, Champaign, IL
Tampa Museum of Art, FL
Honolulu Academy of Art, HI
Shanghai Museum of Fine Art, China
Millennium Museum, Beijing, China
Museum of Contemporary Art, Lake Worth, FL

## Zoltan Bohus

Born: Endrod, Hungary, 1941
*35th Int'l Glass Invitational Award Winner*

### Selected Collections:

Musée du Verre, Sars Poteries, France
Veste Coburg, Germany
Kunstmuseum Düsseldorf, Germany
MUDAC, Lausanne, Switzerland
MAVA, Madrid, Spain
Corning Museum of Glass, NY
Carnegie Museum of Arts, Pittsburgh, PA
Detroit Institute of Arts, MI
Indianapolis Museum of Arts, IN
Kentucky Art and Craft Foundation, KY

## Péter Borkovics

Born:  Salgótarján, Hungary, 1971
*36th Int'l Glass Invitational Award Winner*

### Selected Solo Exhibitions:

2006 "Fres Casting" Glass Pyramid Gallery,
    Budapest
2004 Summary exhibition, Rippl-Rónai
    Museum, Kaposvár
2004 Eventuelle Gallery, Budapest (with
    Kristóf Bihari and Kovács Szabolcs, Gergo
    Kovács)
1995 " Lámpaláz ", Young Artists' club, Budapest
1994 Introductory exhibition, Mátranovák
1994 Introductory exhibition, Bernáth Galéria, Marcali
1994 " On and on", Parti Galéria, Pécs (with István Czebe )

## Stanislaw Jan Borowski

Born: Krosno, Poland, 1981

### Selected Exhibitions:

39th International Glass Invitational, Habatat
    Galleries, MI
Art Palm Beach January 2010, Habatat
    Galleries, MI
Sofa Chicago November 2009, Habatat
    Galleries, MI
Solo Exhibition December 5th 2009, Habatat
    Galleries, MI
38th International Glass Invitational, Habatat Galleries, MI
37th International Glass Invitational, Habatat Galleries, MI
36th International Glass Invitational, Habatat Galleries, MI
35th International Glass Invitational, Habatat Galleries, MI
34th International Glass Invitational, Habatat Galleries, MI
33rd International Glass Invitational, Habatat Galleries, MI
PAN Amsterdam Kunstmesse, Etienne & Van den Doel,
    Expressive Glass Art, Netherlands
Compositions Gallery, San Francisco, CA
International Frankfurt Fair TENDENCE

## Christina Bothwell

Born: New York, New York, 1960

### Selected Collections:

Mobile Museum of Art, Mobile, AL
Tutsek-Stiftung Foundation, Munich, Germany
The Smithsonian Museum of Art's Archives
    of American Art,
Oral History Collection
Fuller Craft Museum, MA
Racine Museum, Racine, WI
Corning Glass Museum, NY
Palm Springs Museum, CA
Lowe Art Museum, FL
Candace Groot Collection, IL

## Latchezar Boyadjiev

Born: Sofia, Bulgaria, 1959
*36th Int'l Glass Invitational Award Winner*
*34th Int'l Glass Invitational Award Winner*
*33nd Int'l Glass Invitational Award Winner*
*32nd Int'l Glass Invitational Award Winner*

### Selected Collections:

De Young Museum, San Francisco, CA
Naples Museum of Art, FL
Museum of Applied Arts, Prague, Czech
    Republic
Glassmuseum, Ebeldorf, Denmark
Glassmuseum der Ernsting, Stiftung, Germany
Museum de Alcorcon, Spain
First Interstate World Trade Center, Los Angeles, CA
The White House, Washington, DC
New Mexico Museum of Art, Santa Fe, NM

## Peter Bremers

Born: Maastricht, The Netherlands. 1957
*38th Int'l Glass Invitational Award Winner*
*37th Int'l Glass Invitational Award Winner*

### Selected Collections:

Den Haag, Gemeentemuseum, Netherlands
National Glassmuseum, Leerdam,
    Netherlands
AON, London, England
Glasmuseum Alter Hof Herding, Coesfeld
    Lette, Germany
Kunstgewerbe Museum, Berlin, Germany
Glasmuseet Ebeltoft, Denmark
Mobile Museum, AL
D.S.M. collection, Delft, Netherlands
Kunst und Gewerbe Museum Hamburg, Germany
Museum Jan van der Togt, Amstelveen, Netherlands
Museo de Arte en Vidrio MAVA, Madrid, Spain
Glasmuseum Alter Hof Herding, Coesfeld Lette, Germany

## Emily Brock

Born: Des Moines, Iowa, 1945
*39th Int'l Glass Invitational Award Winner*
*36th Int'l Glass Invitational Award Winner*

### Selected Collections:

Rockford Art Museum, IL
Bergstrom-Mahler Museum, Neenah, WI
Montreal Museum of Fine Arts, QC, Canada
Franklin Park Conservatory, OH
Patrick and Beatrice Haggerty Museum of
    Art, Marquette University, WI
Hsinchu Cultural Center, Taiwan
Racine Art Museum, WI
Columbus Museum of Art, OH
Detroit Institute of Arts, MI
Albuquerque Museum, NM
Museum of American Glass, Wheaton Village, NJ
University of Iowa Hospitals and Clinics, Iowa City, IA
The Toledo Museum of Art, OH
Shimonoseki City Art Museum, Japan
Hokkaido Museum of Modern Art, Sapporo, Japan
High Museum of Art, Atlanta, GA

# Résumés

### Lucio Bubacco
Born: Murano, Italy, 1957

Selected Collections:
Museum of Arts and Design, New York, NY
Glasmuseum Frauenau, Frauenau, Germany
Atelier du Verre, Sars-Poteries, France
Nagoya Museum, Nagoya, Japan
Museo del Vidrio, Monterrey, Mexico
Niijima Art Center Museum, Niijimamura,
  Tokyo, Japan
Museo del Vetro, Murano, Venezia, Italy
The Corning Museum of Glass, Corning, NY
Venetian Glass Art Museum, Otaru, Japan
National Liberty Museum, Philadelphia, Pennsylvania
J & L Lobmeyr Museum Collection, Vienna, Austria
Museum Boymans Van Beuningen, Rotterdam, The Netherlands
Museum of American Glass, Wheaton Village, Millville, New Jersey
Tampa Museum, Tampa, Florida

### William Carlson
Born: Dover, Ohio, 1950
*35th Int'l Glass Invitational Award Winner*

Selected Collections:
St. Louis Museum of Art, St. Louis, Missouri
Detroit Institute of Art, Detroit, Michigan
Milwaukee Museum, Milwaukee, Wisconsin
Los Angeles County Museum, Los Angeles,
  California
Metropolitan Museum of Art, New York,
  New York
Leigh Yawkey Woodson Art Museum, Wausau, Wisconsin
Columbus Museum of Art, Columbus, Ohio
Kyoto Museum of Modem Art, Kyoto, Japan
Museum of Decorative Arts, Lausanne, Switzerland
Shimonseki Art Museum, Shimonseki City, Japan
Hokkaido Museum of Modem Art, Sapporo, Japan
Corning Museum of Glass, Corning, New York
Royal Ontario Museum, Toronto, Ontario
American Craft Museum, New York City
Yokohoma Museum of Art, Yokohama, Japan

### José Chardiet
*39th Int'l Glass Invitational Award Winner*
*34th Int'l Glass Invitational Award Winner*

Selected Collections:
Museum of Fine Arts, MA
Museum of Arts and Design, NY
Renwick Gallery of the Smithsonian
  American Art Museum, Washington, DC
American Craft Museum, NY
Corning Museum of Glass, NY
Yokohama Museum of Art, Japan
Musée des Arts Décoratifs, Lausanne, Switzerland
High Museum of Art, Atlanta, GA
Detroit Institute of Art, MI
Mint Museum of Art, Charlotte, NC
Asheville Museum of Art, NC
Museum of American Glass, Wheaton Village, NJ
Racine Art Museum, WI
Cincinnati Art Museum, OH
Montreal Museum of Fine Arts, QC, Canada

### Nicole Chesney
Born: New Jersey, 1971

Selected Collections:
Alinda Capital Partners, NY
Australian National University, Canberra,
  Australia
Corning Museum of Glass, NY
Glasmuseum, Ebeltott, Denmark
Mobile Art Museum, AL
MIRVAC Group, Melbourne, Australia
University of Arizona Medical Center, AZ
Palm Springs Art Museum, CA
Pilchuck Glass School, Print Archives. WA
Rhode Island School of Design Museum, Providence, RI
Speed Art Museum, Louisville, KY

### Dale Chihuly
Born: Tacoma, WA, 1941
*32nd Int'l Glass Invitational Award Winner*

Selected Collections:
Carnegie Museum of Art, Carnegie Institute,
  Pittsburgh, PA
Chrysler Museum, Norfolk, VA
Cooper-Hewitt, National Design Museum,
  Smithsonian Institution, New York, NY
Corning Museum of Glass, NY
Glasmuseum, Ebeltoft, Denmark
Haaretz Museum, Tel Aviv, Israel
High Museum of Art, Atlanta, GA
Hokkaido Museum of Modern Art, Hokkaido, Japan
Indianapolis Museum of Art, IN
Metropolitan Museum of Art, New York, NY
Milwaukee Art Museum, WI
Mint Museum of Art, Charlotte, NC
Museum of Fine Arts, Boston, MA
National Gallery of American Art & Renwick Gallery, Smithsonian
  Institution, Washington, DC
Toledo Museum of Art, Toledo, OH
Victoria and Albert Museum, London, England

### Daniel Clayman
Born: Lynn, Massachusetts, 1957
*39th Int'l Glass Invitational Award Winner*
*38th Int'l Glass Invitational Award Winner*
*36th Int'l Glass Invitational Award Winner*
*35th Int'l Glass Invitational Award Winner*
*33rd Int'l Glass Invitational Award Winner*
*32nd Int'l Glass Invitational Award Winner*

Selected Collections:
Renwick Gallery, Smithsonian Institution,
  Washington, DC
Cleveland Museum of Art, OH
Milwaukee Art Museum, WI
Museum of Fine Arts, CA
American Craft Museum, New York, NY
Corning Museum of Glass, Corning, NY
Toledo Museum of Art, OH
Portland Museum of Art, ME
Museum of Art, Rhode Island School of Design, Providence, RI
Charles A. Wustum Museum of Fine Art, WI
Rockford Art Museum, IL
Museum of American Glass, Wheaton, NJ
Museum of Art, Fukui, Japan

## Deanna Clayton

*35th Int'l Glass Invitational Award Winner*
*34th Int'l Glass Invitational Award Winner*
*33rd Int'l Glass Invitational Award Winner*

### Selected Collections and Exhibitions:
Ferro Corporation, Cleveland, OH
Janus Mobile Art Collection Denver, CO
Ritz Carlton, Grand Cayman
The Four Seasons, Doha, Qatar
The Four Seasons, Miami, FL
38th International Glass Invitational, Habatat
    Galleries, MI
SOFA Chicago, Habatat Galleries, MI
37th International Glass Invitational, Habatat Galleries, MI
SOFA Chicago, Habatat Galleries, FL
36th International Glass Invitational, Habatat Galleries, MI

## Keith Clayton

### Selected Collections and Exhibitions:
Invitational Exhibition, Habatat Galleries,
    Royal Oak, MI, 2010
SOFA Chicago, Habatat Galleries, MI
Kaiser Permanente Building Collection,
    Cleveland, OH
Janus Mobile Art Collection, Denver, CO
Invitational Exhibition, Habatat Galleries,
    Royal Oak, MI, 2009
SOFA Chicago, Habatat Galleries, MI
Invitational Exhibition, Habatat Galleries, Royal Oak, MI, 2008
SOFA Chicago, Habatat Galleries, FL
Invitational Exhibition, Habatat Galleries, Royal Oak, MI, 2007
Invitational Exhibition, Habatat Galleries, Royal Oak, MI, 2006
Invitational Exhibition, Habatat Galleries, Boca Raton, FL, 2006
Solo Exhibition, Pismo Gallery, Aspen, CO, 2005
Large Scale Glass Outdoor Sculpture, Oakland Arts Center,
    Pontiac, MI, 2005
Solo Exhibition, Habatat Galleries, Boca Raton, FL, 2005

## Stephen Clements
## (with Leah Wingfield)

Born: Richmond, California, 1948

### Selected Collections:
Arizona Commission on the Arts - Phoenix, AZ
Brockton Museum - Boston, MA
Fine Arts Museums of San Francisco, De
    Young Museum - San Francisco, CA
Kishijimi Collection - Japan
The National Gallery of American Art &
    Renwick Gallery - Smithsonian Institution- Washington DC
President's Collection - People's Republic of China
Richmond Art Museum - Richmond, CA
Standard Oil Corporation – California
Museo Del Vidrio - Monterrey, Mexico

## Matthew Curtis

Born: Luton, England, 1964

### Selected Exhibitions:
Art Trust. Australia.
National Gallery of Australia
Wagga Wagga National Glass Collection,
    Australia
Mobile City Art Glass Museum Collection,
    America
Ernsting Stifting, Glass Museum, Coesfeld
    Germany
De Young Museum, Saxe Collection, San Francisco, CA
Palm Springs Museum, CA
2011 'Geometry' Masters Exhibition, Sabbia Gallery, Sydney
2010 'Transparent' Axia Modern Art, Melbourne
2010 'Sum of Parts', Masters Exhibition, Sabbia Gallery, Sydney
2010 Australian Survey exhibition; Imago Gallery, Palm Desert
2010 SOFA Chicago, Thomas R Riley Gallery
2010 Ranamok glass prize, touring finalist, Australia

## Dan Dailey

Born: Philadelphia, Pennsylvania, 1947
*39th Int'l Glass Invitational Award Winner*

### Selected Collections:
Corning Museum of Glass, NY
Darmstatt Museum, Darmstatt, Germany
Detroit Institute of Arts, MI
Fuller Museum of Art, Brockton, MA
High Museum of Art, Atlanta, GA
Hunter Museum of American Art,
    Chattanooga, TN
Huntington Museum of Art, WV
Mint Museum, Charlotte, NC
Metropolitan Museum of Art, New York, NY
Musee des Arts Decoratifs, Louvre, Paris, France
Musee de Design et d'arts Appliques Contemporains, Lausanne,
    Switzerland
Museum of Arts and Design, New York, NY
National Gallery of Victoria, Melbourne, Australia
National Museum of Modern Art, Kyoto, Japan
Racine Art Museum, WI
Renwick Gallery, Smithsonian Institution, Washington, DC
Speed Art Museum, Louisville, KY
Toledo Museum of Art, OH

## Miriam Di Fiore

Born: Buenos Aires, Argentina, 1959
*37th Int'l Glass Invitational Award Winner*

### Selected Collections:
Corning Museum of Glass, NY
Newark Fine Art Museum, NJ
Cafsejian Museum of Contemporary Art,
    Armenia
Mobile Museum of Fine Arts, AL
Museo Nazional del Vidrio, Segovia, Spain.
Coleccion Estable de la Revista del Vidrio,
    Barcelona, Spain
Hotel Murano, Tacoma, WA
"A Path to Art", Pegli, Genoa, Italy.
Fused Glass Windows of the Town Hall of Suria, Barcelona, Spain

## Laura Donefer

Born: Ithaca, New York, 1955
*38th Int'l Glass Invitational Award Winner*
*37th Int'l Glass Invitational Award Winner*
*35th Int'l Glass Invitational Award Winner*
*34th Int'l Glass Invitational Award Winner*

### Selected Collections:
Museum of Civilization, Hull, Quebec, QC,
    Canada
Museo del Vidrio, Monterrey, Mexico
Corning Museum of Glass, NY
Charles A. Wustum Museum of Fine Arts, WI
Claridge Collection, Montreal, QC, Canada
Pilchuck Permanent Collection, Stanwood, WA
Clay and Glass Gallery, Waterloo, ON, Canada
Indusmin, Toronto, ON, Canada
University of Iowa Hospital Collection, Iowa City, IA
Royal Bank of Canada Collection, Toronto, ON, Canada
Skydome Glass Collection, Toronto, ON, Canada
Julian Art Collection, Trinidad.
Mendel Glass Collection, Montreal, QC, Canada

# Résumés

## Irene Frolic
Born: Stanislavov, Poland, 1941
*35th Int'l Glass Invitational Award Winner*

Selected Collections:
Bergstrom Mahler Museum. Neenah, WI
Canadian Clay and Glass Gallery. Waterloo, ON
Clairidge Collection. Montreal, QC
Contemporary Crafts Gallery. Portland, OR
Indusmin Corporate Collection. Toronto, ON
Montreal Museum of Fine Arts. Montreal, QC
Museum of Decorative Art, Lausanne, Switzerland
Museo del Vidreo, Monterrey, Mexico
National Liberty Museum. Philadelphia, PA
North Lands Creative Glass. Lybster, Scotland

## Susan Taylor Glasgow
Born: Superior, Wisconsin, 1958

Selected Exhibitions:
2011 39th Habatat Galleries International Glass Invitational Award Exhibition, Royal Oak, MI
2010 "Glass Uprising", Swanson Reed Gallery, Louisville, KY. Glass Art Society
2009 "Love Hurts", Heller Gallery, NYC, NY. Solo exhibition
2009 "The Communal Nest", George Caleb Bingham Gallery, Columbia, MO
2008-09 "Absence of Body", Pittsburgh Glass Center, Pittsburgh, PA
2008 Glass Concepts, Lehigh University, Bethlehem, PA
2005-08 SOFA Chicago. Represented by Heller Gallery, NYC
2007 Arkansas Center for the Arts, Little Rock, Arkansas. Permanent Collection
2007 "Reminiscence", Grounds For Sculpture, Hamilton, NJ
2006 Solo Show, "Mirror, Mirror", William & Florence Schmidt Art Center, Belleview, Illinois
2006 Solo Show, "Domestic Fairy Tales", Heller Gallery, NYC
2006 "Life InSight", Kentucky Museum of Art and Craft. Curated by Gail Brown
2006 "Edges Of Grace", Fuller Craft Museum, Brockton, MA. Curated by Gail Brown

## Robin Grebe
*37th Int'l Glass Invitational Award Winner*
*36th Int'l Glass Invitational Award Winner*
*32nd Int'l Glass Invitational Award Winner*

Selected Collections:
Montreal Museum of Fine Arts, Canada
Lowe Museum of Art, University of Miami, Coral Gables, FL
Museum of Fine Arts, Boston, MA
Montgomery Museum of Fine Arts, AL
Fuller Craft Museum, Brockton, MA
National Liberty Museum, Philadelphia, PA
DeCordova Museum and Sculpture Park, Lincoln, MA
Charles A. Wustum Museum, Racine, WI
J.B. Speed Art Museum, Louisville, KY
Detroit Institute of Art, David Jacob Chordorkoff Collection, MI
Corning Museum of Glass, Corning, NY

## Eric Hilton
Born: Bournemouth, England, 1937
*35th Int'l Glass Invitational Award Winner*
*34th Int'l Glass Invitational Award Winner*
*33rd Int'l Glass Invitational Award Winner*
*32nd Int'l Glass Invitational Award Winner*

Selected Collections:
Corning Museum of Glass, NY
Hokkaido Museum of Modern Art, Japan
Lowe Art Museum, FL
Musee Des Arts Decoratifs, France
Musee Des Arts Decoratifs, Switzerland
Otari Memorial Art Museum, Japan
Pilkington Glass Museum, England
Renwick Gallery, Smithsonian Institution, Washington, DC
Liuligongfang Museum, Shanghai, China

## Tomáš Hlavička
Born: Prague, Czech Republic, 1950
*39th Int'l Glass Invitational Award Winner*
*37th Int'l Glass Invitational Award Winner*
*36th Int'l Glass Invitational Award Winner*
*34th Int'l Glass Invitational Award Winner*

Selected Collections:
Museum of Decorativ Arts, Prague, Czech Republic
Glass Museum Koganezaki Crystal Park, Japan
Glass Museum Kanazawa, Japan
The Finnish Glass Museum, Riihimäki, Finland
Dennos Museum, Traverse City, MI, USA
Museum Pardubice, Czech Republic

## Petr Hora
Born: Brno, Czech Republic, 1949
*39th Int'l Glass Invitational Award Winner*
*37th Int'l Glass Invitational Award Winner*
*34th Int'l Glass Invitational Award Winner*
*32nd Int'l Glass Invitational Award Winner*

Selected Exhibitions:
Naples Museum of Art, Naples, FL
Habatat Galleries, Royal Oak, MI
Heller Gallery, New York, NY
Habatat Galleries, Boca Raton, FL
Kinsky Gallery, Chateau Zdar nad Sazavou
Consument Art, Nuremberg, Germany
Czech and Japan Glass Festival - Prague, Tokyo, Hiroshima, Nagano
Gallery Schalkwijk, Schalkwijk, Netherlands
Sofa Chicago - Heller Gallery, New York, NY
Habatat Galleries, Pontiac, MI
Klub Vytvarnych Umelcu Horacka, Zdar nad Sazavou, Czech Republic
Habatat Galleries, International Glass Exhibition in Beijing and Shanghai, China

## David Huchthausen
Born: Wisconsin Rapids, Wisconsin, 1951
*38th Int'l Glass Invitational Award Winner*
*37th Int'l Glass Invitational Award Winner*
*36th Int'l Glass Invitational Award Winner*
*35th Int'l Glass Invitational Award Winner*
*34th Int'l Glass Invitational Award Winner*
*32nd Int'l Glass Invitational Award Winner*

Selected Collections:
Bergstrom-Mahler Museum, Neenah, WI
Chrysler Museum, Norfolk, VA
Corning Museum of Glass, NY
Detroit Institute of Arts, MI
Glasmuseum, Ebeltoft, Denmark
High Museum of Art, Atlanta, GA
Hokkaido Museum of Modern Art, Hokkaido, Japan
Huntington Museum of Art, Huntington, WV
Indianapolis Museum of Art, Indianapolis, IN
Metropolitan Museum of Art, New York, NY
Musée Cantonal des Beaux Arts, Lausanne, Switzerland
Museum of Arts & Design, New York, NY
National Gallery of American Art, Renwick Gallery, Smithsonian Institution, Washington, DC
J. B. Speed Art Museum, Louisville, KY
Tacoma Art Museum, Tacoma, WA
Toledo Museum of Art, Toledo, OH

## Toshi Iezumi

Born: Ashikaga City, Tochigi Prefecture,
   Japan, 1954
*39th Int'l Glass Invitational Award Winner*

Selected Collections:
St. Louis Museum of Art, St. Louis, Missouri
Detroit Institute of Art, Detroit, Michigan
Milwaukee Museum, Milwaukee, Wisconsin
Los Angeles County Museum, Los Angeles,
   California
Metropolitan Museum of Art, New York,
   New York
Leigh Yawkey Woodson Art Museum, Wausau, Wisconsin
Columbus Museum of Art, Columbus, Ohio
Kyoto Museum of Moden Art, Kyoto, Japan
Museum of Decorative Arts, Lausanne, Switzerland
Shimonseki Art Museum, Shimonseki City, Japan
Hokkaido Museum of Modem Art, Sapporo, Japan
Corning Museum of Glass, Corning, New York
Royal Ontario Museum, Toronto, Ontario
American Craft Museum, New York City
Yokohoma Museum of Art, Yokohama, Japan

## Martin Janecky

Born: Liberec, Czech Republic, 1980
*38th Int'l Glass Invitational Award Winner*

Selected Exhibitions:
Art Palm Beach, Habatat Galleries, MI
Art Naples, Habatat Galleries, MI
Art Sarasota, Habatat Galleries, MI
"Theatre" Solo Exhibition Habatat Galleries,
   MI
SOFA Chicago, Habatat Galleries, MI,
Art and Craft, Novy Bor, Czech Republic
Pilchuck Glass School, WA
Marta Hewett Gallery, OH
Pilchuck Auction, Seattle, WA
Habatat Galleries, Chicago, IL
"International Invitational", Habatat Galleries, MI
Traver Gallery, Tacoma, WA
Marta Hewett Gallery, Cincinnati, OH
Jean-Claude Chapelotte Gallery, Luxembourg
Galerie K, Maastricht, Netherlands

## Luke Jerram

Born: Stroud, England, 1974

Selected Collections:
Corning Museum, NY
Museum of Glass, WA
Arkansas Arts Center, AR
Chazen Museum, WI
Alexander Tutsek Foundation, Germany
The Wellcome Collection, London, England
Cosmo Caixa, Barcelona, Spain
University of Southampton,, England
Bristol and Bath Science Park, UK
Bristol City Museum, UK
Institute of Physics, London, England
Pheano Museum, Germany

## Richard Jolley

Born: Wichita, Kansas, 1952
*37th Int'l Glass Invitational Award Winner*

Selected Collections:
Chrysler Museum at Norfolk, Norfolk, VA
Coburg Museum, Coburg, Germany
Corning Museum of Glass, NY
Hokkaido Museum of Modern Art, Sapporo,
   Japan
Hunter Museum of American Art,
   Chattanooga, TN
International Glasmuseum, Ebeltoft, Denmark
Knoxville Museum of Art, TN
Lowe Art Museum, Coral Gables, FL
Mint Museum of Craft & Design, Charlotte, NC
Mobile Museum of Art, Mobile, AL
Museum of Contemporary Arts and Design, New York, NY
Museum of Fine Arts, Boston, MA
Renwick Gallery of the Smithsonian Institution, Washington, DC
Speed Art Museum, Louisville, KY

## Vladimira Klumpar

Born: Rychnov nad Kneznou, Czech
   Republic, 1954
*38th Int'l Glass Invitational Award Winner*
*35th Int'l Glass Invitational Award Winner*

Selected Collections:
Museum of Decorative Arts, Prague, Czech
   Republic
Seven Bridges Foundation, Greenwich, CT
Regionalni Museum Mikulov, Mikulov,
   Czech Republic
Glass Museum, Novy Bor, Czech Republic
North Bohemian Museum of Liberec, Czech Republic
Museum of Glass and Jewelry, Jablonec nad Nisou, Czech Republic
Corning Museum of Glass, NY
Lannan Foundation, Palm Beach, FL
Wusham Museum of Art, Racine, WI
Mint Museum of Art, Charlotte, NC
American Arts and Craft Museum, New York, NY
Cafesjian Museum Foundation, Yerevan, Republic of Armenia

## Jenny Pohlman and Sabrina Knowles

Born: JP – Monterey, CA 1955
   SK – Cincinnati, OH 1960

Selected Collections and Exhibitions:
Cancer Care Alliance Center, Seattle WA
Mobile Museum of Art, AL
Racine Art Museum, WI
Museum of Glass, Tacoma, WA
Museum of American Glass, Millville, NJ
Habatat Galleries, MI
Duane Reed Gallery, MO
Pismo Gallery, CO
Butters Gallery, PR
Edmonds Museum, WA
Thomas Riley Galleries, OH

## Judith LaScola

Selected Collections and Exhibitions:
38th Int'l Glass Invitational Award Winner
36th Int'l Glass Invitational Award Winner
Swedish Cancer Institute Collection, Seattle, WA
Montreal Museum of Fine Art, QC, Canada
Museum of Fine Arts, Houston, TX
Carnegie Museum of Art, Pittsburgh, PA
Charles A Wustum Museum of Fine Art,
   Racine, WI
Hunter Museum of Fine Art, Chattanooga, TN
The Jewish Museum, San Francisco, CA
Habatat Galleries, MI
Maurine Littleton Gallery, DC
Habatat Galleries, FL
Hooks Epstein Galleries, TX

# Résumés

## Shayna Leib
*38th Int'l Glass Invitational Award Winner*
*36th Int'l Glass Invitational Award Winner*

Selected Exhibitions:
Habatat Galleries, MI
Habatat Galleries, IL
Toledo Museum of Art, OH
Pismo Gallery, CO
Paris Gibson Square Museum of Art, MT
Tobin-Hewett Gallery, KY
Arte Gallery, CA
Cervini Haas, AZ
Moment Masters of Fine Art Exhibition, WI

## Antoine Leperlier
Born: Evreux, France, 1953
*33rd Int'l Glass Invitational Award Winner*

Selected Collections:
Musée des Arts Décoratifs de Paris, France
Fonds National d'Art Contemporain, Paris,
    France
Corning Museum of Glass, NY
Hokkaido Museum of Modern Art, Japan
Collection du Conseil Régional de Haute
    Normandie, Rouen, France
Morris Museum, Morristown, NJ
Museum for Contemporary Art Glass, Scottsdale, AZ
Victoria & Albert Museum, London, United Kingdom
Leperlier glass art fund, Vendenheim, France
Liuligongfang Museum, Shanghai, China
Museum of Art & Design, New York, NY

## Jeremy Lepisto
Born: Fort Belvoir, Virginia, 1974

Selected Collections:
ACT Legislative Assembly Collection,
    Canberra, Australia
The Art Gallery of Western Australia, Perth,
    Australia
Museum of Glass, Tacoma, WA
Knoxville Museum, Knoxville, TN
Ebeltoft Museum, Ebeltoft, Denmark
Stoel Rives LLC, Seattle, WA
Dance USA 2006 Conference, Portland, OR
Museum of Northwest Art, La Conner, WA

## K. William LeQuier
Born: Mount Holly, New Jersey, 1953
*35th Int'l Glass Invitational Award Winner*
*34th Int'l Glass Invitational Award Winner*

Selected Collections:
American Glass Museum, Millville, NJ
Cooper Hewitt Museum, New York, NY
Corning Museum of Glass, Corning, NY
High Museum of Art, Atlanta, GA
Indianapolis Art Museum, Indianapolis, IN
Milwaukee Art Museum, Milwaukee, WI
Mobile Museum of Art, Mobile, AL
Morris Museum of Art, Morristown, NJ
National Liberty Museum, Philadelphia, PA
Philadelphia Museum of Art, Philadelphia, PA
Toledo Museum of Art, Toledo, OH

## Steve Linn
Born: Chicago, IL, 1943
*38th Int'l Glass Invitational Award Winner*
*37th Int'l Glass Invitational Award Winner*
*35th Int'l Glass Invitational Award Winner*
*33rd Int'l Glass Invitational Award Winner*

Selected Collections:
Indianapolis Museum of Art, IN
Albany Museum of Art, GA
Musee des Arts Decoratifs, Lausanne,
    Switzerland
Museum of American Glass, Millville, NJ
New York City Fire Museum, New York, NY
Verrerie Ouvrière d'Albi, Albi, France
National Liberty Museum, Philadelphia, PA
Museum of Art and History, Anchorage, AK
Mint Museum, Charlotte, NC
Lowe Art Museum, University of Miami, Coral Gables, FL

## Marvin Lipofsky
Born: Barrington, Illinois, 1938

Selected Collections:
Museum of Arts and Design, New York, NY
Toledo Museum of Art, Toledo, OH
National Museum of Glass, Leerdam, Netherlands
National Gallery, Canberra ACT, Australia
Corning Museum of Glass, NY
National Museum of Modern Art, Kyoto, Japan
International Glass Museum, Ebeltoft, Denmark
Detroit Institute of Art, MI
Musee des Arts Decoratifs (Fonds National d'Art Contemporin)
    Paris, France
Huntington Museum of Art, WV
Hokkaido Museum of Modern Art, Sapporo, Japan
Metropolitan Museum of Art, New York, NY
Cooper-Hewitt National Design Museum, Smithsonian Institution,
    New York, NY
Mint Museum of Craft + Design, Charlotte, NC
Lowe Art Museum, University of Miami, Coral Gables, FL
Tacoma Art Museum, WA

## Susan Longini
Born: Pittsburgh, Pennsylvania

Selected Collections and Exhibitions:
Oakland Museum of California, Oakland, CA
Santa Cruz Museum of Art and History,
    Santa Cruz, CA
Triton Museum of Art, Santa Clara, CA
City of Fremont, Fremont, CA
Toyota Corporation, Toyota City, Japan
Washington Hospital Healthcare System,
    Fremont, CA
Bullseye Gallery, Portland, OR
Micaëla Gallery, San Francisco, CA
Prism Contemporary Glass, Chicago, IL
SOFA West, Cervini-Haas Gallery, Santa Fe, NM

## Carmen Lozar
Born: Illinois, 1975

Collections and Awards:
*Outstanding Emerging Glass Artist 2009-*
    *2010, Florida Glass Art Alliance*
*Finalist for the Bombay Sapphire Glass*
    *Prize 2007. London, England*
*Castellani Art Museum of Niagra*
    *University, Niagra, New York*
Museum of Arts & Design. New York, NY

Selected Solo Exhibitions:
2011 Tailored Glass. Ken Saunders Gallery. Chicago, IL
2011 Theme Song. Foster White Gallery, Seattle, WA
2006 Couture. D & A Fine Arts, Studio City, CA
2006 Stills. Foster/White Gallery, Seattle, WA.
2003 Inner Activity. Foster/White Gallery, Seattle, WA
2003 Master of Fine Arts Thesis. Fosdick-Nelson Gallery, Alfred, NY
1999 Traces of Liquescence. Boneyard Gallery, Champaign, IL

## Maria Lugossy
Born: Budapest, Hungary, 1950
*37th Int'l Glass Invitational Award Winner*
*34th Int'l Glass Invitational Award Winner*

Selected Collections:
Musée de Louvre, Paris, France
Corning Museum of Glass, NY
Suntory Museum of Art, Tokyo, Japan
Museum of Toyamura, Japan
Savaria Museum, Szombathely, Hungary
Hungarian National Gallery, Budapest,
    Hungary
Musée des Arts Decoratifs, Paris, France
Glassmuseum, Ebeltoft, Denmark
Kunstmuseum, Duesseldorf, Germany
Stadt Fellbach, Germany
Veste Coburg, Coburg, Germany
Glasmuseum, Frauenau, Germany
Musée des Arts Decoratifs, Lausanne, Switzerland
Yokohama Museum of Art, Japan
Liberty Museum, Philadelphia, PA

## László Lukácsi
Born: Budapest, Hungary, 1961
*37th Int'l Glass Invitational Award Winner*

Selected Collections and Exhibitions:
Bakony Museum, Veszprém, Hungary
Museum of Applied Arts, Budapest,
    Hungary
Glassmuseum of Frauenau, Germany
Habatat Galleries, Royal Oak, MI
Pfm-Gallery, Köln, Germany
Klebelsberg's Castle, Budapest, Hungary
Gallery Painen, Berlin, Germany
Portia Gallery – Chicago, IL
Art Budapest / Art Expo – Budapest, Hungary
Gallery Rob van den Doel – the Hague, Netherlands
FORD Pyramid Salon – Budapest, Hungary

## Lucy Lyon
Born: Colorado Springs, Colorado, 1947

Selected Solo Exhibitions:
2006 Thomas Riiley Gallery, Cleveland, OH
2002 Intersections, LewAllen Contemporary,
    Santa Fe, NM
2000 Solitude and Society, Portia Gallery,
    Chicago, IL
1999 Portia Gallery, Chicago, IL
1997 Garland Gallery, Santa Fe, NM
1995 Garland Gallery, Santa Fe, NM
1991 Elaine Horwitch Gallery, Santa Fe, NM
1991 Mariposa Gallery, Albuquerque, NM
1991del Mano Gallery, Los Angeles, CA
1987 University of New Mexico, Los Alamos, NM

## John Miller
Born: New Haven, CT, 1966
*33rd Int'l Glass Invitational Award Winner*

Selected Collections and Exhibitions:
Corning Museum of Glass, Corning, NY
Museum of Arts and Design, New York, NY
Tacoma Glass Museum, WA
Pilchuck Glass School, Stanwood, WA
Museum of American Glass, Millville, NJ
Habatat Galleries Annual International Glass
    Exhibition, Royal Oak, MI
Visual Arts Center, Portsmouth, VA
Biennial Exhibition, Wheaton Village, Millville, NJ
Sculpture, Objects, Functional Art (SOFA), Chicago, IL
Faculty Biennial Exhibition, University Galleries, Illinois State
    University, IL

## Debora Moore
Born: St. Louis, Missouri, 1960
*37th Int'l Glass Invitational Award Winner*
*36th Int'l Glass Invitational Award Winner*
*35th Int'l Glass Invitational Award Winner*
*34th Int'l Glass Invitational Award Winner*
*33rd Int'l Glass Invitational Award Winner*

Selected Exhibitions:
Habatat Galleries, Royal Oak, MI
Habatat Galleries, Boca Raton, FL
Nancy Hoffman Gallery, New York, NY
Museum of Glass, Tacoma, WA
Muskegon Museum of Art, MI
Foster White Gallery, Seattle, WA
Butters Gallery Ltd., Portland, OR
Foster White Gallery, Kirkland, WA
Pismo Gallery, Denver, CO

## William Morris
Born: Carmel, California, 1957
*39th Int'l Glass Invitational Award Winner*
*34th Int'l Glass Invitational Award Winner*
*32nd Int'l Glass Invitational Award Winner*

Selected Collections:
American Craft Museum, New York, NY
Auckland Museum, New Zealand
Chrysler Museum of Art, Norfolk, VA
Charles A. Wustum Museum of Fine Arts,
    Racine, WI
Corning Museum of Glass, NY
Daiichi Museum, Nagoya, Japan
Detroit Institute of Arts, MI
Hokkaido Museum of Modern Art, Sapporo, Japan
Hunter Museum, Chattanooga, TN
J.B. Speed Art Museum, Louisville, KY
Metropolitan Museum of Art, New York, NY
Mobile Museum of Art, AL
Musee des Arts Decoratifs, Paris, France
Museum of Fine Arts, Houston, TX
Renwick Gallery, Smithsonian Institution, Washington, DC
Toledo Museum of Art, OH
Victoria and Albert Museum, London, England

## Kathleen Mulcahy
Born: Newark, New Jersey, 1950

Selected Collections:
American Art Museum, Renwick Gallery,
    Smithsonian Institution, Washington, D.C.
American Eagle Outfitters Headquarters,
    Pittsburgh, PA
American Craft Museum, NY
Heinz History Center, PA
State Museum of Pennsylvania, Harrisburg,
    PA
Museum of Art, Carnegie Institute, Pittsburgh, PA
The Corning Museum of Glass, Corning, NY

## Paul Nelson
Born: Milwaukee, Wisconsin, 1970

Selected Collections:
Jewish Hospital East, Louisville, Kentucky
Jewish Hospital South, Louisville, Kentucky
Foote, Cone and Belding Corporation,
    Chicago, Illinois
Engineering Hall, University of Illinois
    Campus, Urbana, Illinois
Morgan Stanley Collection, Chicago, Illinois
Outback Steakhouse Headquarters, Atlanta,
    Georgia
Grace Doherty Library, Centre College, Danville, Kentucky

# Résumés

### Bretislav Novak Jr.
Born: Semily, Czech Republic, 1952

Selected Exhibitions:
2011 39th Habatat Galleries International
    Invitational Award Exhibition, Royal Oak
2009 37th Habatat Galleries International
    Invitational Award Exhibition, Royal Oak
2008 36th Habatat Galleries International
    Invitational Award Exhibition, Royal Oak
2005 Gallery Porkova
2002 30th Habatat Galleries International Invitational Award
    Exhibition, Royal Oak
1997 Riley Hawk Galleries, Columbus
1996-SOFA, Chicago
1995 Heller Galleries, New York
1993 Habatat Galleries, Detroit
1991 21st Habatat Galleries International Invitational Award
    Exhibition, Royal Oak
1989 The Suntory Prize '89 JAPAN
1988 World Glass Now '88
1987 Novak Exhibition, Phoenix

### Stepan Pala
Born: Zlin, Czechoslovakia, 1944
*38th Int'l Glass Invitational Award Winner*
*35th Int'l Glass Invitational Award Winner*

Selected Collections and Exhibitions:
Slovak National Gallery, Bratislava, Slovakia
Museum of Applied Arts, Prague, Czech
    Republic
Museum of Fine Arts, Kanazawa, Japan
Dutch Quin Collection, Netherlands
Nationale Netherlanden, Rotterdam, Netherlands
Castle Lemberk, Collection of Symposia, Czech Republic
Victoria & Albert Museum, London, United Kingdom
Green House, Bratislava, Slovakia
Gallery Jean-Claude Chapelotte, Luxembourg
Gallery Komart, Bratislava, Slovakia

### Albert Paley
Born: Philadelphia, Pennsylvania, 1944
*36th Int'l Glass Invitational Award Winner*

Selected Collections:
British Museum, London, United Kingdom
Detroit Institute of Arts, MI
Cambridge University, The Fitzwilliam
    Museum, United Kingdom
Art Gallery of Western Australia, Perth, Australia
High Museum of Art, Atlanta, GA
Hunter Museum of Art, Chattanooga, TN
Metropolitan Museum of Art, New York, NY
Museum of Fine Arts, Boston, MA
Museum of Fine Arts, Houston, TX
Smithsonian Institution, Renwick Gallery, Washington, DC
Toledo Museum of Art, OH
Victoria & Albert Museum, London, United Kingdom
The White House, Washington, DC
Wustum Museum of Fine Art, Racine, WI

### Zora Palova
Born: Bratislava, Czechoslovakia, 1947
*38th Int'l Glass Invitational Award Winner*

Selected Collections:
Kunstsammlungen der Veste Coburg,
    Coburg, Germany
Museum of Decorative Arts, Prague, Czech
    Republic
Nationale Nederlanden, Rotterdam, Netherlands
Shimonoseki Museum of Modern Art, Japan
Slovak National Gallery, Bratislava, Slovakia
Ulster Museum, Belfast, Ireland
Victoria & Albert Museum, London, United Kingdom
Corning Museum of Glass, NY
Dutch Quin Collection, Netherlands
Koganezaki Glass Museum, Shizuoka, Japan

### Mark Peiser
Born: Chicago, Illinois, 1938
*39th Int'l Glass Invitational Award Winner*
*38th Int'l Glass Invitational Award Winner*
*36th Int'l Glass Invitational Award Winner*
*35th Int'l Glass Invitational Award Winner*

Selected Collections:
Corning Museum of Glass, NY
Detroit Institute of Arts, MI
Fine Arts Museum of the South, Mobile, AL
Glasmuseum, Ebeltoft, Denmark
High Museum of Art, Atlanta, GA
Hokkaido Museum of Modern Art, Sapporo, Japan
Huntington Museum of Art, WV
Renwick Gallery, Smithsonian Institution, Washington, DC
Mint Museum of Art, Charlotte, NC
Museum of Arts and Design, New York, NY
National Museum of American History, Smithsonian Institution,
    Washington, DC
J.B. Speed Art Museum, Louisville, KY

### Sibylle Peretti
Born: Muelheim an der Ruhr, Germany, 1964

Selected Collections:
Montreal Art Museum, Montreal, Canada
Carnegie Museum of Art, Pittsburgh
Museum fuer Angewandte Kunst, MAK
    Frankfurt, Germany
New Orleans Museum of Art, New Orleans
Corning Museum of Glass, Corning
The Ernsting Collection, Museum Alter Hof
    Herding, Coesfeld, Germany
Museum der Stadt Muelheim an der Ruhr, Germany
Baden Wuerthenbergische Landesmuseum, Stuttgart, Germany
Badische Landesmuseum Karlsruhe, Germany
Glasmuseum Frauenau, Germany
American Glass Museum Milleville
Tutsek Stiftung, Munich, Germany
Glasmuseum Frauenau, Frauenau, Germany

### Marc Petrovic
Selected Collections and Exhibitions:
Habatat Galleries, MI
Niijima Museum of Glass, Tokyo, Japan
Charlotte Mint Museum, NC
Tucson Museum of Art, AZ
Racine Art Museum, WI
Arkansas Arts Center Foundation Collection,
    Little Rock, AR
Fuller Craft Museum, Brockton, MA
Vero Beach Art Museum, FL
Irvine Contemporary, Washington, DC
eo art lab; Chester, CT
Reynolds Gallery; Richmond, VA
Heller Gallery; New York, NY

### Stephen Rolfe Powell
Born: Birmingham, Alabama, 1951
*33rd Int'l Glass Invitational Award Winner*

Selected Collections:
Racine Art Museum, WI
Hunter Museum of American Art,
    Chattanooga, TN
Muskegon Museum of Art, MI
Corning Museum of Glass, NY
Wustum Museum of Fine Arts, Racine, WI
Cleveland Museum of Art, OH
Detroit Institute of Arts, MI
Wagga Wagga City Art Gallery, Australia
Sydney College of Art, Sydney, Australia
The Auckland Museum, Auckland, New Zealand
Huntsville Museum of Art, AL
Mobile Museum of Fine Art, AL
Birmingham Museum of Art, AL
Hermitage Museum, St. Petersburg, Russia

## Clifford Rainey
Born: Whitehead, Country Antrim,
    Northern Ireland, 1948
*39th Int'l Glass Invitational Award Winner*
*37th Int'l Glass Invitational Award Winner*
*35th Int'l Glass Invitational Award Winner*
*33rd Int'l Glass Invitational Award Winner*

### Selected Collections:
Ulster Museum, Belfast, Northern Ireland
Victoria and Albert Museum, London, UK
Arts Council of Northern Ireland, Belfast,
    Northern Ireland
Municipal Gallery, Dublin, Ireland
American Museum of Art and Design, New York
Los Angeles County Museum of Art, California
Museum of Modern Art, Dublin, Ireland
Musee des Arts Decoratifs, Lausanne, Switzerland
Detroit Institute of Arts, Detroit, Michigan
Institute du Verre, Hate-Normandie, France
Toledo Museum of Art, Toledo, Ohio
De Young Museum, San Francisco, California
The Speed Art Museum, Louisville, Kentucky
The Corning Museum, New York
Tutsek-Stiftung, Munchen, Germany

## Colin Reid
Born: Cheshire, England, 1953

### Selected Collections:
 Victoria & Albert Museum, London
Corning Museum of Glass, New York
Kunstmuseum der Stadt Dusseldorf,
    Germany.
Musee de Design et d'Arts Appliques
    Lausanne, Switzerland.
Ebeltoft Glass Museum, Ebeltoft, Denmark
Tokyo National Museum of Modern Art, Japan
Hokkaido Museum of Art, Japan
Birmingham Museum & Art Gallery, Birmingham, UK
National Museum of Scotland, Edinburgh
Indianapolis Museum of Art, Indiana, USA
Museum of Decorative Arts, Prague, Czech Republic
Charles A. Wustum Museum of Fine Art. Racine, Wisconsin, USA
J.B. Speed Art Museum, Louisville, Kentucky, USA
National Liberty Museum, Philadelphia, Pennsylvania, USA
Montreal Museum of Fine Arts, Candada
Toledo Museum of Art, OH, USA
Seven Bridges Foundation, USA
Shanghai Museum of Glass, China

## Richard Ritter
Born: Detroit, Michigan, 1940
*37th Int'l Glass Invitational Award Winner*
*34th Int'l Glass Invitational Award Winner*
*32nd Int'l Glass Invitational Award Winner*

### Selected Collections:
Detroit Institute of Arts, Aviva and Jack A.
    Robinson Studio Glass Collection, MI
Chrysler Museum, Norfolk VA
Corning Museum of Glass, NY
High Museum of Art, Atlanta, GA
Hunter Museum, Chattanooga, TN
J.B. Speed Museum, Louisville, KY
Milwaukee Art Museum, WI
Mint Museum of Craft and Design, Charlotte, NC
Racine Art Museum, WI
Renwick Gallery, Smithsonian Institution, Washington, DC
American Art Museum, Smithsonian Institution, Washington, DC
St. Louis Art Museum, MO
The White House Permanent Art Collection, Washington, DC

## Marlene Rose
Born: 1967

### Selected Collection and Exhibitions:
Gulf Coast Museum of Art, Largo, FL
Museum of Contemporary Art, Yerevan,
    Armenia
Habatat Galleries, Royal Oak, MI
PISMO Galleries, Aspen, CO
Hodgell Gallery, Sarasota, FL
Manitou Gallery, Santa Fe, NM
Kuivato Gallery, Sedona, AZ
Gallery DeNovo, Sun Valley, ID
Hawthorn Gallery, Birmingham, AL
Fay Gold Gallery, Atlanta, GA
Kuivato Gallery, Sedona, AZ

## Martin Rosol
Born: Prague Czechoslovakia, 1956

### Selected Collections and Exhibitions:
Philadelphia Museum of Art, PA
Corning Museum of Glass, NY
American Craft Museum, New York, NY
Museum of Fine Arts, Boston, MA
Moravian National Gallery, Brno, Czech
    Republic
Habatat Galleries, MI
Habatat Galleries, VA
SOFA New York, Holsten Gallery, MA
Davis and Cline Gallery, Ashland, OR
Heller Gallery, New York, NY
Chappell Gallery, Boston, MA

## Kari Russell-Pool
Born: Salem, Massachusetts, 1967

### Selected Collections:
American Glass Museum, Millville, NJ
Racine Art Museum, Racine, WI
Charlotte Mint Museum, Charlotte, NC
Seattle Art Museum, Seattle, WA
Corning Museum of Glass, Corning, NY
Smithsonian Museum of American Art, Luce
    Foundation Center, Washington, DC
Mobile Museum Of Art, Mobile, AL
Tacoma Museum of Glass, Tacoma, WA
Niijima Museum of Glass, Tokyo, Japan
Tucson Museum of Art, Tucson, AZ

## Davide Salvadore
Born: Murano, Italy, 1953
*38th Int'l Glass Invitational Award Winner*
*36th Int'l Glass Invitational Award Winner*

### Selected Exhibitions:
Naples Museum of Art, Naples, FL
Art Palm Beach, Habatat Galleries, Royal
    Oak, MI
International Glass Exhibition, Litvak
    Gallery, Tel Aviv, Israel
SOFA Chicago, Habatat Galleries, Royal Oak,
    MI
SOFA Santa Fe, Habatat Galleries, Royal Oak, MI
Invitational Exhibition, Habatat Galleries, Royal Oak, MI
Art Amsterdam, Participation KunstRAI, Amsterdam,
    Netherlands
Hooks-Epstein Galleries, Houston TX
Thomas R. Riley Galleries, Cleveland, OH
SOFA New York, Thomas R. Riley Gallery, Cleveland, OH
Habatat Galleries, Royal Oak, MI

# Résumés

## Jack Schmidt

Born: Toledo, Ohio, 1945
*36th Int'l Glass Invitational Award Winner*
*34th Int'l Glass Invitational Award Winner*

Selected Collections:
Alpena Power and Electric Company,
    Alpena, MI
Bellerive Museum, Zurich, Switzerland
Bowling Green State University, OH
Chubu Institute of Technology, Nagoya,
    Japan
Corning Museum of Glass, NY
Detroit Institute of Art, MI
General Electric Company, Milwaukee, WI
Illinois State University, Normal, IL
Leigh Yawkey Woodson Art Museum, Milwaukee, WI
Rochester Institute of Technology, NY
Shaw Walker Company, Muskegon, MI
Toledo Federation of Art, OH
National Museum of American Art, Smithsonian Institution,
    Washington, DC

## Mary Shaffer

Born: Walterboro, South Carolina, 1945
*36th Int'l Glass Invitational Award Winner*
*35th Int'l Glass Invitational Award Winner*

Selected Collections:
Metropolitan Museum of Art, New York, NY
Museum of Modern Art, Kyoto, Japan
Museum of Art & Design, New York, NY
Renwick Gallery, Smithsonian Institution,
    Washington, DC
Montreal Museum of Fine Arts, Montreal,
    QC, Canada
Huntington Museum, WV
Museum Bellerive, Zurich, Switzerland
Museum of Decorative Arts, Lausanne, Switzerland
Detroit Institute of Arts, MI
Musee du Verre; Sars-Poteries, France
Corning Museum of Glass, NY
Stadt Museum; Frauenau, Germany
Glas Museum; Ebeltoft, Denmark
Indianapolis Museum, IN

## Paul Stankard

Born: Attleboro, Massachusetts, 1943
*39th Int'l Glass Invitational Award Winner*
*38th Int'l Glass Invitational Award Winner*
*37th Int'l Glass Invitational Award Winner*
*34th Int'l Glass Invitational Award Winner*
*33rd Int'l Glass Invitational Award Winner*
*32nd Int'l Glass Invitational Award Winner*

Selected Collections:
Corning Museum of Glass, NY
GlasMuseum, Ebeltoft, Denmark
Hokkaido Museum of Modern Art, Sapporo, Japan
Huntington Museum of Art, WV
Hsinchu Cultural Center, Taiwan
Indianapolis Museum of Art, IN
J.B. Speed Museum, Louisville, KY
Metropolitan Museum of Art, New York, NY
Mobile Museum of Art, AL
Musee des Arts Decoratif, Palais du Louvre, Paris, France
Museum of Arts and Design, New York, NY
Renwick Gallery, The Smithsonian Institution, Washington, DC
Victoria & Albert Museum, London, England

## Therman Statom

Born: Escondido, California, 1953
*35th Int'l Glass Invitational Award Winner*
*33rd Int'l Glass Invitational Award Winner*

Selected Collections:
California African-American Museum, Los
    Angeles, CA
Corning Incorporated, NY
Craft and Folk Art Museum, Los Angeles, CA
Detroit Institute of Arts, MI
High Museum of Art, Atlanta, GA
Lowe Art Museum, University of Miami, FL
Milwaukee Art Museum, Milwaukee, WI
Mint Museum of Craft and Design, Charlotte, NC
Musse des Arts Decoratifs, Palais du Louvre, Paris, France
Musee de Design et D'Arts Appliques /Contemporain, Lausanne,
    Switzerland
Museum of Fine Arts, St. Petersburg, FL
National Afro-American Museum and Cultural Center, Columbus,
    OH
Racine Art Museum, WI
Renwick Gallery, Smithsonian Institution, Washington DC
Toledo Museum of Art, School of Art and Design, OH

## Ethan Stern

Born: Ithaca, New York, 1978

Awards:
*Best Emerging Artist Award, Tacoma
    Museum of Glass, Tacoma, WA, 2010*
*"Jurors choice" Bay Area Glass Institute
    Fine Art Auction, San Francisco, CA,
    2010*
*The George and Dorothy Saxe Award,
    Full Scholarship, Pilchuck Glass School,
    Stanwood, WA, 2009*
*Purchase Award, Soho Myriad, Ritz Carlton, Shenzhen, China,
    2008*
*Fellow, Wheaton Arts and Cultural Center, Millville, NJ, 2008*
*Finalist, Young Glass 2007 Exhibition, Eboltoft Glass Museum,
    Ebeltoft, Denmark, 2007*
*Pilchuck Glass School Staff Scholarship, Pilchuck Glass School,
    Stanwood, WA, 2006*

Selected Collections:
Museum of American Glass, Millville, NJ
Eboltoft Glass Museum, Ebeltoft, DK
Museum of Glass, Tacoma, WA
Palm Springs Contemporary Art Museum, Palm Springs, CA
"Oasis of the Seas" Royal Caribbean Cruises, Finland, 2009

## April Surgent

Born: Missoula, Montana, 1982

Selected Awards:
'Artist Choice Award', Tacoma Museum of
    Glass auction award, USA, 2011
'April Surgent, Forging Relationships in
    Reflections' article, Drawing Magazine,
    Naomi Ekperigin, 2011
Artist in Residence, Museum of Glass,
    Tacoma, USA, 2011
New Talent Award, Urban Glass, New York,
    USA, 2010
Bellevue City Council Grant, in support of Bellevue Arts Museum
    project, Bellevue, WA, 2010
4Culture grant, in support of Bellevue Arts Museum project,
    Seattle, 2010
Selected Collections:
Ulster Museum, Belfast, Ireland
Corning Museum of Glass, Corning, NY, USA
Chrysler Museum, Norfolk, VA, USA
Museum of Glass, Tacoma, WA
 Hotel Murano, Tacoma, WA, USA.
Australian National University Public Artwork Program,
    Canberra, Australia
Bradley Allen Acquisition Award, Canberra, Australia
Embassy of Spain Art Collection, Canberra, Australia

## Tim Tate
Born: Washington D.C., 1960
*38th Int'l Glass Invitational Award Winner*

Selected Collections:
Prince Georges County Courthouse, Upper
    Marlboro, MD
Food and Friends Donor Wall – Washington, DC
District Government Project - Wilson
    Building Public Art, Washington, DC
Liberty Park at Liberty Center, Outdoor
    Sculpture Commission, Arlington, VA
The Adele, Outdoor Sculpture Commission, Silver Spring, MD
US Environmental Protection Agency, Ariel Rios Building
    Courtyard, Outdoor Sculpture Commission, Washington, DC
National Institute of Health (NIH) Sculpture Commission, Hatfield
    Clinic, Bethesda, MD
American Physical Society / Baltimore Science Center, Sculpture
    Commission, Baltimore, MD
Holy Cross Hospital, Sculpture for Oncology Ward, Silver Spring, MD

## Michael Taylor
Born: Lewisburg, Tennessee, 1944
*38th Int'l Glass Invitational Award Winner*

Selected Collections:
National Collection of American Art, Renwick
    Gallery, Smithsonian Institution, Washington, DC
Chrysler Museum of Art, Norfolk, VA
Royal Ontario Museum, Toronto, ON, Canada
Sung - Jin Glass Museum, Kimpo, Korea
Mint Museum of Art, Charlotte, NC
Corning Museum of Glass, NY
National Museum of Glass, Marina Grande, Portugal
Notojima Museum of Art, Japan
Del Vedrio Vidricra, Monterrey, NL, Mexico
Glas Museum Ebeltoft, Ebeltoft, Denmark
Hunter Museum of Art, Chattanooga, TN
National Museum of Glass, Leerdam, Netherlands
Kunsthaus Am Museum, Köln, Germany
Düsseldorf Museum of Art, Düsseldorf, Germany

## Margit Toth
Born: Hajkuszoboszlo, Hungary, 1963
*37th Int'l Glass Invitational Award Winner*
*34th Int'l Glass Invitational Award Winner*
*33rd Int'l Glass Invitational Award Winner*
*32nd Int'l Glass Invitational Award Winner*

Selected Exhibitions:
Habatat Galleries, Royal Oak, MI
Compositions Gallery, San Francisco, CA
Art Glass Centre, Netherlands
Museum of Applied Arts, Budapest
Brauckman Gallerie, Netherlands
Dennos Museum, Traverse City, MI
Habatat Galleries, Mi Wheaton Village 2005, 2007, 2009
Habatat Galleries Mi Sofa Chicago, 2004 - 2010
Habatat Galleries, MI, Art Palm Beach, 2006 - 2011

## Brian Usher
Born: Syracuse, New York, 1963

Selected Exhibitions:
SOFA Santa Fe, Prism Gallery, Santa Fe, NM
SOFA Chicago Prism Gallery, Chicago, IL
38th Habatat International Glass Invitational,
    Royal Oak, MI
36th Habatat International Glass Invitational,
    Royal Oak, MI
SOFA NY Prism Gallery, New York, NY
Singular Forms – Trans Minimalist
    Sculpture, Chicago, IL
In and Out, New Brewery Arts, Quenington, UK
New Sculpture Makostasy Gardens, Makostacy, Czech Republic
SOFA Chicago, Prism Gallery, Chicago, IL
Studio Glass Gallery European Glass Masters, London, UK
New Work Gallery, Sklo, Korea
British Glass Biennale, Ruskin Glass Centre, Stourbridge, UK

## Bertil Vallien
Born: Stockholm, Sweden, 1963

Selected Collections:
Art Gallery of Western Australia, Perth,
    Australia
Corning Museum of Glass, NY
Detroit Institute of Arts, MI
Glasmuseum, Ebeltoft, Denmark
H. M. the King of Sweden's Collection,
    Stockholm, Sweden
Hokkaido Museum of Modern Art, Japan
Metropolitan Museum of Art, New York, NY
MUDAC, Musée de Design et d'Arts Appliqués Contemporains,
    Lausanne, Switzerland
Musée des Arts Décoratifs, Paris, France
Museo del Vidrio, Monterrey, Mexico
Museum of Arts & Design, New York, NY
National Museum of Art, Stockholm, Sweden
National Museum of Modern Art, Kyoto, Japan
National Museum of Modern Art, Tokyo, Japan
Pilkington Glass Museum, St. Helen's, Merseyside, UK
Royal Ontario Museum, Toronto, ON, Canada
Victoria and Albert Museum, London, UK

## Janusz Walentynowicz
Born: Dygowo, Poland 1956
*32nd Int'l Glass Invitational Award Winner*

Selected Collections:
Ebeltoft Glasmuseum, Ebeltoft, Denmark.
Handelsbankens Kunstforening,
    Copenhagen, Denmark.
Corning Museum of Glass, NY
Museum of Arts and Design, New York, NY
Rockford Art Museum, IL
Detroit Institute of Arts, MI
Hsinchu Cultural Center, Taiwan
Museum, Beelden ann Zee, Scheveningen, Netherlands
National Liberty Museum, Philadelphia, PA
Chrysler Museum of Art, Norfolk, VA
Milwaukee Art Museum, WI
Museum of Fine Art, Montreal, QC, Canada
Lowe Art Museum, University of Miami, Coral Gables, FL

## Leah Wingifeld
## (with Stephen Clements)
Born: Phoenix, Arizona, 1957

Selected Collections and Exhibitions:
Naples Museum of Art, Naples, FL
Galerie International du Verre - Biot, France
Museo del Vidrio - Monterrey, Mexico
Museum of Art, Philadelphia, PA
Carnegie Museum of Art, Pittsburg, PA
Toledo Museum of Art, OH
Lux Center for the Arts, Lincoln, NE
Habatat Galleries, Royal Oak, MI
Miller Gallery, New York, NY
Compositions Gallery, San Francisco, CA
Habatat Galleries, Chicago, IL
Hokkaido Museum of Modern Art, Japan
Hsinchu Cultural Center, Taiwan

# Résumés

## Ann Wolff

Born: Gotland Kyllaj, Sweden, 1937
*39th Int'l Glass Invitational Award Winner*
*38th Int'l Glass Invitational Award Winner*
*37th Int'l Glass Invitational Award Winner*
*36th Int'l Glass Invitational Award Winner*
*35th Int'l Glass Invitational Award Winner*
*34th Int'l Glass Invitational Award Winner*
*33rd Int'l Glass Invitational Award Winner*

Selected Collections:
Corning Museum of Glass, NY
Ebeltoft Glasmuseum, Denmark
Frauenau Museum, Germany
Hokkaido Museum of Modern Art, Japan
Lobmayr Museum, Wien, Austria
Metropolitan Museum, New York, NY
Mint Museum of Craft & Design, Charlotte, NC
Musée des Arts Décoratifs, Paris, France
Museum of Arts and Design, New York, NY
Museum Bellerive, Zürich, Switzerland
National Museum of Modern Art, Tokyo, Japan
National Museum, Stockholm, Sweden
Stedelijk Museum, Amsterdam, Netherlands
Victoria and Albert Museum, London, United Kingdom

## John Wood

Born: 1944

Selected Collections:
Habatat Galleries, 38th International Glass
  Invitational, Royal Oak, MI
Alan B. Dow Museum of Science and Art,
  Midland, MI
Flint Institute of Arts, MI
PRISM Contemporary Glass, Chicago IL
Center for Creative Studies, President's
  Permanent Exhibit, Detroit, MI

## Hiroshi Yamano

Born: Fukuoka, Japan, 1956
*35th Int'l Glass Invitational Award Winner*
*33rd Int'l Glass Invitational Award Winner*

Selected Collections:
Charles A. Wustum Museum of Fine Arts,
  Racine, WI,
USA Chrysler Museum of Art, Norfolk, VA,
  USA
Corning Museum of Glass, Corning, NY,
  USA
Gerald L. Cafesjian Museum of Contemporary Art, Yerevan,
  Armenia
Grand Crystal Museum, Taipei, Taiwan
Kurokabe Glass Museum, Nagahama, Japan
Lowe Art Museum, Miami, FL, USA
Museum of American Glass, Millville, NJ, USA
Museum of Arts and Crafts, Itami, Japan
Rochester Institute of Technology Library, Rochester, NY, USA
Winter Park City Hall, Winter Park, FL, USA
Potash Corporation, Northbrook, IL, USA
Palm Springs Art Museum, Palm Springs, CA, USA
Hotel Murano, Tacoma, WA, USA

## Brent Kee Young

Born: Los Angeles, California, 1946

Selected Collections:
American Glass Museum, Millville, NJ
Bergstrom Mahler Art Museum, Neenah, WI
Carnegie Museum of Art, Pittsburgh, PA
Cleveland Museum of Art, Cleveland, OH
Columbia Museum of Art, Columbia, SC
Corning Museum of Glass, Corning, NY
First Contemporary Glass Museum,
  Alcorcon (Madrid), Spain
High Museum of Art, Atlanta, GA
Hokaido Museum of Art, Sapporo, Japan
Niijima Contemporary Glass Art Museum, Niijima, Tokyo, Japan
New Orleans Museum of Art, New Orleans, LA
Racine Art Museum, Racine WI
Smithsonian Museum of American Art, Renwick Gallery,
  Washington, D.C.
The Toledo Museum of Art, Glass Pavilion, Toledo OH

## Albert Young

Born: Mt. Clemens, Michigan, 1951
*38th Int'l Glass Invitational Award Winner*
*35th Int'l Glass Invitational Award Winner*

Selected Exhibitions:
Muskegon Museum of Art, MI
Hodgell Gallery, Sarasota, FL
Habatat Galleries, Chicago, IL
Habatat Galleries, Boca Raton, FL
Habatat Galleries, Pontiac, MI
Miller Gallery, New York, NY
Vesperman Gallery, Atlanta, GA
Flint Institute of Arts, MI
Museo Del Vidrio, Monterrey, Mexico
Habatat Galleries, International Glass Invitational, Royal Oak, MI
"Sculpture Objects Functional Art" SOFA Exhibition, Chicago, IL

## Udo Zembok

Born: Braunschweig, German, 1951

Selected Collections:
Alexander Tutsek Stiftung, München, Germany
Musée-Atelier du Verre, Sars-Poteries, France
Europïsches Museum für Modernes Glas,
  Coburg, Germany
Communauté Urbaine, Strasbourg, France
Museo de Arte en Vidrio de Alcorcón,
  Madrid, Spain
City Hall, St. Just-St. Rambert, France
Préfecture de L'Allier (regional administration), Moulins, France
Frac Haute-Normandie, Rouen, France
Musée des Beaux-Arts, Lyon, France
Entergy Corporate Collection, New Orleans, Louisiana, USA
Mobile Museum of Art, Mobile, Alabama, USA

## Toots Zynsky

Born: Boston, Massachusetts, 1951
*38th Int'l Glass Invitational Award Winner*
*37th Int'l Glass Invitational Award Winner*
*34th Int'l Glass Invitational Award Winner*

Selected Collections:
Corning Museum of Glass, NY
Detroit Institute of Arts, MI
Glasmuseum, Ebeltoft, Denmark
Hokkaido Museum of Modern Art, Sapporo,
  Japan
Hunter Museum of Art, Chattanooga, TN
Huntington Museum of Art, Huntington, WV
J.B. Speed Museum, Louisville, KY
Metropolitan Museum of Art, New York, NY
Musée de Design et D'Arts Appliqués, Lausanne, Switzerland
Musée des Arts Décoratifs du Louvre, Paris, France
Museo Municipal de Arte en Vidrio de Alcorcon, Spain
Museo del Vidrio, Monterrey, Mexico
National Museum of American Art, Smithsonian Institution,
  Washington, DC